T0201178

Canon® EOS Rebel T7/2000D

by Julie Adair King

A Wiley Brand

Canon® EOS® Rebel T7/2000D For Dummies®

Published by: **John Wiley & Sons, Inc.,** 111 River Street, Hoboken, NJ 07030-5774, www.wiley.com

Copyright © 2018 by John Wiley & Sons, Inc., Hoboken, New Jersey

Published simultaneously in Canada

For general information on our other products and services, please contact our Customer Care Department within the U.S. at 877-762-2974, outside the U.S. at 317-572-3993, or fax 317-572-4002. For technical support, please visit https://hub.wiley.com/community/support/dummies.

Wiley publishes in a variety of print and electronic formats and by print-on-demand. Some material included with standard print versions of this book may not be included in e-books or in print-on-demand. If this book refers to media such as a CD or DVD that is not included in the version you purchased, you may download this material at http://booksupport.wiley.com. For more information about Wiley products, visit www.wiley.com.

Library of Congress Control Number: 2018948229

ISBN 978-1-119-47156-1 (pbk); ISBN 978-1-119-47154-7 (ebk); ISBN 978-1-119-47155-4 (ebk)

Manufactured in the United States of America

SKY10081752_081024

Contents at a Glance

Table of Contents

Introduction

n 2003, Canon revolutionized the photography world by introducing the first digital SLR camera (dSLR) to sell for less than $1,000, the EOS Digital Rebel/300D. The camera delivered exceptional performance and picture quality, earning it rave reviews and multiple industry awards. No wonder it quickly became a best-seller.

That tradition of excellence and value lives on in the EOS Rebel T7/2000D. Like its ancestors, this baby offers a range of controls for experienced photographers plus an assortment of tools designed to help beginners be successful. For added fun, this Rebel offers some cool Wi-Fi functions, including one that enables you to send pictures wirelessly to a smartphone or tablet and to use that device as a camera remote control.

In fact, the T7/2000D is so feature-packed that sorting everything out can be a challenge. For starters, you may not even know what SLR means, let alone have a clue about what all the menu options and other camera features do. If you're like many people, you may be so overwhelmed that you never take your camera out of automatic shooting mode, which is a shame because you can enjoy so much more creativity and success by moving beyond auto.

Therein lies the point of *Canon EOS Rebel T7/2000D For Dummies.* In this book, you can discover not only what each bell and whistle on your camera does but also when, where, why, and how to put it to best use. And unlike many photography books, this one doesn't require any previous knowledge of photography or digital imaging to make sense of concepts. In classic *For Dummies* style, everything is explained in easy-to-understand language, with lots of illustrations to help clear up any confusion.

In short, what you have in your hands is the paperback version of an in-depth photography workshop tailored specifically to your Canon picture-taking power-house. Whether your interests lie in taking family photos, exploring nature and travel photography, or snapping product shots for your business, you'll get the information you need to capture the images you envision.

How This Book Is Organized

This book is organized into four parts, each devoted to a different aspect of using your camera. Although chapters flow in a sequence that's designed to take you from absolute beginner to experienced user, I also tried to make each chapter as self-standing as possible so that you can explore topics that interest you in any order you please. The next sections offer a brief preview of what you can find in each of the four parts.

Part 1: Fast Track to Super Snaps

This part contains chapters that help you get up and running:

» Chapter 1 offers a brief overview of camera controls and walks you through initial setup and customization steps.

» Chapter 2 explains basic picture-taking options, such as shutter-release mode, image quality settings, and flash features.

» Chapter 3 shows you how to use the camera's simplest exposure modes, including Scene Intelligent Auto, Creative Auto, and scene modes (Portrait, Sports, Close-up, and so on).

Part 2: Taking Creative Control

Chapters in this part help you unleash the full creative power of your camera, showing you how to adjust exposure, color, and focus and also how to take advantage of movie-recording features.

» Chapter 4 covers the all-important topic of exposure, helping you to understand such fundamentals as f-stops and shutter speed and also exploring ways to deal with exposure problems.

» Chapter 5 explains your camera's focusing features and shows you how to manipulate depth of field (the distance over which focus appears sharp in a photograph).

» Chapter 6 details your camera's color controls, including the White Balance and Picture Style options.

>> Chapter 7 provides a quick-reference guide to shooting strategies for specific types of pictures: portraits, action shots, landscape scenes, and close-ups.

>> Chapter 8 explains how to record and play movies.

Part 3: After the Shot

As its title implies, this part discusses things you can do (or should do) with your photos after you capture them.

>> Chapter 9 covers picture playback features, including options for customizing what you see on the screen in playback mode. I also explain how to understand exposure-evaluation tools known as *histograms.*

>> Chapter 10 explains how to rate, protect, and delete photos and then helps you transfer pictures from your camera to your computer. This chapter also introduces you to the free Canon photo software and discusses ways to process files that you shoot in the Raw format and prepare pictures for online sharing. Skip to the end of the chapter to find out how to connect your camera wirelessly to a smartphone or tablet and then transfer images to that device.

Part 4: The Part of Tens

In famous *For Dummies* tradition, the book concludes with two top-ten lists containing additional bits of information.

>> Chapter 11 reveals ten ways to customize your camera that aren't covered in earlier chapters.

>> Chapter 12 takes a look at ten features that, though not found on most "Top Ten Reasons I Bought My Camera" lists, are nonetheless interesting, useful on occasion, or a bit of both.

Beyond the Book

When you have a minute or two to go online, visit www.dummies.com and enter the text "Canon EOS Rebel T7/2000D For Dummies Cheat Sheet" in the search box. Along with information about the book, you should find a link to a Cheat Sheet, which provides a handy reference guide to important camera settings and terms. You can print the Cheat Sheet and carry it in your camera bag or download it so that you can read it even if you don't have Internet access.

Icons Used in This Book

Like other books in the *For Dummies* series, this book uses the following icons to flag especially important information:

TIP

A Tip icon flags information that will make your life easier. You'll save time, effort, money, or other valuable resources, including your sanity.

REMEMBER

This icon highlights important information that's especially worth storing in your brain's long-term memory or to remind you of a fact that may have been displaced from that memory by another pressing fact.

TECHNICAL STUFF

If I present a detail that's useful mainly for impressing your geeky friends (but otherwise not critical for you to retain), I mark it with this icon.

WARNING

When you see this icon, look alive. It indicates a potential danger zone that can result in much wailing and teeth-gnashing if it's ignored.

Additionally, replicas of some of your camera's buttons and onscreen graphics appear in the margins and in some tables. I include these images to provide quick reminders of the appearance of the button or option being discussed.

Where to Go From Here

To wrap up this preamble, I want to stress that if you think that digital photography is too confusing or too technical for you, you're in good company. *Everyone* finds this stuff a little mind-boggling at first. Take it slowly, exploring just one concept at a time. Then make it a point to experiment with a new camera feature or photography skill on each photo outing.

With patience and practice, you'll soon wield your camera like a pro, dialing in the necessary settings to capture your creative vision almost instinctively. Your Rebel T7/2000D is the perfect partner for your photographic journey, and I thank you for allowing me, in this book, to serve as your tour guide.

1

Fast Track to Super Snaps

Familiarize yourself with the basics of using your camera, from attaching lenses to navigating menus.

Find out how to select the exposure mode, Drive mode, and Image Quality (resolution and file type), and monitor important settings while shooting.

Discover options available for flash photography.

Get step-by-step help with shooting your first pictures in Scene Intelligent Auto mode.

Take more creative control by using scene modes and Creative Auto mode.

Chapter **1**

Getting Up and Running

I f you're like many people, shooting for the first time with a dSLR (digital single-lens reflex) camera produces a blend of excitement and anxiety. On one hand, you can't wait to start using your new equipment, but on the other, you're a little intimidated by all its buttons, dials, and menu options.

Well, fear not: This chapter provides the information you need to start getting comfortable with your Rebel T7/2000D. The first section walks you through initial camera setup. Following that, you can get an overview of camera controls, discover how to view and adjust camera settings, work with lenses and memory cards, and get my take on some basic setup options.

Preparing the Camera for Initial Use

After unpacking your camera, you need to assemble a few parts. In addition to the camera body and the supplied battery (be sure to charge it before the first use), you need a lens and a memory card. Later sections in this chapter provide details about lenses and memory cards, but here's what you need to know up front:

>> **Lens:** Your camera accepts Canon EF and EF-S model lenses. The 18–55mm kit lens sold as a bundle with the camera body falls into the EF-S category. If you want to buy a non-Canon lens, check the lens manufacturer's website to find out which lenses work with your camera.

>> **SD (Secure Digital), SDHC, or SDXC memory card:** The SD stands for *Secure Digital;* the HC and XC for *High Capacity* and *eXtended Capacity.* The different labels reflect how many gigabytes (GB) of data the card holds. SD cards hold less than 4GB; SDHC, 4GB to 32GB; and SDXC, greater than 32GB.

With camera, lens, battery, and card within reach, take these steps:

1. **Turn the camera off.**

2. **Attach a lens.**

 First, remove the caps that cover the front of the camera and the back of the lens. Then locate the proper *lens mounting index* on the camera body. Your camera has two of these markers, one red and one white, as shown in Figure 1-1. Which marker you use to align your lens depends on the lens type:

 ● *Canon EF-S lens:* The white square is the mounting index.

 ● *Canon EF lens:* The red dot is the mounting index.

 Your lens also has a mounting index; align that mark with the matching one on the camera body, as shown in Figure 1-1, which features the 18–55mm EF-S lens. Place the lens on the camera mount and rotate the lens toward the lens-release button, labeled in the figure. You should feel a solid click as the lens locks into place.

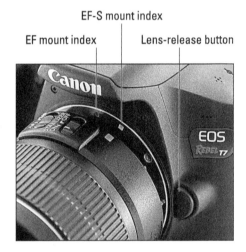

EF-S mount index

EF mount index Lens-release button

FIGURE 1-1:
Align the mounting index on the lens with the one on the camera body.

3. **Install the battery and memory card into the compartment on the bottom of the camera.**

 Hold the battery with the gold contacts facing down and the Canon label oriented toward the back of the camera. Then slide it into the compartment and gently push it in until the battery-release switch closes. I labeled the switch in Figure 1-2. (To remove the battery, you must push the release switch.)

 Orient the memory card as shown in Figure 1-2. (The label faces the back of the camera, and the notched corner of the card goes in first.) Push the card gently into the slot and close the cover.

4. **Turn the camera on and adjust the settings.**

When you power up the camera for the first time, the monitor displays a screen asking you to set the date, time, and time zone. To adjust the values on the screen, use the Set button and the four keys surrounding it — known as *cross keys*.

Press the left or right cross keys to highlight an option box; press Set to activate the box. Press the up/down keys to change the value in the box and then press Set again. Lather, rinse, and repeat until you adjust all the settings. Highlight the OK box and press Set.

5. **Adjust the viewfinder to your eyesight.**

Tucked above the right side of the rubber eyepiece that surrounds the viewfinder is a dial that enables you to adjust the viewfinder focus to accommodate your eyesight. Officially known as a *diopter adjustment dial,* it's highlighted in Figure 1-3.

If you don't take this step, subjects may appear sharp in the viewfinder when they aren't actually in focus, and vice versa.

Here's how to properly adjust the viewfinder: Remove the lens cap, look through the viewfinder, and press the shutter button halfway to display data at the bottom of the viewfinder. Then rotate the diopter adjustment dial until the data appears sharpest. The markings in the center of the viewfinder, which relate to autofocusing, also become more or less sharp. (In dim lighting, the built-in flash may pop up when you depress the shutter button halfway; just close the flash unit after you complete the viewfinder adjustment.)

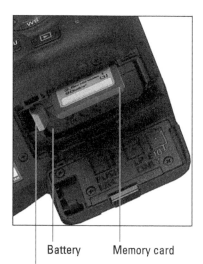

Battery Memory card

Battery-release switch

FIGURE 1-2:
Insert the memory card with the label facing the back of the camera.

Rotate to adjust viewfinder

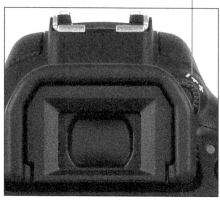

FIGURE 1-3:
Rotate this dial to set the viewfinder focus for your eyesight.

DECODING CANON LENS TERMINOLOGY

When you shop for Canon lenses, you may encounter these lens specifications:

- **EF and EF-S:** EF stands for *electro focus;* the S stands for *short back focus.* And *that* simply means the rear element of the lens is closer to the sensor than with an EF lens. The good news is that your T7/2000D works with both of these Canon lens types. However, you can't put an EF-S lens on Canon cameras that have only an EF mount, which include current high-end, full-frame camera bodies.

- **IS:** Indicates that the lens offers *image stabilization,* a feature that helps prevent blur that can result from camera shake when you handhold the camera.

- **STM:** Refers to *stepping motor technology,* an autofocusing system that's designed to provide smoother, quieter autofocusing.

That's all there is to it — the camera is now ready to go. From here, I recommend that you keep reading the rest of this chapter to familiarize yourself with the main camera features. But if you're anxious to take a picture right away, I won't think any less of you if you skip to Chapter 3, which guides you through the process of using the camera's automatic shooting modes. Just promise that at some point, you'll read the pages in between, because they actually do contain important information.

Exploring External Camera Features

If you're new to dSLR photography, some aspects of using your camera, such as working with the lens, may be unfamiliar. But even if you've used a dSLR before, it pays to spend time before your first shoot with a new camera to get familiar with its controls. To that end, the upcoming pages provide an overview of external bells and whistles.

Topside controls

Your virtual tour begins on the top of the camera, shown in Figure 1-4. Here's a guide to the many bits and pieces found there, starting in the upper-right corner and traveling clockwise:

Main dial Shutter button

Speaker Red-eye reduction/Self-timer lamp Flash button

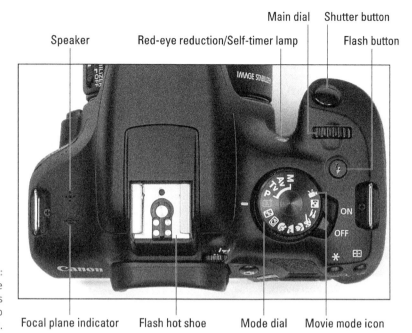

FIGURE 1-4:
Here's a guide
to controls
found on top
of the camera.

Focal plane indicator Flash hot shoe Mode dial Movie mode icon

>> **Red-eye reduction/Self-timer lamp:** When you set your flash to Red-Eye Reduction mode, this lamp emits a brief burst of light prior to the real flash — the idea being that your subjects' pupils will constrict in response to the light, thus lessening the chances of red-eye. If you use the camera's self-timer feature, the lamp lights during the countdown period before the shutter is released. See Chapter 2 for more details about Red-Eye Reduction flash mode and the self-timer function.

TIP

>> **Shutter button:** You no doubt already understand the function of this button. But you may not realize that when you use autofocus and autoexposure, you need to use a two-stage process when taking a picture: Press the shutter button halfway, pause to let the camera set focus and exposure, and then press the rest of the way to capture the image. You'd be surprised how many people mess up their pictures because they press that button with one quick jab, denying the camera the time it needs to set focus and exposure. The beep you may hear is the camera telling you it was able to focus and is ready to take the photo.

>> **Main dial:** You use this dial when selecting many camera settings. (Specifics are provided throughout the book.) In fact, this dial plays such an important role that you'd think it might have a more auspicious name, but Main dial it is.

>> **Flash button:** Press this button to raise the built-in flash in the advanced exposure modes (P, Tv, Av, and M).

>> **On/Off switch:** I won't insult your intelligence by explaining what this switch does. But note that even when the switch is in the On position, the camera automatically goes to sleep after 30 seconds of inactivity to save battery power. You can adjust this timing via the Auto Power Off option on Setup Menu 1.

>> **Mode dial:** Rotate this dial to select an *exposure mode,* which determines whether the camera operates in fully automatic, semi-automatic, or manual exposure mode when you take still pictures. To shift to Movie mode, rotate the dial so that it aligns with the movie mode icon, labeled in Figure 1-4. Chapter 2 provides an overview of the still photography exposure modes; Chapter 8 covers movie recording.

>> **Viewfinder diopter-adjustment dial:** Use this dial (shown close-up in Figure 1-3) to adjust the viewfinder focus to your eyesight.

>> **Flash hot shoe:** This is the connection for attaching an external flash and other accessories such as the GP-E2 GPS Receiver.

TECHNICAL STUFF

>> **Focal plane indicator:** The *focal plane indicator* marks the plane at which light coming through the lens is focused onto the camera's image sensor. That's important only if you need to document the specific distance between your subject and the camera, as you might if you were doing forensics work, for example. Basing the subject distance on this mark produces a more accurate measurement than using the end of the lens or some other point on the camera body as your reference point.

>> **Speaker:** When you play a movie that contains audio, the sound comes wafting through these little holes.

Back-of-the-body controls

Traveling over the top of the camera to its back, you encounter the smorgasbord of controls shown in Figure 1-5.

TIP

Buttons with a white icon perform shooting mode functions; buttons with blue icons are used in playback. Some buttons sport dual colors, meaning that they come into play for both functions.

REMEMBER

Throughout this book, pictures of some buttons appear in the margins to help you locate the button being discussed. So even though I provide the official names in the following list, don't worry about getting all those straight right now. Note, however, that some buttons have multiple names because they serve multiple purposes depending on whether you're taking pictures, reviewing images, recording a movie, or performing some other function. In this book, I take the approach used in the camera instruction manual, which is to reference the button according to the name that relates to the current function. Again, though, the margin icons help you know exactly which button you're to press.

AF Point Selection/Magnify button

AE Lock/Index/Reduce button

Cross keys and Set button

Live View/Movie-record button

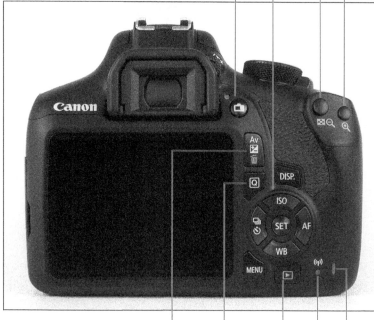

FIGURE 1-5:
Having lots
of external
buttons makes
accessing
the camera's
functions
easier.

Exposure Compensation/Delete button Playback button | Card access light

Quick Control button Wi-Fi indicator

With that preamble out of the way, it's time to explore the camera back, starting at the top-right corner and working westward (well, assuming that your lens is pointing north, anyway):

>> **AF Point Selection/Magnify button:** In certain shooting modes, you press this button to specify which autofocus points you want the camera to use when establishing focus. (Chapter 5 tells you more.) In Playback mode, covered in Chapter 9, you use this button to magnify the image display (thus the plus sign in the button's magnifying glass icon).

>> **AE Lock/Index/Reduce button:** During shooting, you press this button to lock autoexposure (AE) settings, as covered in Chapter 4, and to lock flash exposure (FE), a topic I discuss in Chapter 2.

This button also serves two image-viewing functions: It switches the display to Index mode, enabling you to see multiple image thumbnails at once, and it reduces the magnification of images when displayed one at a time.

>> **Live View/Movie-record button:** Press this button to shift to Live View mode, which enables you to compose your pictures using the monitor instead of the viewfinder. When shooting movies, you press this button to start and stop recording. (You must first set the Mode dial to the Movie position.)

REMEMBER

After you shift to Live View or Movie mode, certain buttons perform different functions than they do for viewfinder photography. I spell out the differences when showing you how to use Live View and movie features throughout the book.

>> **Exposure Compensation/Erase button**: In the P, Tv, and Av exposure modes, you press this button while rotating the Main dial to adjust *exposure compensation,* a feature that enables you to tell the camera to produce a brighter or darker photo on your next shot. If you shoot in the M exposure mode, you press the button while rotating the Main dial to change the aperture setting (f-stop). Chapter 4 discusses both issues.

During playback, press this button to erase pictures — thus the blue trash-can symbol, the universal sign for "dump it." See Chapter 10 for details.

>> **Q (Quick Control) button:** Press this button to display the Quick Control screen, which gives you one way to adjust picture settings. See "Changing Settings via the Quick Control Screen," later in this chapter, for help.

>> **DISP button:** In Live View, Movie, and Playback modes, pressing this button changes the picture-display style. When menus are displayed, pressing the button brings up the Camera Settings display, also covered later in this chapter.

>> **Set button and cross keys:** Figure 1-5 points out the Set button and the four surrounding buttons, known as *cross keys.* These buttons team up to perform several functions, including choosing options from the camera menus. You use the cross keys to navigate through menus and then press the Set button to select a specific menu setting.

REMEMBER

In this book, the instruction "Press the left cross key" means to press the one to the left of the Set button, "press the right cross key" means to press the one to the right of the Set button, and so on.

During viewfinder photography — that is, when you're using the viewfinder and not the monitor to frame your shots — the cross keys also have individual responsibilities, which are indicated by their labels:

● *Press the up cross key to change the ISO setting.* Detailed in Chapter 4, this exposure-related control determines how sensitive the camera is to light. You can adjust this setting only when shooting in the P, Tv, Av, and M

exposure modes. (If the Mode dial is set to one of those modes and nothing happens when you press this cross key or any other buttons, give the shutter button a half-press and release it to wake up the camera.)

- *Press the right cross key to adjust the AF mode.* This option controls one aspect of the camera's autofocus behavior, as outlined in Chapter 5. Again, you can access this setting only in P, Tv, Av, and M shooting modes.

- *Press the left cross key to change the Drive mode.* The Drive mode settings enable you to switch the camera from single-frame shooting to continuous capture or self-timer/remote-control shooting. See Chapter 2 for details.

- *Press the down cross key to change the White Balance setting.* The White Balance control, explained in Chapter 6, enables you to ensure that colors are rendered accurately. The White Balance setting is also off-limits unless the Mode dial is set to P, Tv, Av, or M, but Chapters 3 and 6 show you some options for modifying colors in some of the other shooting modes.

For Live View and Movie shooting, the cross keys perform actions related to autofocusing; I get into those details in Chapter 5.

 » **Playback button:** Press this button to switch the camera into picture-review mode.

» **Menu button:** Press this button to access the camera menus.

» **Wi-Fi indicator:** This lamp lights to indicate an active Wi-Fi connection. Chapter 10 explains the Wi-Fi feature that enables you to transfer pictures to a smartphone or tablet. Chapter 12 details the other Wi-Fi possibilities, which include using your phone or tablet as a wireless trigger for the camera's shutter button.

» **Card access light:** This light glows while the camera is recording data to the memory card. Don't power off the camera or remove the memory card while the light is lit; you may damage the card or camera.

Front-left features

The front-left side of the camera sports three important features, labeled in Figure 1-6:

» **Lens-release button:** Press this button to disengage the lens from the lens mount so that you can remove it from the camera. While pressing the button, rotate the lens toward the shutter-button side of the camera to dismount the lens.

>> **Microphone:** This cluster of holes leads to the camera's microphone. See Chapter 8 for details about choosing microphone settings.

>> **NFC mark:** Labeled in Figure 1-6, this mark indicates where the camera emits the signal that enables your camera to communicate wirelessly to a smartphone or tablet via Near Field Communication technology. Chapter 10 helps you set up your camera to take advantage of this and other Wi-Fi features.

>> **Connection ports:** Hidden under the cover labeled *port access door* in Figure 1-6 are inputs for connecting the camera to various devices. Figure 1-7 labels each connection.

● *Remote-control terminal:* You can attach a remote-control unit such as the Canon Remote Switch RS-60E3 wired controller here.

TIP

The RS-60E3 currently sells for about $20 and is a worthwhile investment for long-exposure shooting (such as nighttime shots and fireworks). By using the remote control, you eliminate the chance that the action of your finger on the shutter button moves the camera enough to blur the shot, which is especially problematic during long exposures.

● *Digital terminal (USB port):* This terminal is used for connecting your camera to a USB port on your computer so that you can download images to the

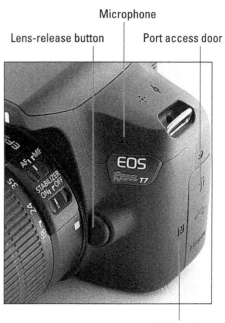

Microphone
Lens-release button Port access door

NFC mark

FIGURE 1-6:
When recording movies, be careful not to cover the microphone with your finger.

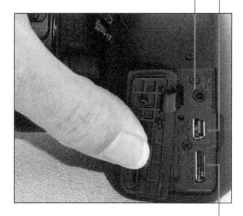

Digital terminal (USB)
Remote-control terminal

HDMI terminal

FIGURE 1-7:
Inputs for connecting the camera to other devices are found under the cover on the left side of the camera.

computer. If your printer supports PictBridge technology, you can also print directly from the camera by connecting the two devices via their respective USB ports.

To take advantage of either option, you must buy a special USB cable. The least expensive option, the Canon IFC-400PCU cable, sells for about $15. But before you buy the cable, know that you can alternatively deliver images to your computer by using a memory-card reader, as explained in Chapter 10.

The terminal also comes into play when you use the optional GPS receiver GP-E2; after attaching the unit to the flash hot shoe on top of the camera, you connect the unit's cable to the digital terminal.

- *HDMI terminal:* For playback on a high-definition television or screen, you can connect the camera via this terminal, using an optional HDMI male to mini-C cable. You'll pay about $50 if you buy Canon's version, the HTC-100 cable. Shop around for better deals on third-party cables if you like.

If you turn the camera over, you find a tripod socket, which enables you to mount the camera on a tripod that uses a ¼-inch screw, plus the chamber that holds the battery and memory card. Also found in the chamber is a connection that enables you to operate the camera using electrical power instead of battery power. To take advantage of this option, you need to buy either the AC Adapter Kit ACK-E10 or both the DC Coupler DR-E10 and the Compact Power Adapter CA-PS700. See the camera manual for specifics on running the camera on AC power.

Ordering from Camera Menus

Only a handful of camera settings can be adjusted by using the external buttons and controls. To access other options, press the Menu button. The following sections tell you what you need to know about the menu system.

Understanding menu basics

Menus are organized into the categories labeled in Figure 1-8. Notice that the icons that represent the menus are color coded: Shooting menu icons are red; Playback menu icons are blue; Setup menu icons are gold; and the My Menu icon is green. (Chapter 11 explains the My Menu feature, which enables you to create a personalized menu.)

TIP

The number of dots above the icon tells you the menu number — one dot for Shooting Menu 1, two dots for Shooting Menu 2, and so on.

The highlighted icon marks the active menu; options on that menu appear automatically on the main part of the screen. In Figure 1-8, Shooting Menu 1 is active, for example.

REMEMBER

To display all the menus shown in Figure 1-8, you must set the Mode dial to P, Av, Tv, or M. In other modes, you see only a handful of menus because you have limited control over camera operation in those modes. Additionally, when you set the camera to Movie mode, three of the four Shooting menus are replaced by Movie menus, which offer movie-recording options, and a limited version of Shooting Menu 1 is bumped to the right to make room for the Movie menus. The menu icon for the Movie menus changes to a movie-camera symbol to indicate the shift. In addition, Movie mode does not display the My Menu icon.

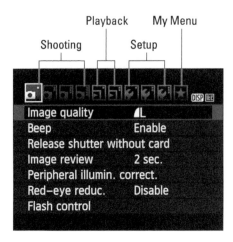

FIGURE 1-8:
You see all these menus only when the Mode dial is set to P, Tv, Av, or M.

To cycle through menus, rotate the Main dial or press the left or right cross keys. After landing on a menu, press the up or down cross key to highlight the feature you want to adjust. Then press the Set button to display the available options. Use the cross keys to select a setting and press the Set button again.

When you're ready to exit the menus and start shooting, press the shutter button halfway and release it, or press the Menu button.

Navigating Custom Functions screens

When you select Custom Functions from Setup Menu 3 — a menu available only in the P, Tv, Av, and M exposure modes — you delve into submenus containing advanced settings. Initially, you see a screen similar to the one shown on the left in Figure 1-9.

Some explanation may help you make sense of these screens:

>> **Custom Functions are grouped into four categories:** Exposure, Image, Autofocus/Drive, and Operation/Others. The category number and name appear in the upper-left corner of the screen.

>> **The number of the selected function appears in the upper-right corner.** Custom Function 1 is indicated in Figure 1-9.

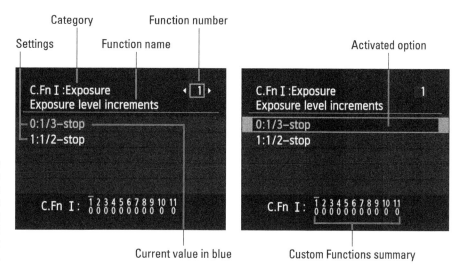

FIGURE 1-9:
The Custom
Functions
menu screens
are divided
into several
important
areas.

Category

Settings Function name Function number Activated option

C.Fn I :Exposure
Exposure level increments ◄ 1 ►
0:1/3–stop
1:1/2–stop

C.Fn I : 1 2 3 4 5 6 7 8 9 10 11
 0 0 0 0 0 0 0 0 0 0 0

Current value in blue

C.Fn I :Exposure
Exposure level increments 1
0:1/3–stop
1:1/2–stop

C.Fn I : 1 2 3 4 5 6 7 8 9 10 11
 0 0 0 0 0 0 0 0 0 0 0

Custom Functions summary

>> **Settings for the current function appear in the middle of the screen.** The blue text indicates the current setting. The default setting is represented by the number 0.

>> **Numbers at the bottom of the screen show you the current setting for all Custom Functions.** The top row of numbers represents the Custom Functions, with the currently selected function indicated with a tiny horizontal bar over the number. The lower row shows the number of the current setting for each Custom Function; again, 0 represents the default. So in the figure, all the Custom Functions are using the default settings.

To scroll from one Custom Function to the next, press the left or right cross keys. When you reach the setting you want to adjust, press the Set button to activate that option. The screen updates to display a highlight box around the current setting, as shown on the right in Figure 1-9. Use the cross keys to move the highlight box over the setting you want to use and then press the Set button again to lock in your choice.

As with normal menu screens, you can exit the menus and return to shooting by pressing the Menu button or pressing the shutter button halfway and releasing it.

Displaying the Camera Settings screen

Anytime the menus are active, you can press the DISP button to bring up the Camera Settings screen, shown in Figure 1-10. (As a reminder, the text DISP appears in the top-right corner of the menu screens, as shown in Figure 1-8.)

This screen offers a quick summary of certain camera settings. The data displayed varies depending on the setting of the Mode dial; Figure 1-10 shows data that appears in the P, Tv, Av, and M exposure modes. If a setting can't be adjusted in the current exposure mode, it disappears from the screen.

Moving from top to bottom, here's your decoder ring to the screen:

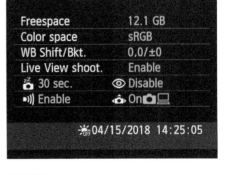

Freespace	12.1 GB
Color space	sRGB
WB Shift/Bkt.	0.0/±0
Live View shoot.	Enable
📷 30 sec.	👁 Disable
🔊 Enable	🔄 On 📷🖥
	🌞 04/15/2018 14:25:05

FIGURE 1-10:
Press the DISP button when the menus are active to view this screen.

>> **Freespace:** Indicates the amount of empty storage space on your camera memory card.

>> **Color Space:** Tells you whether the camera is using the sRGB or Adobe RGB color space, an option I cover in Chapter 11. (Stick with sRGB until you have time to explore that information.)

>> **White Balance Shift/Bracketing:** Indicates the amount of White Balance shift or bracketing, a color option covered in Chapter 6.

>> **Live View Shooting:** Tells you whether Live View is enabled; skip to the next section to investigate Live View.

>> **Auto Power Off and Red-Eye Reduction flash mode:** These two functions share a line on the screen. The first readout tells you the delay time selected for the Auto Power Off option, found on Setup Menu 1; the second symbol indicates whether the flash is set to Red-Eye Reduction mode, found on Shooting Menu 1.

>> **Beep and Auto Rotate Display:** The first setting determines whether the camera beeps after certain operations; you can turn the sound on and off via Shooting Menu 1.

The second symbol reflects the setting of the Auto Rotate option on Setup Menu 1, which determines whether pictures are rotated to their proper orientation during playback and when you view them on your computer (assuming the software you use can read the rotation data embedded in the image file). The symbol shown in the figure indicates that both rotation features are enabled. See the first part of Chapter 9 for more about this feature.

>> **Date/Time:** The last line of the display shows the date and time, which you enter via the Date/Time/Zone option on Setup Menu 2. The sun symbol at the beginning of the line indicates whether you told the camera to adjust the time automatically to account for Daylight Saving Time.

Of course, with the exception of the free-card-space value, you also can simply go to the menu that contains the option in question to check its status. The Camera Settings display just gives you a quick way to monitor some of the critical functions without hunting through menus.

To exit the Camera Settings screen, press the Menu button or press the shutter button halfway and release it.

Using the Monitor as Viewfinder: Live View Shooting

Live View enables you to use the monitor instead of the viewfinder to compose photos. You also must rely on the monitor for recording movies; the viewfinder is disabled for movie recording.

REMEMBER

How you activate Live View depends on whether you want to shoot still photos or movies:

>> **Live View for still photography:** First, ensure that Live View shooting is enabled in the menus. Where you find the option depends on the setting of the Mode dial. In Scene Intelligent Auto, Creative Auto, and Scene modes, it's found on Shooting Menu 2, as shown on the left in Figure 1-11. In the P, Tv, Av, and M modes, the Live View option is found on Shooting Menu 4, as shown on the right in the figure.

Why set the menu option to Disable? Because it's easy to hit the Live View button accidentally and switch to Live View when you don't really want to go there.

FIGURE 1-11: If Live View mode doesn't activate, make sure that the Live View Shoot menu option is enabled.

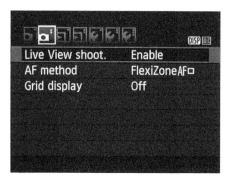
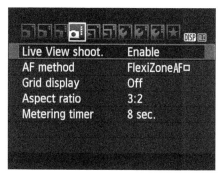

After enabling the feature on the menu, press the Live View button, labeled in Figure 1-12. You hear a clicking sound as the internal mirror that normally sends the image from the lens to the viewfinder flips up. Then the scene in front of the lens appears on the monitor, and you can no longer see anything in the viewfinder. Data representing certain camera settings is displayed over the live image, as shown in Figure 1-12. You can press the DISP button to change the type of data that appears.

To exit Live View mode and return to using the viewfinder, press the Live View button again.

Live View button

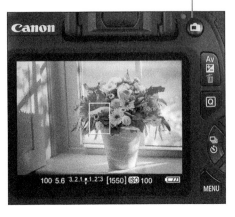

FIGURE 1-12:
In Live View mode, picture data is superimposed over the live preview.

>> **Live View for recording movies:** Rotate the Mode dial to the Movie mode icon. Live View engages automatically, and you then press the Live View button to start and stop recording. (Chapter 8 has details on movie shooting.) To exit Movie mode, rotate the Mode dial to any other exposure mode.

In many ways, shooting photos in Live View mode is the same as for viewfinder photography, but some important aspects, such as autofocusing, work very differently. Chapter 3 shows you how to take a picture in Scene Intelligent Auto exposure mode using Live View; Chapter 5 details Live View autofocusing options; and Chapter 8 covers movie recording.

LIVE VIEW SAFETY TIPS

WARNING

Be aware of the following precautions when you use Live View and Movie modes:

- **Cover the viewfinder to prevent light from seeping into the camera and affecting exposure.** The camera ships with a cover designed just for this purpose. In fact, it's conveniently attached to the camera strap. To install it, first remove the rubber eyecup that surrounds the viewfinder by sliding it up and out of the groove that holds it in place. Then slide the cover down into the groove and over the viewfinder. (Orient the cover so that the *Canon* label faces the viewfinder.)

- **Using Live View or Movie mode for an extended period can harm your pictures and the camera.** Using the monitor full-time causes the camera's innards to heat up more than usual, and that extra heat can create the right conditions for *noise*, a defect that looks like speckles of sand. More critically, the increased temperatures can damage the camera. A thermometer symbol appears near the right edge of the monitor to warn you when the camera is getting too hot. (Refer to the top-right screen in Figure 1-15 for a look at this symbol.) Initially, the symbol is white. If you continue shooting and the temperature continues to increase, the symbol turns red and blinks, alerting you that the camera soon will shut off automatically. But it's not a good idea to keep shooting after the icon initially appears because image quality can degrade. Instead, turn the camera off and give it a chance to cool off.

- **Aiming the lens at the sun or other bright lights also can damage the camera.** Of course, you can cause problems doing this even during normal shooting, but the possibilities increase when you use Live View and Movie mode.

- **Live View and Movie modes put additional strain on the camera battery.** The extra juice is needed to power the monitor for extended periods of time. If you do a lot of Live View or movie shooting, you may want to invest in a second battery so that you have a spare on hand when the first one runs out of gas.

- **The risk of camera shake during handheld shots is increased.** When you use the viewfinder, you can help steady the camera by bracing it against your face. But when you compose shots using the monitor, you have to hold the camera away from your body to view the screen, making it harder to keep the camera absolutely still. Any camera movement during the exposure can blur the shot, so using a tripod is the best course of action for Live View photography and movie recording.

Monitoring Critical Picture Settings

You can display current picture-taking settings on the monitor. The left side of Figure 1-13 shows the Shooting Settings screen, which appears during viewfinder photography; the right side of the figure shows the data as it appears during Live View shooting. For viewfinder shooting, you can also display some data at the bottom of the viewfinder, as shown in Figure 1-14.

If your screen doesn't look like what you see in the figures, don't panic: Different data appears depending on your exposure mode and whether or not features such as flash are enabled. In Live View mode, you also can change the amount of data that appears by pressing the DISP button. (More on that feature momentarily.) Both screens in Figure 1-13 show the default display style for the Scene Intelligent Auto exposure mode.

FIGURE 1-13:
The Shooting
Settings screen
(left) and the
Live View
display (right)
both show
critical picture
settings on the
monitor.

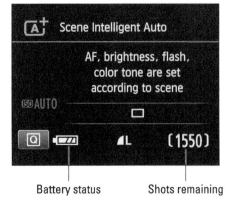

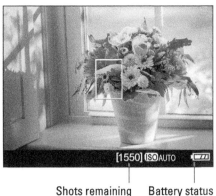

Battery status Shots remaining

Shots remaining Battery status

Figure 1-13 labels two key points of data that appear in any mode, though: how many more pictures can fit on your memory card at the current settings and the status of the battery. A "full" battery icon like the one in the figures shows that the battery is charged. When the icon appears empty, it's time to find your battery charger.

The next sections provide some additional tips about these displays.

Using the Shooting Settings display

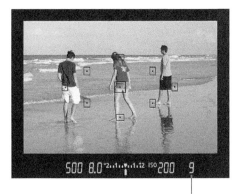

Maximum burst frames

FIGURE 1-14:
For viewfinder photography, certain settings also appear at the bottom of the viewfinder screen.

By default, the display appears when you turn on the camera and then turns off if no camera operations are performed for 30 seconds. You can turn the display on again by pressing the shutter button halfway and then releasing it. To turn off the display before the automatic shutoff occurs, press the DISP button. (You can adjust this shutoff timing via the Auto Power Off setting on Setup Menu 1.)

TIP

On the Shooting Settings display, curved arrows bordering an option mean that you can adjust the setting by rotating the Main dial. For example, in the shutter-priority autoexposure mode (Tv, on the Mode dial), the shutter speed is bordered by the arrows, indicating that the setting is active and that rotating the Main dial will change the setting.

Reading viewfinder data

Data appears at the bottom of the viewfinder when you first turn on the camera, and it then shuts off after a few seconds to save battery power. To wake up the display, press the shutter button halfway and release it. Those little markings in the center of the viewfinder represent autofocusing points. Chapter 5 details autofocusing.

TECHNICAL STUFF

One other point about a viewfinder value that's often misunderstood: The value at the far right end of the viewfinder (9, in Figure 1-14) shows you the number of *maximum burst frames.* This number relates to shooting in the Continuous capture mode, where the camera fires off multiple shots in rapid succession as long as you hold down the shutter button. Although the highest number that the viewfinder can display is 9, the actual number of maximum burst frames may be higher. At any rate, you don't really need to pay attention to the number until it starts dropping toward 0, which indicates that the camera's *memory buffer* (its temporary internal data-storage tank) is filling up. If that happens, just give the camera a moment to catch up with your shutter-button finger.

Customizing the Live View display

In Live View mode, press the DISP button to change the amount and type of data that appears on the monitor. Again, the data readout depends on the current exposure mode and whether you're shooting stills or movies. Figure 1-15 shows the four styles you can use when shooting still photos in the P, Tv, Av, or M exposure modes. In Movie mode, some data changes to show movie-recording options instead of still-photography settings, and the histogram display shown at the lower left of Figure 1-15 is not available.

TECHNICAL STUFF

A *histogram* is a tool you can use to gauge exposure. See the discussion on interpreting a Brightness histogram in Chapter 9 to find out how to make sense of what you see. But note that when you use flash, the histogram is dimmed; it can't display accurate information because the final exposure will include light from the flash and not just the ambient lighting. In addition, the histogram dims when you set the shutter speed to Bulb, a special setting available only in the M (Manual) exposure mode. Bulb mode keeps the shutter open for as long as you hold down the shutter button. The camera can't predict how long you're going to hold that button down, so it can't create a histogram that will reflect your final exposure.

Also note the little box labeled *Exposure Simulation* in Figure 1-15. This symbol, which appears in two display modes, indicates whether the monitor is simulating the actual exposure that you'll record. If the symbol blinks or is dimmed, the camera can't provide an accurate exposure preview, which can occur if the ambient light is either very bright or very dim. Exposure Simulation is also disabled when you use flash in Live View mode.

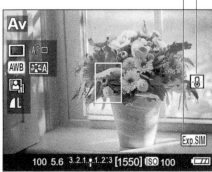

Heat warning

Exposure Simulation symbol

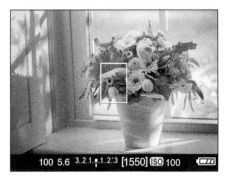

Histogram

FIGURE 1-15:
Press the DISP button to cycle through the Live View display styles.

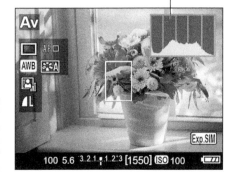

As mentioned in the earlier sidebar "Live View safety tips," a thermometer appears if the camera gets so hot that it needs to shut down to avoid damaging itself. I labeled this symbol Heat warning in Figure 1-15.

You can make these additional tweaks to the Live View display:

>> **Display an alignment grid.** To assist you with composition, the camera can display a grid on the screen, as shown on the left in Figure 1-16. In fact, you can choose from two grid styles. Where you turn the grid on depends on your exposure mode. In P, Tv, Av, or M modes, the option appears on Shooting Menu 4, as shown on the right in Figure 1-16. In other still photography modes, Shooting Menu 2. In Movie mode, look for the option on Movie Menu 2.

>> **Adjust the exposure-data shutdown timing.** By default, exposure information such as f-stop and shutter speed disappears from the display after 8 seconds if you don't press any camera buttons. If you want the exposure data to remain visible for a longer period, you can adjust the shutdown time when you shoot in P, Tv, Av, or M exposure mode. Make

the change via the Metering Timer option, which lives on Shooting Menu 4 for still photography (refer to Figure 1-16). In Movie Mode, the same option resides on Movie Menu 2. The metering mechanism uses battery power, so the shorter the cutoff time, the better.

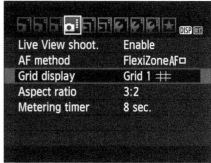

FIGURE 1-16:
You can display a grid as an alignment aid.

Changing Settings via the Quick Control Screen

True to its name, the Quick Control screen provides you with a fast way to change certain picture-taking settings. You can use this screen to adjust settings in any exposure mode, but the settings that are accessible depend on the mode you select and, for still photography, whether you're using the viewfinder or Live View mode. You also get different Quick Control options when the camera is in shooting mode than when you switch to playback mode.

When you're using the viewfinder to compose pictures — that is, the camera isn't set to Live View shooting — follow these steps to use the Quick Control screen:

1. **If a menu screen is displayed, press the Menu button to exit to shooting mode.**

 You can't get to the Quick Settings screen while a menu is displayed. Depending on the camera settings, you may see the Shooting Settings screen or the monitor may turn off.

2. **Press the Q button.**

 The screen shifts into Quick Control mode, and one of the options on the screen becomes highlighted. For example, the White Balance option is highlighted in the left screen in Figure 1-17. (AWB stands for Auto White Balance.) If nothing happens when you press the button, the camera may be in sleep mode; give the shutter button a half-press and release it to nudge the camera awake.

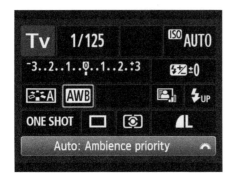

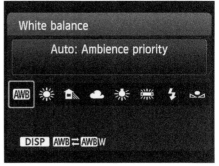

FIGURE 1-17:
The active
option appears
highlighted.

3. **Use the cross keys to highlight the setting you want to adjust.**

TIP

When you first highlight a setting, a text tip appears to remind you of the purpose of the setting. If you find the text tips annoying, you can get rid of them by disabling the Feature Guide option on Setup Menu 2.

4. **Select the option you want to use.**

You can use these techniques:

- *To scroll through the available settings, rotate the Main dial.* The current setting appears at the bottom of the screen, as shown in Figure 1-17. (Your camera offers two Auto White Balance settings, which you can explore in Chapter 6.) Note the little wheel icon at the far-right side of the text bar — it's a graphical reminder to use the Main dial for this function.

- *To display all available settings, press the Set button.* For example, if you're adjusting the White Balance setting and press Set, you see the screen shown on the right in Figure 1-17. Highlight the option you want to use by rotating the Main dial or using the cross keys. In some cases, the screen contains a brief explanation or note about the option, regardless of whether the Feature Guide is enabled.

TIP

Pay attention, too, if you see cryptic symbols like the one at the bottom of the right screen in Figure 1-17. These symbols offer reminders of how to modify the available options. In this case, the symbols tell you to press the DISP button to cycle between the default Auto White Balance setting (Ambience priority) and the other option (White Priority).

After selecting your choice, press the Set button to return to the Quick Control screen.

A few controls require a slightly different approach, but don't worry — I spell out all the needed steps throughout the book.

5. **To exit Quick Control mode and return to shooting, press the Q button again.**

You also can simply press the shutter button halfway and release it. Either way, you're returned to the Shooting Settings display.

Things work pretty much the same way in Live View and Movie modes except that after you press the Q button, the options appear on the left side of the screen, as shown on the left in Figure 1-18. Again, the active option is highlighted; notice the orange border around the AWB (White Balance) option in the figure. The current setting appears at the bottom of the screen. You can then either rotate the Main dial to cycle through the available settings or press Set to view all the possibilities at once, as shown on the right in the figure. Here again, the DISP label appears under the settings to tell you to press DISP to change from Ambience Priority white balance to White Priority white balance.

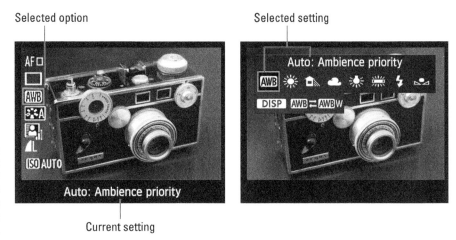

FIGURE 1-18:
You also can use the Quick Control screen in Live View and Movie modes.

Familiarizing Yourself with the Lens

Because I don't know which lens you're using, I can't give you full instructions on its operation. But the following sections explain the basics that apply to most Canon EF-S lenses as well as to certain other lenses that support autofocusing. Explore the lens manual for specifics, of course.

Switching from auto to manual focusing

Assuming that your lens can autofocus with the T7/2000D, the first step is to set the lens to automatic or manual focusing by moving the focus-method switch on the lens. For example, Figure 1-19 shows the switch as it appears on the 18–55mm kit lens. On this lens, set the switch to AF for autofocusing and to MF for manual focusing. Then use these focusing techniques:

>> **Autofocusing:** Press and hold the shutter button halfway to initiate autofocusing.

Auto/Manual focus switch

Focal-length indicator

Image Stabilizer switch

FIGURE 1-19:
Here are a few
features that
may be found
on your lens.

Manual focusing ring Zoom ring Lens-release button

>> **Manual focusing:** After setting the lens switch to MF, rotate the focusing ring on the lens barrel until focus appears sharp. The position of the focusing ring varies depending on the lens; I labeled the one on the kit lens in Figure 1-19.

With some lenses, you have the option to use automatic focusing with manual override: After using autofocusing to set the initial focusing distance, you can fine-tune focus by turning the focusing ring. This feature is usually indicated on the lens by a setting labeled AF/M. If your lens doesn't offer that feature, never try to rotate the focusing ring before setting the lens switch to the manual focusing position. You can damage the lens if you do.

For a thorough explanation of your camera's focusing features, see Chapter 6.

Working with a zoom lens

If you bought a zoom lens, it most likely has a movable *zoom ring* that you use to adjust the focal length of the lens. (If you're new to the term *focal length*, the

sidebar "Focal length and the crop factor," elsewhere in this chapter, explains the subject.) The location of the zoom ring on the kit lens is shown in Figure 1-19. To zoom in or out, rotate the ring.

Some zoom lenses, though, don't offer a zoom ring. Instead, you push the lens barrel away from or toward the camera body to zoom to a different focal length. See your lens manual to be certain how its zoom function works.

TIP

You can determine the focal length of the lens by looking at the number aligned with the bar labeled *focal-length indicator* in Figure 1-19. In the figure, the focal length is 55mm, for example.

Enabling image stabilization

Many Canon lenses, including the kit lens, offer this feature, which compensates for small amounts of camera shake that can occur when you handhold the camera. Camera movement during the exposure can produce blurry images, so turning on Image Stabilization — IS, for short — can help you get sharper handheld shots. On the 18–55mm IS kit lens, as well as on many other Canon lenses, you turn the feature on and off via a lens switch, which I labeled in Figure 1-19.

WARNING

However, when you use a tripod, image stabilization can have detrimental effects because the system may try to adjust for movement that isn't actually occurring. Although this problem shouldn't be an issue with most Canon IS lenses, if you do see blurry images while using a tripod, try turning the feature off. (You also save battery power by turning off image stabilization.)

On non-Canon lenses, image stabilization may go by another name: *antishake, vibration compensation,* and so on. In some cases, manufacturers recommend that you leave the system turned on or select a special setting when you use a tripod, so check the lens manual for information. Additionally, some lenses offer two types of stabilization, typically labeled Normal and Active. The first option is for every-day shooting; the Active option is designed for use in situations where you expect lots of motion, as when you're shooting from a speedboat.

Whatever lens you use, image stabilization isn't meant to eliminate the blur that can occur when your subject moves during the exposure. That problem is related to shutter speed, a topic you can explore in Chapter 4.

Removing a lens

After turning the camera off, press and hold the lens-release button on the camera (refer to Figure 1-19), and turn the lens toward the shutter-button side of the camera until the lens detaches from the lens mount. Put the rear protective cap

onto the back of the lens and, if you aren't putting another lens on the camera, cover the lens mount with its cap, too.

TIP

FOCAL LENGTH AND THE CROP FACTOR

Camera lenses come in different *focal lengths,* with the focal length (measured in millimeters) determining the angle of view that a lens can "see." A lens with a short focal length is called a *wide-angle lens* because it captures a wide view and has the effect of making objects seem smaller and farther away. At the other end of the spectrum, a lens with a long focal length — referred to as a *telephoto lens* — has a narrow angle of view, and far-away subjects appear closer and larger. Zoom lenses offer a range of focal lengths, such as 18–55mm.

However, the angle of view you get from any focal length depends on the size of the recording medium. Lenses are standardized around the dimensions of a 35mm film negative, which means that you get the full angle of view only if you mount the lens on a 35mm-film camera or a digital camera that has a *full-frame sensor* (a sensor that's the size of a 35mm negative). The T7/2000D sensor is smaller than that, so it can't record the entire angle of view that the lens focal length indicates.

To figure out what angle of view you'll get from a particular focal length — an important piece of information when you shop for a new lens — multiply the focal length by the camera's *crop factor,* a value that depends on the size of the image sensor. On the T7/2000D, the crop factor is 1.6. So the 18–55mm kit lens produces the angle of view you would get from a focal length of approximately 29–88mm on a full-frame digital camera or 35mm film camera (18–55 times 1.6 equals 29–88). In the figure here, the red line shows you the angle of view you get on your T7/2000D as compared to the image you would get on a full-frame camera.

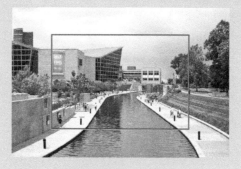

Always switch lenses in a clean environment to reduce the risk of getting dust, dirt, and other contaminants inside the camera or lens. Changing lenses on a sandy beach, for example, isn't a good idea. For added safety, point the camera body slightly down when performing this maneuver; doing so helps prevent any flotsam in the air from being drawn into the camera by gravity.

Working with Memory Cards

As the medium that stores your picture files, the memory card is a critical component of your camera. See the steps at the start of this chapter for help inserting a card into your camera; follow these tips for buying and maintaining cards:

>> **Buying SD cards:** Again, you can use regular SD cards, which offer less than 4GB of storage space; SDHC cards (4GB–32GB); and SDXC cards (more than 32GB). Aside from card capacity, the other specification to note is *SD speed class,* which indicates how quickly data can be moved to and from the card (the *read/write speed*).

Card speed is indicated in several ways. The most common spec is called SD Speed Class, which rates cards with a number between 2 and 10, with 10 being the fastest. Most cards also carry another designation, UHS-1, -2, or -3; UHS (Ultra High Speed) refers to a new technology designed to boost data transmission speeds above the normal Speed Class 10 rate. The number 1, 2, or 3 inside a little U symbol tells you the UHS rating.

Your camera can use UHS-1 cards, but because it doesn't follow the UHS-1 standard, you'll still get Class 10 read/write speeds. In other words, don't pay more for the UHS functionality if you're buying the card to use just with the T7/2000D.

Some SD cards also are rated in terms of their performance when used to record video — specifically, how many frames per second the card can handle. As with the traditional Speed Class rating and UHS rating, a higher video-speed number indicates a faster card. (As far as the traditional speed-class ratings, Canon recommends a speed class of 6 or higher for good recording performance.)

>> **Formatting a card:** The first time you use a new memory card or insert a card that's been used in other devices, you need to *format* it to prepare it to record your pictures. Card manufacturers also recommend that you format your cards every so often just to optimize their performance.

Formatting erases everything on your memory card. So before you format a card, be sure that you've copied any data on it to your computer. After doing so, get the formatting job done by selecting Format Card from Setup Menu 1.

When you choose the Format option, you can perform a normal card formatting process or a *low-level* formatting, which gives your memory card a deeper level of cleansing than ordinary formatting and thus takes longer to perform. Normally, a regular formatting will do, although performing a low-level formatting can be helpful if your card seems to be running more slowly than usual. To take advantage of this option, press the Erase button, which selects the box next to the Trash Can symbol on the menu screen. Then highlight OK and press the Set button.

» **Removing a card:** After making sure that the memory card access light (in the lower-right corner of the camera back) is off, which indicates that the camera has finished recording your most recent photo, turn off the camera. Open the battery chamber door, depress the memory card slightly, and then let go. The card pops up a bit, enabling you to grab it by the tail and remove it.

» **Handling cards:** Don't touch the gold contacts on the back of the card. (See the right card in Figure 1-20.) When cards aren't in use, store them in the protective cases they came in or in a memory card wallet. Keep cards away from extreme heat and cold as well.

Lock switch Don't touch!

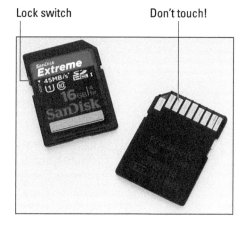

» **Locking cards:** The tiny switch on the side of the card, labeled *Lock switch* in Figure 1-20, enables you to lock your card, which prevents any data from being erased or recorded to the card. If you insert a locked card into the camera, a message on the monitor alerts you to that fact.

FIGURE 1-20:
Avoid touching the gold contacts on the card.

TIP

You can safeguard individual images from accidental erasure by using the Protect Images option on the Playback menu, which I cover in Chapter 10. Note, though, that formatting the card *does* erase even protected pictures; the safety feature prevents erasure only when you use the camera's Erase function.

» **Using Eye-Fi memory cards:** Your camera works with *Eye-Fi memory cards,* which are special cards that enable you to transmit your files wirelessly to your computer and other devices. That's a cool feature, but unfortunately, the cards themselves are more expensive than regular cards and require some configuring that I don't have room to cover in this book. Also, Canon doesn't guarantee complete camera compatibility with these cards. For more details, visit www.eye.fi.

REMEMBER

If you do use Eye-Fi cards, enable and disable wireless transmission via the Eye-Fi Settings option on Setup Menu 1. When no Eye-Fi card is installed in the camera, this menu option disappears.

Also check out Chapter 10 for information on using your camera's built-in wireless connectivity features to transfer photos to a smartphone or tablet.

Reviewing Basic Setup Options

One of the many advantages of investing in the Rebel T7/2000D is that you can customize it to suit the way *you* like to shoot. The following sections talk about a handful of setup options that I suggest you consider from the get-go.

Setup Menu 1

Open Setup Menu 1, shown in Figure 1-21, to access the following options:

>> **Auto Power Off:** To save battery power, the camera automatically goes to sleep after a certain period of inactivity. By default, the shut-down happens after 30 seconds, but you can change the shutdown delay to 1, 2, 4, 8, or 15 minutes. Or you can disable auto shutdown alto-gether by selecting the Disable setting, although even at that setting, the monitor still turns itself off if you ignore the camera for 30 minutes. Just give the shutter button a quick half-press and release or press the Menu, DISP, Playback, or Live View button to bring the monitor out of hibernation.

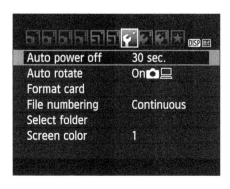

FIGURE 1-21:
The Auto Power Off setting determines how long the camera waits to go to sleep after a period of inactivity.

>> **File Numbering:** This option controls how the camera names your picture files:

● *Continuous:* This is the default; the camera numbers your files sequentially, from 0001 to 9999, and places all images in the same folder (100Canon, by default) unless you specify otherwise using the Select Folder option described in the next bullet point. This numbering sequence is retained even if you change memory cards.

When you reach picture 9999, the camera automatically creates a new folder (101Canon, by default) and restarts the file numbering at 0001 — again, the folder issue being dependent on the status of the Select Folder option.

- *Auto Reset:* If you switch to this option, the camera restarts file numbering at 0001 each time you put in a different memory card or create a new folder. I don't recommend this option because it's easy to wind up with multiple photos that have the same file number if you're not careful about storing them in separate folders.

WARNING

Beware of one gotcha that applies both to the Continuous and Auto Reset options: If you swap memory cards and the new card already contains images, the camera may pick up numbering from the last image on the new card, which throws a monkey wrench into things. To avoid this problem, format the new card before putting it into the camera, as explained earlier in this list.

- *Manual Reset:* Select this setting if you want the camera to begin a new numbering sequence, starting at 0001, for your next shot. A new folder is automatically created to store your new files. The camera then returns to whichever mode you previously used (Continuous or Auto Reset) to number subsequent pictures.

» **Select Folder:** By default, your camera creates an initial file-storage folder named 100Canon and puts as many as 9,999 images in that folder. When you reach image 9999, the camera creates a new folder, named 101Canon, for your next 9,999 images. The camera also creates a new folder if you perform a manual file-numbering reset.

If your memory card contains multiple folders, you must use the Select Folder option to choose the folder where you want to store the next photos you shoot. But selecting the menu option also leads to another neat feature: You can create your own storage folders at any time. You might create separate folders for each person who uses the camera, for example. Chapter 11 shows you how to create custom folders. Here's how to view which folder is active and choose a different one:

- *See which folder is currently selected.* Choose Select Folder to display a list of all folders, with the current one highlighted and appearing in blue type. The number to the right of the folder name shows you how many pictures are in the folder. You also see a thumbnail view of the first and last pictures in the folder, along with the file numbers of those two photos.

- *Choose a different folder.* Highlight the folder by using the cross keys and then press the Set button.

» **Screen color:** Select this option to choose from four color schemes for the Shooting Settings display.

Setup Menu 2

Setup Menu 2, posing in Figure 1-22, contains these options:

>> **LCD Brightness:** This option enables you to make the camera monitor brighter or darker. If you take this step, remember that what you see on the display may not be an accurate rendition of exposure. The default setting is 4, which is the position at the midpoint of the brightness scale.

>> **LCD Off/On Btn:** Through this option, you tell the camera what to do with regard to the Shooting Settings display when you press the shutter button halfway. You get three choices:

LCD brightness	☀ ├──┴──┤ ☀
LCD off/on btn	Shutter btn.
Date/Time/Zone	04/23/'18 12:52
Language	English
Clean manually	
Feature guide	Disable
GPS device settings	

FIGURE 1-22:
Setup Menu 2 offers more ways to customize basic operations.

- *Shutter Btn:* The display turns off when you press the shutter button halfway and reappears when you release the button. This setting is the default.

- *Shutter/DISP:* The display turns off when you press the shutter button halfway and remains off even after you release the button. You then press the DISP button to view the Shooting Settings screen.

- *Remains On:* The display stays on until you press the DISP button. (This setting is a battery-waster because it keeps the monitor on even when your eye is to the viewfinder.)

>> **Date/Time/Zone:** When you turn on your camera for the very first time, it automatically displays this option and asks you to set the date, time, and time zone. You also can specify whether you want the clock to update automatically to accommodate Daylight Saving Time (accomplish this by selecting the little sun symbol and then choosing On or Off).

TIP

Keeping the date/time accurate is important because that information is recorded as part of the image file. In your photo browser, you can then see when you shot an image and, equally handy, search for images by the date they were taken. Chapter 9 shows you where to locate the date/time data when browsing your picture files.

When the Time Zone setting is active, the value displayed in the upper-right corner of the screen is the difference between the Time Zone you select and Coordinated Universal Time, or UTC, which is the standard by which the world sets its clocks. For example, New York City is 5 hours behind UTC. This information is provided so that if your time zone isn't in the list of available options, you can select one that shares the same relationship to the UTC.

» **Language:** This option determines the language of any text displayed on the camera monitor.

» **Clean Manually:** This setting, which appears on the menu only when the Mode dial is set to P, Tv, or Av, locks up the camera mirror to allow you to clean the image sensor manually. I don't recommend that you tackle this maintenance job unless you're either experienced at it or willing to risk turning your camera into a paperweight. Instead, take the camera to a local camera store that provides this service.

How do you know when the sensor needs cleaning? Usually, you see a spot in the same position of every frame you shoot. If you clean your lens and the spot remains, it's sensor-cleaning time. Until you can get your sensor cleaned, the Dust Delete Data feature that I cover in Chapter 12 may be of some help in diminishing the appearance of sensor dust in your images.

» **Feature Guide:** When this option is enabled and you choose certain camera settings, notes appear on the monitor to explain the feature. Although the Feature Guide screens are helpful at first, having them appear all the time is a pain after you get familiar with your camera. So I leave this option set to Disable — and for the sake of expediency in this book, assume that you keep the option turned off as well. (If not, just don't be concerned when my instructions don't mention the screens in the course of showing you how to work the camera.)

» **GPS Device Settings:** If you attach the optional GP-E2 GPS device, this menu option offers settings related to its operation.

Setup Menu 3

To access all the options found on this menu, shown in Figure 1-23, you must set the Mode dial to P, Tv, Av, or M. Otherwise, the menu contains only the first two items, both related to the camera's wireless technology. (These items are dimmed in the figure because they're not available when you connect the camera to an HDMI video device, including the one I use to take snapshots of the camera screens that you see in figures in the book.)

Here's a quick rundown of Setup Menu 3 offerings:

FIGURE 1-23:
To access all Setup Menu 3 items, set the Mode dial to P, Tv, Av, or M.

>> **Wi-Fi/NFC:** Use this option to turn the camera's wireless connectivity function on and off. To save battery power, keep the feature off when you're not using it.

>> **Wi-Fi Function:** After you enable the Wi-Fi/NFC option, you can access this option, which enables you to customize various aspects of how the camera connects to your smartphone or tablet via a wireless connection. Chapter 10 has details on basic wireless setup.

>> **Certification Logo Display:** You have my permission to ignore this screen, which simply displays logos that indicate a couple electronics-industry certifications claimed by the camera. You can find additional logos on the bottom of the camera.

>> **Custom Functions:** Choose this option to explore a batch of advanced settings. See the section "Navigating Custom Functions screens," earlier in this chapter, for help using these special menu options.

>> **Copyright information:** If you want to include your copyright information in the *metadata* (hidden extra data) of your picture files, start by selecting this menu option. Chapter 12 has details.

REMEMBER

>> **Clear Settings:** Via this option, you can restore the default shooting settings. After selecting the option, choose Clear All Camera Settings to reset everything but Custom Functions settings. To restore those defaults, choose Clear All Custom Functions instead.

>> **Firmware Ver:** This screen tells you the version number of the camera firmware (internal operating software). At the time of publication, the current firmware version was 1.0.0.

WARNING

Keeping your camera firmware up to date is important, so visit the Canon website (www.canon.com) regularly to find out whether your camera sports the latest version. Follow the instructions given on the website to download and install updated firmware if needed.

ONE CAMERA, MANY NAMES

By now, you've probably wondered why this book refers to your camera by two model numbers: EOS Rebel T7/2000D. What gives? The answer is that Canon assigns different names to the same camera depending on the part of the world where it's sold. In the United States and Canada, the camera carries the EOS Rebel T7 label; in Europe, EOS 2000D. In Asia and some other regions, the model number is 1500D.

The *EOS* part, by the way, stands for Electro Optical System, the core technology used in Canon's autofocus SLR (single-lens reflex) cameras. According to Canon, the proper pronunciation is *EE-ohs,* which is also how you pronounce the name *Eos,* the goddess of dawn in Greek mythology.

With apologies to the goddess, I elected to save a little room in this book by shortening the camera name to T7/2000D.

Chapter **2**

Choosing Basic Picture Settings

E very camera manufacturer strives to ensure that your first encounter with the camera is a happy one. To that end, the camera's default (initial) settings are selected to make it easy to take a good picture the first time you press the shutter button. At the default settings, your camera works about the same way as any point-and-shoot camera you may have used in the past: You compose the shot, press the shutter button halfway to focus, and then press the button the rest of the way to take the picture.

Although you can get a good photo using the default settings in many cases, they're not designed to give you optimal results in every situation. You may be able to take a decent portrait, for example, but probably need to tweak a few settings to capture action. Adjusting a few options can help turn that decent portrait into a stunning one, too.

So that you can start fine-tuning settings to match your subject, this chapter explains the most basic picture-taking options, such as the exposure mode, shutter-release mode (officially called Drive mode), the Image Quality option, and flash settings. They're not the most exciting options (don't think I didn't notice you stifling a yawn), but they make a big difference in how easily you can capture the photo you have in mind.

Note: This chapter relates to still photography; for information about shooting movies, see Chapter 8.

Selecting an Exposure Mode

The first picture-taking setting to consider is the exposure mode, which you select via the Mode dial, shown in Figure 2-1. For now, ignore Movie mode, represented by the symbol labeled in the figure; again, I cover movies in Chapter 8.

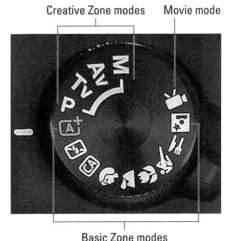

Creative Zone modes Movie mode

Basic Zone modes

FIGURE 2-1:
Settings on the Mode dial determine the exposure mode.

For still photography, exposure modes are grouped into two categories: Basic Zone and Creative Zone, also labeled in the figure. Your choice determines how much control you have over two critical exposure settings — aperture and shutter speed — as well as many other options, including those related to color and flash photography.

REMEMBER

The next sections offer a quick look at your exposure mode options. But first, I want to clear up one often-misunderstood aspect about exposure modes: Although your choice determines access to exposure and color controls, as well as to some other advanced camera features, it has *no* bearing on your *focusing* choices. You can choose from manual focusing or autofocusing in any mode, assuming that your lens offers autofocusing. However, access to options that modify how the autofocus system works is limited to Creative Zone modes. Read about those options in Chapter 6.

Basic Zone modes

This zone includes the following point-and-shoot modes, represented on the Mode dial with the icons shown in the margins:

>> **Scene Intelligent Auto:** The most basic mode; the camera analyzes the scene and selects the settings it thinks would best capture the subject.

>> **Flash Off:** Works like Scene Intelligent Auto except that flash is disabled.

>> **Creative Auto:** This mode is like Scene Intelligent Auto but with some manual override options. You can exercise a little creative control by tweaking some picture qualities, such as whether the background blurs.

>> **Image Zone modes:** *Image Zone* is the Canon name for exposure modes more commonly referred to as *scene modes*. Each mode in this group is geared to capturing specific types of scenes. You can choose from the following settings:

- *Portrait,* for taking portraits using the traditional style of a sharply focused subject and a blurred background

- *Landscape,* for capturing scenic vistas or other subjects that encompass a large area, with focus appearing sharp over a long distance

- *Close-up,* for shooting flowers and other subjects at close range, with the background blurred to add emphasis to the subject

- *Sports,* for capturing moving subjects (whether they happen to be playing a sport or not)

- *Food,* designed to render bright, especially colorful images of that to-die-for meal you're about to devour and want to share on Facebook or Instagram before you do

- *Night Portrait,* for better outdoor flash photographs of people at night

WARNING

Chapter 3 tells you more about these modes, but be forewarned: To remain easy to use, these modes prevent you from taking advantage of many exposure, color, and autofocusing features. You can adjust the options discussed in this chapter, but the camera controls almost everything else.

Creative Zone modes

When you're ready to take more control over the camera, step up to one of these modes, which include P (programmed autoexposure), Tv (shutter-priority autoexposure), Av (aperture-priority autoexposure), and M (manual exposure) modes.

Chapter 4 explains which of these modes work best for which subjects and details how you use each one. For now, just remember that these modes, which I refer to generically as *advanced exposure modes,* give you access not only to all exposure settings, but also to every menu option on your camera.

Choosing a Shutter-Release (Drive) Mode

In Canon vernacular, *Drive mode* refers to the setting that tells the camera what to do when you press the shutter button: Record a single frame, record a series of frames, or record one or more shots after a short delay. In other words, this setting determines when and how the shutter is released to expose the picture. Read on to find out more about your Drive mode options and how to adjust the setting.

Understanding the Drive mode options

In total, your camera offers five Drive mode settings. But you can access all five only if you set the Mode dial to one of the advanced exposure modes (P, Tv, Av, or M). In the other modes, your choices are more limited. The next sections describe each Drive mode and detail which ones you can use in each exposure mode.

Single mode

Consider this mode, represented by the single square shown in the margin here, as normal shooting mode: The camera records one frame each time you press the shutter button.

Single mode is the default setting for all exposure modes except Portrait and Sports, which put Single mode off-limits and instead use Continuous mode, explained next. To capture a single frame in either of those two modes, choose one of the Self-Timer Drive mode options, detailed a bit down the road from here.

Continuous (burst) mode

Sometimes known as *burst mode,* Continuous mode records a series of images as long as you hold down the shutter button. It's represented by the "multiple frames" symbol shown in the margin. The camera can capture roughly 3 frames per second.

Keep these tips in mind when using Continuous mode:

>> **Continuous mode is the default setting for Portrait and Sports modes.**
 Using continuous capture for portraits may seem odd, but it can actually help you capture the perfect expression on your subject's face — or, at least, a moment between blinks! Be careful about using flash for your portraits, however; not only can it slow the burst rate, but your subject may not react too kindly to multiple blasts of flash at a time. See Chapter 7 for ideas on how to take great portraits without flash. (Flash is disabled in Sports mode.)

» **You can't select Continuous mode in any other scene modes, Auto mode, or Auto Flash Off mode.** If you don't want to shoot in Portrait or Sports mode, you must switch to Creative Auto, P, Tv, Av, or M exposure mode to access burst-mode shooting.

» **The number of frames per second depends in part on your shutter speed.** At a slow shutter speed, the camera may not be able to reach the maximum frame rate. (See Chapter 4 for an explanation of shutter speed.)

» **Using flash slows the frames-per-second rate.** The frame rate slows because the flash needs time to recycle between shots.

» **The burst rate is also affected by the Image Quality setting and the speed of the memory card.** The Image Quality setting determines the file size of each picture, and the larger the file, the longer the camera needs to record it to the memory card. And the card read-write speed determines how quickly the card can store all that picture data. (For best performance, buy a card that has an SD speed class rating of 10; see Chapter 1 for more on this issue.)

» **Whether focus is adjusted between each frame depends on the AF Operation setting.** I detail focusing in Chapter 5, but the short story is that if you rely on autofocusing and set the AF Operation option to AI Servo, focus is adjusted as needed between shots. The same is true when you set the AF Operation option to AI Focus, a mode in which the camera automatically shifts to AI Servo autofocusing if it senses movement in front of the lens.

Either way, AI Servo produces the best focusing performance if your subject is moving toward or away from you, but it can slow the burst rate because of the time the camera takes to adjust focus between frames. For a still subject, set the AF Operation option to One-Shot AF instead. The camera then sets focus only once, using the same focusing distance for all shots in the burst.

TIP

You can use One-Shot AF for faster performance when shooting moving subjects, too, as long as the subject isn't moving closer to or farther from your lens. For example, if you're photographing a baby that's sitting in a high chair, the baby may not remain still. But unless it has super baby powers, it will stay about the same distance from the camera. In photo lingo, the subject will remain on the same *focal plane* throughout your burst of shots. That means that the focusing point established before the burst will work for all the frames.

Self-timer modes

You're probably familiar with self-timer mode, which delays the shutter release until a few seconds after you press the shutter button. It's long been the go-to mode when you want to put yourself in the picture, but you can also use the

self-timer function to avoid camera shake that can be caused by the mere motion of pressing the shutter button. Put the camera on a tripod and then activate the self-timer function to enable hands-free — and therefore motion-free — picture taking.

Your camera offers three self-timer settings:

>> **Self-Timer: 10 Second:** Delays the shutter release for 10 seconds.

>> **Self-Timer: 2 Second:** Available only in P, Tv, Av, and M exposure modes, this setting releases the shutter 2 seconds after you press the shutter button.

>> **Self-Timer: Continuous:** With this option, the camera waits 10 seconds after you press the shutter button and then captures a continuous series of images. You can set the camera to record two to ten images per each shutter release.

When you use any of the Self-Timer modes, it's a good idea to use the cover on the viewfinder. Otherwise, light may seep in through the viewfinder and mess up the camera's exposure calculations. Canon provides a viewfinder cover on the camera strap just for this purpose.

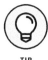

TIP

If you have a smartphone or tablet that can run the Canon Camera Connect app, you have an alternative to using self-timer mode: Use your smart device to trigger the camera's shutter via a Wi-Fi connection. Chapter 10 explains the basic setup steps for connecting your camera and phone or tablet; Chapter 12 talks more about using your device as a wireless remote control.

Checking and adjusting the Drive mode

A symbol representing the current Drive mode setting appears in the Shooting Settings and Live View displays, as shown in Figures 2-2 and 2-3. The icon representing the Drive mode appears in a different area depending on your exposure mode; the left screens in the figures show you where to look when shooting in Scene Intelligent Auto, for example, and the right screens show where the icon hangs out when you use the advanced exposure modes. Both figures show the icon that represents the Single Drive mode.

How you change the Drive mode depends on whether you're using Live View or the viewfinder to compose the picture:

>> **Press the left cross key (not available in Live View mode).** As shown in Figure 2-4, the key is marked by two of the Drive mode icons to help you remember its function. After you press the cross key, you see the settings screen displayed in the figure. Again, you don't see all the options shown in the figure unless you shoot in the advanced exposure modes.

Drive mode symbol

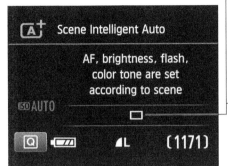

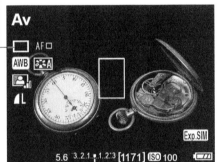

FIGURE 2-2:
The Shooting
Settings screen
displays an
icon indicating
the current
Drive mode.

Drive mode symbol

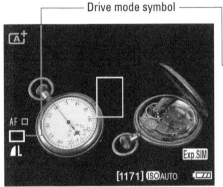

FIGURE 2-3:
In Live View
mode, look
here for the
Drive mode
symbol.

Drive mode cross key

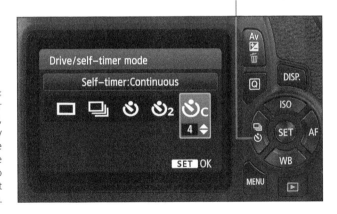

FIGURE 2-4:
For viewfinder
photography,
the fastest way
to get to the
Drive mode
setting is to
press the left
cross key.

For the Self-Timer: Continuous mode, selected in Figure 2-4, press the up or down cross key to set the number of continuous shots you want the camera to capture.

 » **Use the Quick Control screen.** After pressing the Q button to enter Quick Control mode, select the Drive mode icon, as shown in Figure 2-5. (The left screen in the figure shows you where to look on the Shooting Settings screen; the right screen, the Live View display.) The name of the current setting appears at the bottom of the screen. Rotate the Main dial to cycle through the available settings or press Set to display the selection screen shown in Figure 2-4.

You must use this method to change the Drive mode when Live View is engaged; pressing the left cross key performs a focus-related function during Live View shooting.

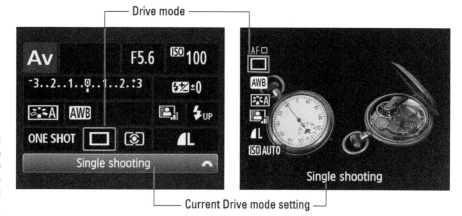

FIGURE 2-5: But you also can change the setting via the Quick Control screen.

Setting Resolution and File Type (The Image Quality Setting)

The T7/2000D can capture top-notch pictures, but getting the maximum output from your camera depends on choosing the right capture settings. Chief among them is the appropriately named Image Quality setting.

REMEMBER

This control determines two important aspects of your pictures: *resolution*, or pixel count; and *file format*, which refers to the type of computer file the camera uses to store your picture data. The next section shows you how to view and adjust the setting; following that, you can get background information to help you select the right resolution and file type.

Adjusting the Image Quality setting

An icon representing the current Image Quality setting appears on the Shooting Settings and Live View displays. Figure 2-6 shows you where to find the symbols when shooting in the P, Tv, Av, and M modes; in other modes, the symbols appear elsewhere on the screen. (Help with decoding the symbols arrives shortly.)

Image Quality symbol

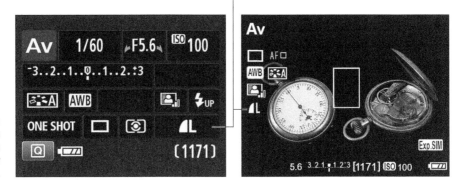

FIGURE 2-6: These symbols represent the Image Quality setting.

Your options for changing the Image Quality setting depend on your exposure mode, as follows:

>> **Shooting Menu 1 (any exposure mode):** After selecting the Image Quality option, as shown on the left in Figure 2-7, press Set to display the available settings, as shown on the right.

Pixel dimensions

Resolution (megapixels) Shots remaining

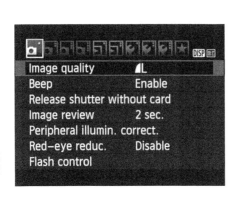

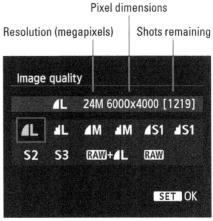

FIGURE 2-7: You can access the Image Quality setting via Shooting Menu 1.

 » **Quick Control screen (P, Tv, Av, and M modes only):** After highlighting the setting (see Figure 2-6), rotate the Main dial to cycle through the available settings. Or if you prefer, press the Set button to display all the options at once.

If you're new to digital photography, the Image Quality settings won't make much sense until you read the next sections, which explain resolution and file type in detail. But even if you're schooled in those topics, you may need some help deciphering the way that the settings are represented on your camera. As you can see from Figures 2-6 and 2-7 the options are presented in rather cryptic fashion, so here's your decoder ring:

» At the top of the Shooting Menu's Image Quality selection screen, you see three bits of information, labeled in Figure 2-7: the *resolution,* or total pixel count (measured in megapixels); the *pixel dimensions* (number of horizontal pixels, followed by the number of vertical pixels); and the number of subsequent shots you can fit on your current memory card at the current Image Quality setting. This same information appears at the bottom of the Quick Control screen when the Image Quality setting is selected.

 » The next two rows of the menu screen contain icons representing the available Image Quality settings. The settings marked with the arc symbols capture images in the JPEG file format, as do the S2 and S3 settings. The arc icons represent the level of JPEG *compression,* which affects picture quality and file size. You get two options: Fine and Normal. The smooth arcs represent the Fine setting; the jagged arcs represent the Normal setting.

Both S2 and S3 use the JPEG Fine recording option. And no, I don't know why they don't sport the arc icons — maybe the arc-supplier guy was sick the day that S2 and S3 got added to the mix. At any rate, check out the upcoming section "JPEG: The imaging (and web) standard" for details about all things JPEG.

» Within the JPEG category, you can choose from five resolution settings, represented by L, M, S1, S2, and S3 (*large, medium, small, smaller, smallest*). See the next section for information that helps you select the right resolution.

» You also can capture images in the Raw format. Raw files are always created at the Large resolution setting, giving you the maximum pixel count. One of the two Raw settings also records a JPEG Fine version of the image, also at the maximum resolution. The upcoming section "Raw (CR2): The purist's choice" explains the Raw format.

Which Image Quality option is best depends on several factors, including how you plan to use your pictures and how much time you care to spend processing images on your computer. The next several sections explain these and other issues related to the Image Quality setting.

Considering resolution: Large, Medium, or Small?

To choose an Image Quality setting, the first decision you need to make is how many pixels you want your image to contain. *Pixels* are the little square tiles from which all digital images are made; *pixel* is short for *picture element*. You can see some pixels close up in the right image in Figure 2-8, which shows a greatly magnified view of the eye area in the left image.

FIGURE 2-8: Pixels are the building blocks of digital photos.

When describing a digital image, photographers use the term *image resolution* to refer to the number of pixels it contains. Every image starts with a specific number of pixels, which you select on your camera via the Image Quality setting. You can choose from five options: Large, Medium, and Small (1–3), represented on the list of Image Quality settings by the initials L, M, and S (1–3). Table 2-1 shows you the pixel count that results from each option. If you select Raw as your Quality setting, images are always captured at the Large resolution value.

TABLE 2-1

The Image Resolution Side of the Quality Settings

Symbol	Setting	Pixel Count
L	Large	6000 x 4000 (24MP)
M	Medium	3984 x 2656 (11 MP
S1	Small 1	2976 x 1984 (5.9 MP)
S2	Small 2	1920 x 1280 (2.5 MP)
S3	Small 3	720 x 480 (0.3 MP)

TECHNICAL STUFF

In the table, the first pair of numbers in the Pixel Count column represents the *pixel dimensions* — the number of horizontal pixels and the number of vertical pixels. The values in parentheses indicate the total resolution, which you get by multiplying the horizontal and vertical pixel values. This number is usually stated in *megapixels*, or MP for short. The camera displays the resolution value using only one letter M, however. (Refer to Figure 2-7.) Either way, 1 MP equals 1 million pixels. Also, the numbers reflect the standard 3:2 picture–aspect ratio that the camera produces by default in Live View mode. See the later sidebar "Changing the Live View aspect ratio" for details on the other options. (You can't change the aspect ratio for regular viewfinder photography.)

Resolution affects your pictures in three ways:

>> **Print size:** Pixel count determines the size at which you can produce a high-quality print. When an image contains too few pixels, details appear muddy, and curved and diagonal lines appear jagged. Such pictures are said to exhibit *pixelation.*

Depending on your photo printer, you typically need anywhere from 200 to 300 pixels per linear inch, or *ppi,* for good print quality. To produce an 8-x-10 print at 300 ppi, for example, you need a pixel count of 2400 x 3000, or about 7.2 megapixels. To determine the maximum print width at any resolution, divide the number of horizontal pixels by the desired ppi; to calculate the maximum print height, divide the number of vertical pixels by the ppi value.

WARNING

Even though many photo-editing programs enable you to add pixels to an existing image — known as *upsampling* — doing so doesn't enable you to successfully enlarge your photo. In fact, upsampling typically makes matters worse.

To give you a better idea of the impact of resolution on print quality, Figures 2-9, 2-10, and 2-11 show you the same image at 300 ppi, at 50 ppi, and then upsampled from 50 ppi to 300 ppi (respectively). As you can see, there's no way around the rule: If you want quality prints, you need the right pixel count from the get-go

TECHNICAL STUFF

You also may hear the process of adding pixels referred to as *resampling,* which technically means changing the number of pixels in the image. For clarity's sake, though, I use *upsample* to mean adding pixels and *downsample* to mean eliminating pixels.

>> **Screen display size:** Resolution doesn't affect the quality of images viewed on a monitor or television, or another screen device, the way it does for printed photos. Instead, resolution determines the *size* at which the image appears. This issue is one of the most misunderstood aspects of digital photography, so I explain it thoroughly in Chapter 10. For now, just know that you need *way* fewer pixels for onscreen photos than you do for prints. In fact, even the Small

resolution setting creates a picture too big to be viewed in its entirety in many email programs.

» **File size:** Every additional pixel increases the amount of data used to create a digital picture file. So a higher-resolution image has a larger file size than a low-resolution image.

300 ppi

FIGURE 2-9:
A high-quality print depends on a high-resolution original.

50 ppi

FIGURE 2-10:
At 50 ppi, the image has a jagged, pixelated look.

50 ppi resampled to 300 ppi

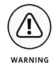

WARNING

Large files present several problems:

- You can store fewer images on your memory card, your computer's hard drive (either internal or external), online storage site *(cloud storage),* or removable storage media such as a DVD or flash drive.

- The camera needs more time to process and store the image data, which can hamper fast-action shooting.

- When you share photos online, larger files take longer to upload and download.

- When you edit photos in your photo software, your computer needs more resources to process large files.

As you can see, resolution is a bit of a sticky wicket. What if you aren't sure how large you want to print your images? What if you want to print your photos *and* share them online? I take the better-safe-than-sorry route, which leads to the following recommendations:

- ❯❯ **Shoot at a resolution suitable for print.** You then can create a low-resolution copy of the image for use online. In fact, your camera has a built-in Resize tool that can do the job. Chapter 10 shows you how to use that feature.

- ❯❯ **For everyday images, Medium is a good choice.** Even at the Medium setting, the pixel count is enough for an 8 x 10 print at 300 ppi.

» **Choose Large for an image that you plan to crop, print very large, or both.** The benefit of maxing out resolution is that you have the flexibility to crop your photo and still generate a decent-sized print of the remaining image. Figure 2-12 offers an example. I wanted to fill the frame with the butterfly, but couldn't do so without getting so close that I risked scaring it away. So I kept my distance and took the picture at the Large resolution setting, resulting in the composition shown on the left in the figure. Because I had oodles of pixels in that photo, I could crop it and still have enough pixels left over to produce a great print. In fact, the cropped image can be printed much larger than space permits in this book.

FIGURE 2-12: When you can't get close enough to fill the frame with the subject, capture the image at the Large resolution setting (left) and crop later (right).

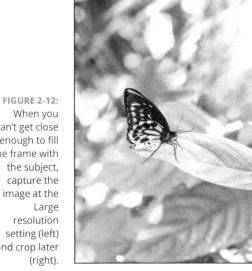
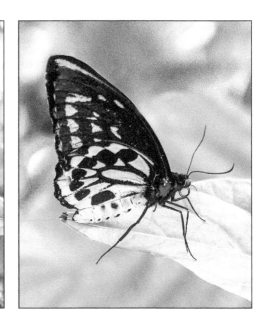

Understanding file type (JPEG or Raw)

In addition to establishing the resolution of your photos, the Image Quality setting determines the *file type*, which refers to the kind of data file that the camera produces. Your camera offers two file types — JPEG and Raw (sometimes seen as *raw* or *RAW*), with a couple variations of each. The next sections explain the pros and cons of each setting.

TIP

CHANGING THE LIVE VIEW ASPECT RATIO

When you shoot with the viewfinder, the camera takes photos with a 3:2 *aspect ratio* (the relationship of a photo's width to its height). But in Live View mode, you can choose a different aspect ratio if you shoot in the advanced exposure modes (P, Tv, Av, and M). Pull up Shooting Menu 4 and then choose the Aspect Ratio option. You can change to an aspect ratio of 4:3, 16:9, or 1:1. The Live View display updates to show you the area that will be captured at the chosen aspect ratio.

How many pixels your image contains depends on the aspect ratio; at the 3:2 setting, you get the full complement of pixels delivered by your chosen Image Quality setting. (See Table 2-1 earlier in the chapter.) Note, too, that if you set the Image Quality option to record JPEG pictures, the camera creates the different aspect ratios by cropping a 3:2 original — and the cropped data can't be recovered. Raw photos include picture data from the entire 3:2 frame, no matter what aspect ratio you choose. During playback, crop lines appear atop the image to indicate the aspect ratio selected for the shot. But you aren't locked into that aspect ratio; you can choose any aspect ratio when you process Raw files using the provided Canon software. In fact, you can create one copy of the Raw file using one aspect ratio and create a second copy that has a different aspect ratio. See Chapter 10 for information about using the Canon software to process Raw files.

JPEG: The imaging (and web) standard

This format is the default setting on your camera, as it is for most digital cameras. JPEG is popular for two main reasons:

>> **Immediate usability:** JPEG is a longtime standard format for digital photos. All web browsers and e-mail programs can display JPEG files, so you can share them online immediately after you shoot them. You also can get JPEG photos printed at any retail outlet, whether it's an online or a local printer. Additionally, any program that has photo capabilities, from photo-editing programs to word-processing programs, can handle your files.

>> **Small files:** JPEG files are smaller than Raw files. And smaller files mean that your pictures consume less room on your camera memory card and on your computer's hard drive.

The downside (you knew there had to be one) is that JPEG creates smaller files by applying *lossy compression*. This process actually throws away some image data. Too much compression gives your image a blotchy look, with random color defects. Figure 2-13 offers an example of these defects, known in the biz as *JPEG artifacts*.

On your camera, the amount of compression that's applied depends on whether you choose an Image Quality setting that carries the label Fine or Normal:

>> **Fine:** At this setting, very little compression is applied, so you shouldn't see many compression artifacts, if any. Canon uses the symbol that appears in the margin here to indicate the Fine compression level; however, the S2 and S3 settings both use the Fine level even though they don't sport the symbol.

>> **Normal:** Switch to Normal, and the compression amount rises, as does the chance of seeing some artifacting. Notice the jaggedy-ness of the Normal icon, as shown in the margin? That's your reminder that all may not be "smooth" sailing when you choose a Normal setting.

Note, though, that the Normal setting doesn't result in anywhere near the level of artifacting that you see in Figure 2-13. I exaggerated the defects in this example to help you see how JPEG artifacts differ from the quality defects that appear in low-resolution prints (refer to Figure 2-10). If you keep your image print or display size small, you aren't likely to notice a great deal of quality difference between the Fine and Normal compression levels. The differences become apparent only when you greatly enlarge a photo.

Given that the differences between Fine and Normal aren't all that easy to spot until you really enlarge the photo, is it okay to shift to Normal and enjoy the benefits of smaller files? Well, only you can decide what level of quality your pictures demand. For most photographers, the added file sizes produced by the Fine setting aren't a concern in terms of running out of memory-card space during a shoot; cards are small enough (and cheap enough) that you can easily carry multiple cards in your camera bag. Figuring out where to put those new files when you get home is another matter. Most of us already have bulging digital closets, and the larger your image files, the harder it is to cram more of them onto your

computer's hard drive, an external storage drive, or an online storage account (*cloud storage,* as the hip kids say).

In the end, I prefer to take the storage hit in exchange for the lower compression level of the Fine setting. You never know when a casual snapshot is going to be so great that you want to print or display it large enough that even minor quality loss becomes a concern. And of all the defects that you can correct in a photo editor, artifacting is one of the hardest to remove. So I stick with Fine when shooting in the JPEG format.

If you don't want *any* risk of artifacting, bypass JPEG and change the file type to Raw (CR2). The next section offers details.

Raw (CR2): The purist's choice

The other picture-file type that you can create is *Camera Raw,* or just *Raw* (as in uncooked) for short.

Each manufacturer has its own flavor of Raw files; your T7/2000D produces files that have the designation CR2 (Camera Raw 2). This three-character label appears in filenames of images you shoot in the Raw format — IMG_0814.CR2, IMG_0815. CR2, and so on.

Raw is popular with many pro and advanced photographers for these reasons:

>> **Greater creative control:** With JPEG, internal camera software tweaks your images, adjusting color, exposure, and sharpness as needed to produce the results that Canon believes its customers prefer (or according to certain camera settings you choose, such as the Picture Style). With Raw, the camera simply records the original, unprocessed image data. The photographer then copies the image file to the computer and uses software known as a *raw converter* to produce the actual image, making decisions about color, exposure, and so on, at that point. The upshot is that "shooting Raw" enables you, not the camera, to have the final say on the visual characteristics of your image.

>> **More flexibility:** Having access to the Raw photo data means that you can reprocess the same photo with different settings as many times as you want without losing any quality from the original Raw file.

>> **Higher bit depth:** *Bit depth* is a measure of how many color values an image file can contain. JPEG files restrict you to 8 bits each for the red, blue, and green color components, or *channels,* that make up a digital image, for a total of 24 bits. That translates to roughly 16.7 million possible colors. On the T7/2000D, a Raw file delivers a higher bit count, collecting 14 bits per channel.

Although jumping from 8 to 14 bits sounds like a huge difference, you may not ever notice any difference in your photos — that 8-bit palette of 16.7 million values is more than enough for superb images. Where having the extra bits can come in handy is if you really need to adjust exposure, contrast, or color after the shot in your photo-editing program. In cases where you apply extreme adjustments, having the extra original bits sometimes helps avoid a problem known as *banding* or *posterization,* which creates abrupt color breaks where you should see smooth, seamless transitions. (A higher bit depth doesn't always prevent the problem, however, so don't expect miracles.)

>> **Best picture quality:** Because Raw doesn't apply the kind of destructive compression associated with JPEG, you don't run the risk of the artifacting that can occur with JPEG.

But just like JPEG, Raw isn't without its disadvantages:

>> **You can't do much with your pictures until you process them in a Raw converter.** You can't share them online, for example, or put them into a text document or multimedia presentation. You can print them immediately if you use Canon Digital Photo Professional 4, the free software that you can download from the Canon website. (Go to the product support page for your camera and follow the links to the software download page.) But most other photo programs require you to convert the Raw files to a standard format first. Ditto for retail photo printing. So when you shoot Raw, you add to the time you spend in front of the computer instead of behind the camera lens. Chapter 10 gets you started processing your Raw files using your Canon software.

>> **Raw files are larger than JPEG files.** Unlike JPEG, Raw doesn't apply lossy compression to shrink files. This means that Raw files are significantly larger than JPEG files, so they take up more room on your memory card and on your computer's hard drive or other file-storage devices. A larger file also can cause a slightly slower frames-per-second rate when you shoot a burst of images in the Continuous Drive mode.

Whether the upside of Raw outweighs the down is a decision that you need to ponder based on your photographic needs, schedule, and computer-comfort level. If you decide to try Raw shooting, you can select from the following Image Quality options:

>> **RAW:** This setting produces a single Raw file at the maximum resolution (24 MP).

>> **RAW+Large/Fine:** This setting produces two files: the Raw file plus a JPEG file captured at the Large/Fine setting. The advantage is that you can share the JPEG online or get prints made immediately and then process your Raw files when you have time. The downside, of course, is that creating two files for every image eats up substantially more space on your memory card and your computer's hard drive.

HOW MANY PICTURES FIT ON MY MEMORY CARD?

Image resolution (pixel count) and file format (JPEG or Raw) together contribute to the size of the picture file which, in turn, determines how many photos fit in a given amount of camera memory. The following table shows you the approximate size of the files, in megabytes (MB), that are generated at each of the resolution/format combinations on your camera. (The actual file size of any image also depends on other factors, such as the subject, ISO setting, and Picture Style setting.) In the Image Capacity column, you see approximately how many pictures you can store at the setting on an 8GB (gigabyte) memory card.

Picture Capacity of an 8GB Memory Card

Symbol	Quality Setting	File Size	Image Capacity*
◢L	Large/Fine	7.5MB	940
◢L	Large/Normal	3.7MB	1,920
◢M	Medium/Fine	3.9MB	1,820
◢M	Medium/Normal	1.9MB	3,580
◢S1	Small 1/Fine	2.4MB	2,880
◢S1	Small 1/Normal	1.3MB	5,440
S2	Small 2/Fine	1.3MB	5,440
S3	Small 3/Fine	0.3MB	19,380
RAW	Raw	30.3MB	230
RAW ◢L	Raw+Large/Fine	37.8MB**	180

Values for 8GB card.
**Combined size of the two files produced at this setting.*

My take: Choose Fine or Raw

At this point, you may be finding all this technical goop a bit much, so allow me to simplify things until you have the time or energy to completely digest all the ramifications of JPEG versus Raw:

>> If you require the absolute best image quality and have the time and interest to do the Raw conversion process, shoot Raw.

>> If great photo quality is good enough for you, you don't have wads of spare time, or you aren't that comfortable with the computer, stick with one of the Fine JPEG settings.

>> If you want to enjoy the best of both worlds, consider Raw+Large/Fine — assuming, of course, that you have an abundance of space on your memory card and your hard drive. Otherwise, creating two files for every photo on a regular basis isn't practical.

>> Select JPEG Normal if you aren't shooting pictures that demand the highest quality level and you aren't printing or displaying the photos at large sizes. The smaller file size also makes JPEG Normal the way to go if you're running low on memory-card space during a shoot.

Adding Flash

The built-in flash on your camera offers an easy, convenient way to add light to a too-dark scene. But whether you can use flash and what flash features are available depend on your exposure mode, as outlined in the next few sections.

TIP

Before you digest that information, note these universal tips:

>> **The effective range of the built-in flash depends on the ISO setting and the lens focal length.** The ISO setting affects the camera's sensitivity to light; Chapter 4 has details. At the lowest ISO setting (ISO 100), the flash range is about 3 to 8.5 feet at a lens focal length of 18mm — the widest angle on the 18–55mm kit lens. The flash range is shorter at the longest focal length of that lens (55mm), extending from about 3 to 5 feet. To illuminate a subject that's farther away, use a higher ISO speed or an auxiliary flash that offers greater power than the built-in flash.

>> **Don't get too close.** If the flash is too near your subject, the light may not illuminate the subject entirely. So take a test shot and modify your shooting distance if necessary.

>> **Watch for shadows cast by the lens or a lens hood.** When you shoot with a long lens, you can wind up with unwanted shadows caused by the flash light hitting the lens. Ditto for a lens hood.

>> **While the flash is recycling, you see a "Busy" signal.** In the viewfinder, a lightning bolt like the one in the lower-left corner of Figure 2-14 tells you that the flash is enabled. The word "Busy" along with the lightning bolt means that the flash needs a few moments to recharge. You also may see the Busy alert on the monitor when shooting in Live View mode.

FIGURE 2-14: A Busy signal means that the flash is recharging.

>> **For brighter backgrounds in flash photos, use a slower shutter speed.** Explained fully in Chapter 4, *shutter speed* is the setting that determines how long the shutter remains open, allowing light to hit the image sensor and expose the photo.

At a slow shutter speed, the camera has time to soak up ambient light and thus needs less flash power to illuminate the subject. As a result, background objects beyond the reach of the flash are brighter than when you use a fast shutter speed, and the flash light that hits your subject is less harsh. Figure 2-15 offers an example: The left image was taken at a shutter speed of 1/60 second; the right, at 1/8 second.

Slow-sync flash is the technical term for the technique of combining flash with a slow shutter speed. *Slow* refers to the shutter speed; *sync* refers to how the timing of the flash is synchronized with the opening of the camera's shutter when the exposure is made.

TECHNICAL STUFF

Shutter speed: 1/60 second Shutter speed: 1/8 second

FIGURE 2-15: When you use a slow shutter speed with flash, back-grounds are brighter, and the flash light is softer.

Some cameras have a special slow-sync flash setting, but on the T7/2000D, you just dial in the slow shutter speed you want to use. To control shutter speed, set the Mode dial to Tv (shutter-priority) or M (manual) exposure mode. Then rotate the Main dial to adjust the shutter speed. You can select a shutter speed as slow as 30 seconds.

TIP

If you're not up to using Tv or M mode yet but want slow-shutter flash results, set the Mode dial to the Night Portrait setting, which automatically uses a slower shutter speed than other modes that permit flash.

Either way, remember that a slow shutter speed can produce blurring if the camera or subject moves during the exposure. So use a tripod and tell your subject to remain as still as possible.

WARNING

>> **The fastest shutter speed you can use with the built-in flash is 1/200 second.** This limitation is due to the way the camera has to synchronize the flash firing with the opening of the shutter. The shutter speed limitation can cause two problems. First, a very quickly moving subject may appear blurry at 1/200 second. (See Chapter 4 to understand the relationship between motion blur and shutter speed.) Second, in very bright light, you may need a faster shutter speed to avoid overexposing the picture. The sidebar "Using flash outdoors," later in this chapter, has more to say on that subject.

Enabling and disabling flash

Whether you can use flash or control its firing depends on the exposure mode. Here's how things shake out:

>> **Scene Intelligent Auto, Portrait, Close-Up, and Night Portrait:** If the camera thinks extra light is needed, it automatically raises and fires the built-in flash. Otherwise, the flash remains closed.

>> **Landscape, Sports, and Flash Off modes:** Flash is disabled.

>> **Food mode:** Flash is disabled by default, and Canon suggests that you avoid using flash in this mode so that the light from the flash doesn't cause distracting shadows or reflect in the surfaces of plates, silverware, and glasses. However, if you want to use flash, you can; make the adjustment via the Quick Control screen. (The symbols representing the flash On and Off settings look the same as shown for the Creative Auto mode, described next.) When flash is enabled, the built-in flash pops up when you press the shutter button halfway.

>> **Creative Auto mode:** You can choose from three flash modes:

- *Auto Flash:* The camera decides when to fire the flash, basing its decision on the lighting conditions.

- *On:* The flash pops up and fires regardless of the lighting conditions. Using a fill flash is an effective way to light people's faces even in bright conditions.

- *Off:* The flash does not fire, no way, no how, even if the flash is raised because you used it on the previous shot.

You can view the current flash setting in the Shooting Settings and Live View displays, as shown in Figure 2-16. Chapter 3 explains the other stuff you see on the screen and provides more details about using Creative Auto mode.

Flash setting

FIGURE 2-16: Look here to view the current flash setting in Creative Auto mode.

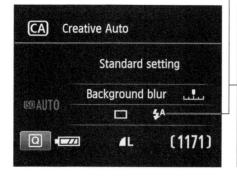
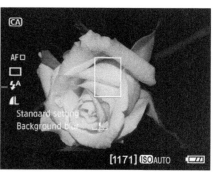

To set the flash mode, press the Q button to activate the Quick Control screen. Use the cross keys to highlight the flash setting and then rotate the Main dial to cycle through the three flash settings. You also can press the Set button to display a selection screen showing all the available flash settings.

» **P, Tv, Av, and M modes:** If you want to use the built-in flash, press the Flash button on top of the camera. (The button is a little difficult to spot: Look for it between the Main dial and the Mode dial, on the top right side of the camera.)

When you push the button, the flash pops up and fires on your next shot. Don't want flash? Just close the flash unit. There is no such thing as auto flash in these exposure modes — but don't worry, because using flash (or not) is one picture-taking setting you definitely want to control.

REMEMBER

As explained in the preceding section, your flash results depend in part on the shutter speed. And the range of available shutter speeds for flash photography depends on which of the four exposure modes you use:

- *Food mode and P mode:* The camera selects a shutter speed ranging from 1/60 to 1/200 second.

- *Av mode:* By default, the camera selects a shutter speed ranging from 1/200 to 30 seconds when you use flash in Av mode. However, if you want to avoid the potential problems that can arise with a slow shutter — camera shake and blurred moving subjects — you can bump up the slow limit of this range via Custom Function 3, Flash Sync Speed in Av Mode, shown in Figure 2-17.

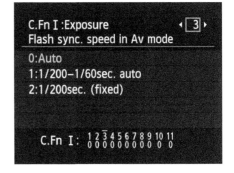

FIGURE 2-17:
You can limit the camera to a fast shutter when using Av mode with flash.

 The default setting — numbered 0 on the menu screen — is Auto, which uses the 1/200-to-30 seconds range. At setting 1, the shutter speed range is 1/200 to 1/60 second; and at setting 2, the camera always sets the shutter speed to 1/200 second.

- *Tv mode:* You can select a shutter speed from 1/200 to 30 seconds. Remember that at slow shutter speeds, you need to use a tripod and tell your subject to remain still to avoid a blurry photo.

- *M mode:* You can access the same range as in Tv mode, but with one additional setting available: Bulb, which keeps the shutter open as long as you keep the shutter button pressed, however. By default, the flash fires at

the beginning of the exposure. You also can choose to have the flash fire at the beginning and end of the exposure or, if you attach an external flash, at the end of the exposure only. Control this aspect of the flash through the Shutter Sync setting, which I explain in the last section of this chapter.

Using Red-Eye Reduction flash

Red-eye is caused when flash light bounces off a subject's retinas and is reflected back to the camera lens. Red-eye is a human phenomenon, though; with animals, the reflected light usually glows yellow, white, or green.

Man or beast, this issue isn't nearly the problem with the flash on your T7/2000D as it is on point-and-shoot compact cameras and smartphone cameras. (The difference has to do with the positioning of the flash with respect to the lens.) However, red-eye may still be an issue when you use a lens with a long focal length (a telephoto lens), you shoot subjects from a distance, or the ambient lighting is very dim.

If you notice red-eye, try enabling Red-Eye Reduction flash. When you turn on this feature, the Red-Eye Reduction Lamp on the front of the camera lights up when you press the shutter button halfway and focus is achieved. The purpose of this light is to shrink the subject's pupils, which helps reduce the amount of light that enters the eye and, thus, the chances of that light reflecting and causing red-eye. The flash itself fires when you press the shutter button the rest of the way. (Warn your subjects to wait for the flash, or they may stop posing after they see the light from the Red-Eye Reduction Lamp.)

You can enable this feature in any exposure mode that permits flash. The control lives on Shooting Menu 1, as shown in Figure 2-18. Note that the camera doesn't display any symbols in the viewfinder or on the Shooting Settings or Live View displays to remind you that Red-Eye Reduction mode is in force.

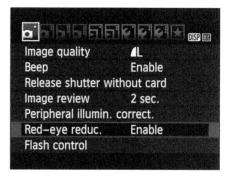

TIP

After you press the shutter button halfway in Red-Eye Reduction flash mode, a row of vertical bars appears in the bottom of the viewfinder display,

FIGURE 2-18:
Turn Red-Eye Reduction flash mode on and off via Shooting Menu 1.

replacing the exposure index. The bars quickly turn off from the outside and work their way toward the center. For best results, wait until all the bars are off to take

the picture. (The delay gives the subject's pupils time to constrict in response to the Red-Eye Reduction Lamp.) This feature isn't available in Live View mode; it only works when you use the viewfinder to compose your photos.

Exploring advanced flash features (P, Tv, Av, and M modes)

When you shoot in the P, Tv, Av, and M exposure modes, you have access to flash features not available in other modes. You can adjust the flash power, tell the camera to stick with the same flash output for a series of shots, and tweak a few other aspects of flash performance, as outlined in the rest of this chapter.

Adjusting flash power with Flash Exposure Compensation

TIP

On some occasions, you may want a little more or less light than the camera thinks is appropriate. If so, you can adjust the flash output by using *Flash Exposure Compensation.*

Flash Exposure Compensation settings are stated in terms of *exposure value (EV)* numbers. A setting of EV 0.0 indicates no flash adjustment; you can increase the flash power to EV +2.0 or decrease it to EV −2.0.

Figure 2-19 shows an example of the benefit of this feature. The left image shows you a flash-free shot. Clearly, a little more light was needed, but at normal flash power, the flash was too strong, blowing out the highlights in some areas, as shown in the middle image. Reducing the flash power to EV −1.3, resulted in a softer flash that straddled the line perfectly between no flash and too much flash.

No flash	Flash EV 0.0	Flash EV -1.3

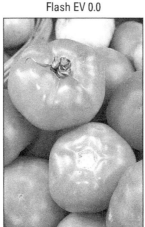
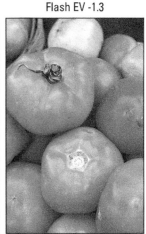

FIGURE 2-19: When normal flash output is too strong, lower the Flash Exposure Compensation value.

As for boosting the flash output, well, you may find it necessary on some occasions, but don't expect the built-in flash to work miracles even at a Flash Exposure Compensation of +2.0. Any built-in flash has a limited range, so the light simply can't reach faraway objects.

Here are the ways you can adjust flash power:

>> **Quick Control screen (not available in Live View mode):** This path is by far the easiest way to travel. After shifting to the Quick Control display, highlight the Flash Exposure Compensation value, as shown on the left in Figure 2-20. (Note that this value does not appear until you activate the Quick Control screen unless you already dialed in Flash Exposure Compensation.)

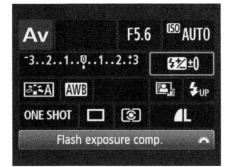
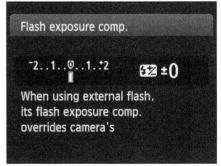

FIGURE 2-20:
The quickest way to adjust flash power is via the Quick Control screen.

Rotate the Main dial to raise or lower the amount of flash adjustment. Or press Set to display the second screen in the figure, which contains a meter along with a text note that tells you that if you use an external flash, any compensation you dial in via the flash itself overrides the on-camera setting. Press the right/left cross keys to adjust the flash power on this screen. Press Set when you finish.

>> **Shooting Menu 1:** On Shooting Menu 1, select Flash Control. On the resulting menu, shown on the left in Figure 2-21, make sure that the first option, Flash Firing, is enabled. Then choose Built-in Flash Func Setting, as shown in the figure, and press Set to display the right screen. Highlight Flash Exp Comp and press Set to activate the control. Then use the left/right cross keys to adjust the value. Press Set when you finish.

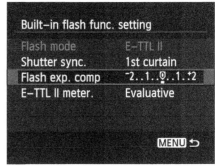

FIGURE 2-21:
You can also
change flash
power by using
the menus, but
it's a tedious
task.

TIP

You also have the option of customizing the Set button to whisk you directly to the Flash Exposure Compensation setting. You make this change via Custom Function 9. (Chapter 11 shows you how.) If you use Live View and flash compensation a lot, this tweak can save you loads of time because you no longer have to wade through Shooting Menu 1 to adjust the flash compensation setting.

When Flash Exposure Compensation is in effect, the value appears in the Shooting Settings screen and Live View display, as shown in Figure 2-22. In the viewfinder, you see a plus/minus flash symbol without the actual Flash Exposure Compensation value. If you change the Flash Exposure Compensation value to zero, the flash-power icon disappears from all the displays.

Flash Compensation setting

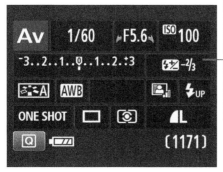

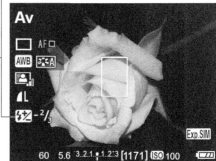

FIGURE 2-22:
When Flash
Exposure
Compensation
is enabled, the
value appears
onscreen
during Live
View shooting.

WARNING

Any flash-power adjustment you make remains in force until you reset the control, even if you turn off the camera. So be sure to check the setting before using your flash. Additionally, the Auto Lighting Optimizer feature, covered in Chapter 4, can interfere with the effect produced by Flash Exposure Compensation, so you might want to disable it.

Locking the flash exposure

You might never notice it, but when you press the shutter button to take a picture with flash enabled, the camera emits a brief *preflash* before the actual flash. This preflash is used to determine the proper flash power needed to expose the image.

TIP

Occasionally, the information that the camera collects from the preflash can be off-target because of the assumptions the system makes about what area of the frame is likely to contain your subject. To address this problem, your camera has a feature called *Flash Exposure Lock*, or FE Lock. This tool enables you to set the flash power based on only the center of the frame.

REMEMBER

Unfortunately, FE Lock isn't available in Live View mode. If you want to use this feature, you must abandon Live View and use the viewfinder to frame your images.

The following steps show you how to lock flash exposure. Before you start, take a second to locate the AE Lock button, shown in the margin here. (Look for the button on the top-right corner of the camera back.) Rest your thumb on the button — don't press it yet — and then take these steps:

1. **With the flash raised, frame your photo so that your subject falls under the center autofocus point.**

Don't worry if you don't want the subject to be in the center of the final image; you can reframe the shot after locking the flash exposure, if needed.

2. **Press the shutter button halfway.**

The camera meters the light in the scene. If you're using autofocusing, the autofocus system goes to work, too, but ignore this function for now. You can set the final focusing distance after establishing the flash exposure.

3. **Release the shutter button and then press the AE Lock button.**

The camera emits the preflash, and the letters FEL display for a second in the viewfinder. (FEL stands for *flash exposure lock.*) You also see the asterisk symbol — the one that appears above the AE Lock button on the camera body — next to the flash icon in the viewfinder.

The flash setting will remain in force for about 16 seconds.

4. **If needed, reframe the shot to your desired composition.**

5. **Set focus.**

In autofocus mode, press and hold the shutter button halfway. In manual focus mode, rotate the focusing ring on the lens to establish focus.

6. **Press the shutter button the rest of the way to take the picture.**

The image is captured using the flash output setting you established in Step 3.

Flash exposure lock is also helpful when you're shooting portraits. The preflash sometimes causes people to blink, which means that with normal flash shooting, in which the actual flash and exposure occur immediately after the preflash, their eyes are closed at the exact moment of the exposure. With flash exposure lock, you can fire the preflash and then wait a second or two for the subject's eyes to recover before you take the actual picture. And because the flash exposure setting remains in force for about 16 seconds, you can shoot several images using the same flash setting without firing another preflash at all. (The flash needs time to recycle between shots, however, so the number of images you can take in that 16 seconds varies.)

USING FLASH OUTDOORS

Although most people think of flash as a tool for nighttime and low-light photography, adding a bit of light from the built-in flash can improve close-ups and portraits that you shoot outdoors during the day. Suppose that it's around noon, which means that your main light source — the sun — is overhead. Although the top of the subject may be adequately lit, the front typically needs some additional illumination. And when your subject is backlit — that is, the light is hitting them from behind — flash is essential to properly exposing the subject. Without flash, the camera almost always underexposes the front of the subject because it takes all the bright background lighting into consideration when calculating exposure. Chapter 4 explains how you can modify the way exposure is calculated (see the section related to metering mode), but using flash is usually easier.

Do be aware of a couple issues that arise when you supplement the sun with the built-in flash, however:

- **You may need to make a white balance adjustment.** Adding flash may result in colors that are slightly warmer (more yellow/red), or cooler (bluish) because the camera's white balancing system can get tripped up by mixed light sources. If you don't appreciate the shift in colors, see Chapter 6 to find out how to make a white balance adjustment to solve the problem.

- **You may need to stop down the aperture or lower ISO to avoid overexposing the photo.** When you use flash, the fastest shutter speed you can use is 1/200 second, which may not be fast enough to produce a good exposure in very bright light when you use a wide-open aperture, even if you use the lowest possible ISO setting. If you want both flash *and* the short depth of field that comes with an open aperture, you can place a neutral density filter over your lens. This accessory reduces the light that comes through the lens without affecting colors. In addition, some Canon external flash units enable you to access the entire range of shutter speeds on the camera.

Investigating the other Shooting Menu flash options

In the P, Tv, Av, and M modes, selecting the Flash Control option on Shooting Menu 1 brings up the screen shown in Figure 2-23. From here, you can access the following flash settings:

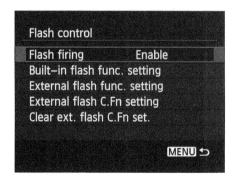

>> **Flash Firing:** Normally, this option is set to Enable. If you want to disable the flash, you can choose Disable. However, you don't have to take this step in most cases — just close the pop-up flash head on top of the camera if you don't want to use flash.

FIGURE 2-23:
From Shooting Menu 1, choose Flash Control to access this screen, which enables you to customize additional flash options.

What's the point of this option, then? Well, if you use autofocusing in dim lighting, the camera may need some help finding its target. To that end, it sometimes emits an *AF-assist beam* from the flash head — the beam is a series of rapid pulses of light. If you want the benefit of the AF-assist beam but you don't want the flash to fire, you can disable flash firing. Remember that you have to pop up the flash unit to expose the lamp that emits the beam. You also can take advantage of this option when you attach an external flash head.

>> **Built-In Flash Function Setting:** Highlight this option and press Set to display the screen shown in Figure 2-24, which offers the following options related to the built-in flash:

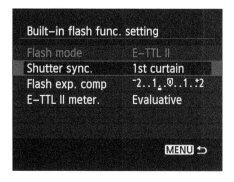

- *Flash Mode:* Ignore this option. It's related to using an external flash and isn't adjustable when you use the built-in flash. (Don't ask me why it's on the menu; Canon never consults with me on this stuff.)

FIGURE 2-24:
These advanced flash options affect only the built-in flash.

- *Shutter Sync:* By default, the flash fires at the beginning of the exposure. This flash timing, known as *1st curtain sync,* is the best choice for most subjects. However, if you use a very slow shutter speed and you're photographing a moving object, 1st curtain

sync causes the blur that results from the motion to appear in front of the object, which doesn't make much visual sense.

To solve this problem, you can change the Shutter Sync option to *2nd curtain sync,* also known as *rear-curtain sync.* In this Flash mode, the motion trails appear behind the moving object. The flash fires twice in this mode: once when you press the shutter button and again at the end of the exposure.

- *Flash Exposure Compensation:* This setting adjusts the power of the built-in flash; see the earlier section "Adjusting flash power with Flash Exposure Compensation" for details. (This menu option is the only way to adjust flash power for Live View shooting.)

- *E-TTL II Metering:* Your camera uses a flash-metering system that Canon calls E-TTL II. The *E* stands for *evaluative, TTL* stands for *through the lens,* and *II* refers to the fact that this system is an update to the first version of the system.

 This menu option enables you to choose from two flash metering setups. In the default mode, Evaluative, the camera exposes the background using ambient light when possible and then sets the flash power to serve as fill light on the subject. If you instead select the Average option, the flash is used as the primary light source, meaning that the flash power is set to expose the entire scene without relying on ambient light. Typically, this results in a more powerful (and possibly harsh) flash lighting and dark backgrounds.

» **External Flash controls:** The last three options on the Flash Control sub-menu (refer to Figure 2-23) relate to external flash heads; they don't affect the performance of the built-in flash. However, they apply only to Canon EX-series Speedlites that enable you to control the flash through the camera. If you own such a flash, refer to the flash manual for details.

Chapter **3**

Taking Great Pictures, Automatically

Your camera is loaded with features for the advanced photographer, enabling you to exert precise control over exposure, focusing, and much more. But you don't have to wait until you understand all those options to take great pictures because your camera also offers exposure modes that provide point-and-shoot simplicity. This chapter shows you how to get the best results in those modes, including Scene Intelligent Auto, Flash Off, the six Image Zone (scene) modes, and Creative Auto.

Shooting in Auto and Flash Off Modes

For the simplest camera operation, set the camera to Scene Intelligent Auto mode, as shown in Figure 3-1. Or, if you're shooting in an environment that doesn't permit flash, choose Flash Off, represented by the symbol labeled in the figure. This mode works the same as Scene Intelligent Auto but, as its name promises, prevents the flash from firing.

TECHNICAL STUFF

The name Scene Intelligent Auto stems from the fact the camera uses its digital brain to analyze the scene — it's an intelligent camera, see — and then selects the most appropriate settings for that scene.

Although the camera handles most picture-taking chores for you in both modes, you need to consider a few settings, starting with whether you want to use the viewfinder to compose the photo or enable Live View, which sends a live preview of the subject to the camera monitor. Your choice makes a difference in how the camera's autofocusing system works and, therefore, how you take the picture. The next section shows you how things work for viewfinder photography; following that, I show you how to take a picture in Live View mode.

Flash Off

Scene Intelligent Auto

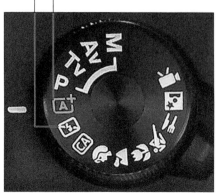

FIGURE 3-1:
Set the Mode dial to Scene Intelligent Auto or Auto Flash Off for point-and-shoot simplicity.

REMEMBER

Both sets of instructions assume that you're using the camera's default settings. To restore the defaults, set the Mode dial to P, Tv, Av, or M and then choose Clear Settings from Setup Menu 3. (You can't access this menu option in any of the point-and-shoot modes.)

Viewfinder photography in Scene Intelligent Auto and Flash Off modes

The following steps show you how to take a picture using Scene Intelligent Auto or Flash Off exposure modes, relying on the default camera settings and auto-focusing. If your lens doesn't autofocus with the T7/2000D, ignore the focusing instructions and focus manually.

1. **Set the Mode dial to Scene Intelligent Auto (refer to Figure 3-1).**

 Or, for flash-free photography, select the Flash Off mode.

2. **Set the lens focusing method to autofocusing.**

 On the 18–55mm kit lens, set the switch to AF.

3. **Looking through the viewfinder, frame the image so that your subject appears under an autofocus point.**

 The *autofocus points* are the nine rectangles scattered around the viewfinder frame, as shown in Figure 3-2.

Center autofocus point

TIP

Framing your subject so that it falls under the center autofocus point (labeled in the figure) typically produces the fastest and most accurate autofocusing.

4. **Press and hold the shutter button halfway down.**

 The camera's autofocus and autoexposure meters begin to do their thing. In Auto exposure mode, the flash pops up if the camera thinks additional light is needed. Additionally, the flash may emit an *AF-assist beam,* a few rapid pulses of light designed to help the autofocusing mechanism find its target.

 When the camera establishes focus, one or more of the autofocus points blink red to indicate which areas of the frame are in focus. In Figure 3-3, for example, the focus points on the horse's face are lit.

 In most cases, you also hear a tiny beep, and the focus indicator in the viewfinder lights, as shown in Figure 3-3. Focus is locked as long as you keep the shutter button halfway down.

REMEMBER

If the camera senses motion in front of the lens, however, you may hear a series of small beeps, and the viewfinder's focus lamp may not light. Both signals mean that the camera switched to continuous autofocusing, which adjusts focus as necessary up to the time you take the picture. Your only job in this scenario is to keep the subject framed within the area covered by the autofocus points.

Selected focus point

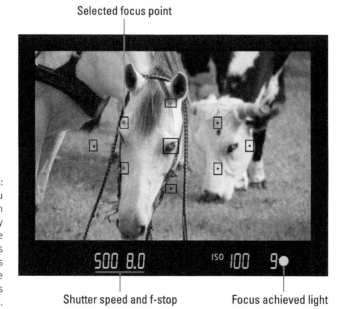

FIGURE 3-3:
When you
photograph
stationary
subjects, the
green focus
indicator lights
when the
camera locks
focus.

Shutter speed and f-stop Focus achieved light

5. **Press the shutter button the rest of the way down to take the photo.**

 When the recording process is finished, the picture appears briefly on the camera monitor. If the picture doesn't appear or you want to take a longer look at the image, see Chapter 9, which covers picture playback.

A few more pointers about shooting in Scene Intelligent Auto and Flash Off modes:

WARNING

» **Exposure:** After the camera meters exposure, it displays its chosen exposure settings at the bottom of the viewfinder, as shown in Figure 3-3. You can ignore all this data except for the shutter speed value, labeled in the figure. In dim lighting, that value may blink, which is the camera's way of alerting you that the shutter speed may be slow enough that handholding the camera is risky. Any movement of the camera during the exposure can blur the image, so when you see the blinking shutter speed, use a tripod. Typically, this issue arises only when you use Flash Off mode in dim lighting. In Scene Intelligent Auto mode, the camera's flash provides sufficient light to keep the shutter speed fast enough that most people can handhold the camera (although it never hurts to use a tripod just in case). Turning on Image Stabilization, which compensates for minor camera shake, also helps. On the kit lens, set the Stabilizer switch to the On position to take advantage of this feature. Keep in mind that if your subject moves during a long exposure, it may appear blurry regardless of whether you use a tripod.

Additionally, dim lighting may force the camera to use a high ISO setting, which increases the camera's sensitivity to light. Unfortunately, a high ISO can create *noise,* a defect that makes your picture look grainy.

See Chapter 4 to get a better understanding of shutter speed and ISO.

>> **Drive mode:** By default, the camera uses the Single mode, which means you get one picture for each press of the shutter button. Your other choices are to use either the standard Self-Timer mode (10-second delay) or the continuous Self-Timer mode (record up to nine frames with each press of the shutter button). To change the setting, press the left cross key or use the Quick Control screen, as outlined in Chapter 2.

>> **Flash:** The built-in flash has a relatively short reach, so if the flash fires but your picture is still too dark, move closer to the subject. In Scene Intelligent Auto mode, you can set the flash to the Red-Eye Reduction mode (the control lives on Shooting Menu 1), but you can't disable flash. To go flash free, you have to set the Mode dial to the Flash Off setting.

Live View photography in Scene Intelligent Auto and Flash Off modes

Follow these steps to take a picture in Live View mode using autofocusing and the default settings for Scene Intelligent Auto and Auto Flash Off modes:

1. **Set the Mode dial to Scene Intelligent Auto or Flash Off.**

 Refer to Figure 3-1 if you need help locating the symbols that represent these shooting modes.

2. **Set the lens focusing method to autofocusing.**

 On the 18–55mm kit lens, set the switch to AF.

3. **Press the Live View button to engage Live View.**

 The viewfinder goes to sleep, and the scene in front of the lens appears on the monitor. What data you see superimposed on top of the scene depends on your display mode; press DISP to cycle through the available displays.

 If you press the Live View button and nothing happens, Live View may be disabled. To turn it back on, press the Menu button, pull up Shooting Menu 4, and set the Live View Shooting option to Enable.

4. **Focus.**

 By default, the camera uses a Live View autofocusing option called FlexiZone-Single. In this mode, you use the cross keys to move the focus frame, labeled in

Figure 3-4, over your subject. Then press the shutter button halfway and hold it there to initiate autofocusing. When focus is achieved, the focus frame turns green and the camera beeps, signifying that you're ready to shoot.

For details on other Live View focusing options, see Chapter 5.

5. **Press the shutter button fully to take the shot.**

You see your just-captured image on the monitor for a few seconds before the Live View preview returns.

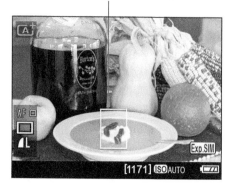

FlexiZone-Single focus frame

FIGURE 3-4:
Move the focus frame over your subject and press the shutter button halfway to focus.

6. **To exit the Live View preview, press the Live View button.**

You can then return to framing your images through the viewfinder.

For tips on exposure, Drive mode, and flash, see the end of the preceding section. All the notes provided there for viewfinder photography apply to Live View photography as well.

Exploring Image Zone (Scene) Modes

In addition to Auto and Auto Flash Off modes, the T7/2000D offers several *Image Zone modes*, labeled in Figure 3-5. Each mode is designed to make it easy to capture a specific type of scene, which is why such modes are known generically as *scene modes.*

The following list describes each scene mode. But before you dig in, understand that whether any scene mode can produce the results it promises depends on many factors, including the ambient light and your lens capabilities. In other words, your mileage may vary.

>> **Portrait:** Select this mode to create the classic portraiture look, with a sharply focused subject and a blurred background, as illustrated in Figure 3-6. Portrait mode also warms colors (makes them a little more red) and reduces skin texture slightly, the idea being to create a more flattering rendition of your subject.

>> **Landscape mode:** This mode produces traditional landscape characteristics, with sharp focus maintained over a long distance from the camera lens, as shown in Figure 3-7. (I set focus on the rocks in the foreground for this shot.) Landscape mode also increases contrast and color saturation, with blues and greens appearing especially vibrant. Flash is disabled.

>> **Close-up mode:** Switching to Close-up mode doesn't enable you to focus at a closer distance to your subject than normal, as it does on some non-SLR cameras. The close-focusing capabilities of your camera depend entirely on the lens you use. (Your lens manual should specify the minimum focusing distance.)

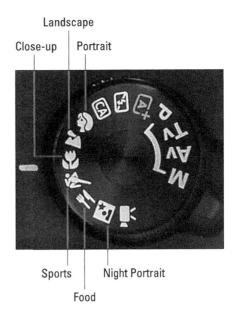

FIGURE 3-5:
These symbols represent other easy-to-use shooting modes.

FIGURE 3-6:
Portrait setting produces a softly focused background.

Instead, Close-up mode, like Portrait mode, is designed to blur background objects so that they don't compete for attention with your main subject. I used Close-up mode to capture the orchid in Figure 3-8, for example. But in

Close-up mode, the camera doesn't play with color, sharpness, or contrast as it does in Portrait and Landscape modes. So in that regard, Close-up mode is the same as Scene Intelligent Auto.

 » **Sports mode:** Sports mode is designed for capturing moving subjects without blur, as in Figure 3-9. Colors, sharpness, and contrast are all standard in Sports mode, with none of the adjustments that occur in Portrait and Landscape modes.

In dim lighting, your subjects may appear blurred even in Sports mode. The problem is that the lack of light requires a slow shutter speed, and you need a fast shutter speed to capture motion without blur. Unfortunately, you can't add light by using the camera's built-in flash; it's disabled in Sports mode.

FIGURE 3-7:
Landscape mode produces a large zone of sharp focus.

 » **Food mode:** The goal of this mode is to tweak color and exposure in a way that makes food more appetizing — at least, in a way that Canon thinks makes food look better to most people. Specifically, if you shoot the picture in incandescent lighting, which emits reddish light, the camera tweaks colors to tone down those warm hues. Exposure is also increased just a hair to make everything a little brighter.

 » **Night Portrait:** As its name implies, Night Portrait mode is designed to deliver a better-looking portrait at night, which it attempts by combining flash with a slow shutter speed. The longer exposure time enables the camera to rely more on ambient light and less on the flash to expose the picture. The result is a brighter background and softer, more even lighting. If you can keep your subject and the camera perfectly still during the exposure, Night Portrait mode works great. Otherwise, either the subject or the entire picture may blur.

FIGURE 3-8:
Close-up mode also produces short depth of field.

Night Portrait mode also differs from regular Portrait mode in that it renders the scene in the same way as Scene Intelligent Auto in terms of colors, contrast, and sharpness.

Taking pictures in scene modes

The process of taking a picture in one of the scene modes is pretty much the same as for Auto and Flash Off modes, detailed earlier in this chapter. But there are a few variations to understand:

FIGURE 3-9:
To capture moving subjects and minimize blur, try Sports mode.

>> **Autofocusing in Sports mode:** In Sports mode, the camera sets initial focus on the object at the center of the frame when you press the shutter button halfway. However, if the subject moves from that spot, autofocus is adjusted as needed until the time you press the shutter button the rest of the way to take the shot.

WARNING

This continuous autofocusing is *not* available if you shoot in Live View mode. So use the viewfinder when photographing in Sports mode.

>> **Autofocusing in other scene modes:** Autofocusing behavior depends on whether you use the viewfinder or Live View to shoot the picture:

- *Viewfinder photography:* When you press the shutter button halfway, focus is locked. The camera decides which of the nine focus points to use to set the focusing distance (usually choosing the one that falls over the object closest to the lens).

- *Live View photography:* By default, the camera uses the AF FlexiZone-Single autofocusing option, which requires you to use the cross keys to position the focus frame over your subject. You can choose either of the two other Live View autofocusing options, which I cover in Chapter 5. Use the Quick Control screen to change the setting.

>> **Changing the Drive mode:** Detailed in Chapter 2, this setting determines when and how the shutter releases after you press the shutter button. Here are the default settings used for the scene modes:

- *Landscape, Close-up, Food, Night Portrait:* The Drive mode is set to Single, which means that you get one frame each time you press the shutter button.

- *Portrait, Sports:* The default Drive mode is Continuous, which means that the camera records a series of images in rapid succession as long as you hold down the shutter button.

All the scene modes enable you to switch to the normal Self-Timer mode, which delays the shutter release for 10 seconds after you press the shutter button. You also can choose the continuous Self-Timer mode, which also has a 10-second delay but enables you to capture up to nine frames each time you press the shutter button. The 2-second Self-Timer mode is off-limits.

The fastest way to adjust the Drive mode setting during viewfinder photography is to press the left cross key, but you can also adjust it via the Quick Control screen. (You must use the Quick Control method in Live View mode.)

» **Using flash:** Flash is disabled in Landscape and Sports modes. In Food mode, flash is turned off by default, but you can enable it via the Quick Control screen. (Note that using flash in Food mode may eliminate the color and brightness adjustments that normally happen in that mode.)

In Portrait, Close-up, and Night Portrait modes, flash is set to automatic firing; the camera raises and fires the built-in flash when the ambient light is insufficient to expose the picture. For modes that allow flash, you can turn on Red-Eye Reduction via Shooting Menu 1.

Modifying scene mode results

When you rely on the scene modes, you don't have much control over the final look of your picture. But you can make small adjustments to color, sharpness, contrast, and exposure. The next three sections tell all.

Taking a look at the Ambience option

In all the scene modes, you can modify the results of your next shot via the Ambience setting. The upcoming section "Adjusting the ambience and color settings" explains how to access the Ambience feature. First, here's a look at what the various Ambience options accomplish:

» **Standard:** Consider this the "off" setting. When you select this option, the camera makes no adjustment to the characteristics normally produced by your selected scene mode.

» **Vivid:** Increases contrast, color saturation, and sharpness.

» **Soft:** Creates the appearance of slightly softer focus.

» **Warm:** Warms (adds a reddish-orange color cast) and softens.

>> **Intense:** Boosts contrast and saturation (color intensity) even more than the Vivid setting.

>> **Cool:** Adds a cool (blue) color cast.

>> **Brighter:** Lightens the photo.

>> **Darker:** Darkens the photo.

>> **Monochrome:** Creates a black-and-white photo, with an optional color tint.

Unfortunately, only one setting can be in force at a time. You can't ask for both a more vivid photo and a warmer photo, for example.

REMEMBER

Also note that all adjustments are applied *in addition* to whatever adjustments occur by virtue of your selected scene mode. For example, Landscape mode already produces slightly sharper, more vivid colors than normal. If you add the Vivid ambience option, you amp things up another notch.

You can control the amount of the adjustment, however, through a related setting, Effect. You can choose from three Effect levels. The level name and its effect depend on the adjustment you choose. Most Effects have Low, Standard, and Strong settings. Darker and Lighter have Low, Medium, and High settings. In the case of the Monochrome setting, the Effect setting enables you to switch from a black-and-white image to a monochrome image with a warm (sepia) or cool (blue) tint.

As a quick example of the results you can achieve, Figure 3-10 shows the same subject shot at four Ambience settings. I took all pictures in the Landscape scene mode. For the three variations — Vivid, Warm, and Intense — I applied the maximum level of adjustment, setting the Effect option to Strong.

TIP

If you're more concerned with exposure than color, check out the Brighter and Darker settings, which give you a way to overrule the camera's exposure decisions. For example, in the left image in Figure 3-11, the exposure of the background was fine, but the flower was overexposed. So I set the Ambience option to Darker, set the Effect option to Medium, and shot the flower again.

Eliminating color casts

Normally, the camera renders colors accurately through its automatic white-balancing system, which compensates for any color added to a scene by the light source. For example, incandescent lights infuse a scene with a warm tint, which is neutralized by the white-balancing system. (Chapter 6 explains white balance in detail.)

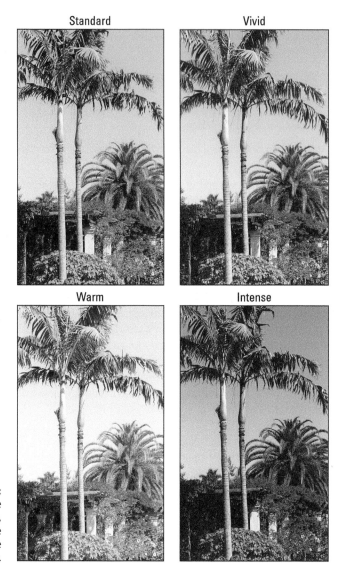

Standard Vivid

Warm Intense

FIGURE 3-10:
To create these variations, I used the Ambience setting.

When a scene is lit by two or more light sources, though, the camera can get confused, creating a photo that has an unnatural color tint. In that event, you may be able to fix things through the following options:

>> **Light/Scene Type:** Available in Portrait, Landscape, Sports, and Close-up scene modes, this option enables you to tell the camera to compensate for a particular light source or, for outdoor shots, the lighting conditions. Your choices include Default (no adjustment), Daylight, Shade, Cloudy, and Sunset. For Portrait, Sports, and Close-up modes, you also can choose Fluorescent

Light and Tungsten Light (select this setting for incandescent bulbs as well as tungsten bulbs).

>> **Color Tone (Food mode only):** When you use the Food scene mode, you lose access to the Light/Scene Type option. In its place, you get a Color Tone slider that enables you to make colors warmer (more red) or cooler (more blue).

Standard Darker

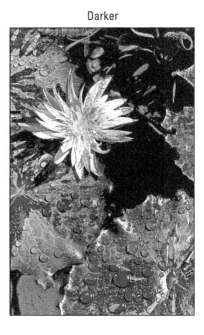

FIGURE 3-11:
If the initial exposure leaves your subject too bright, choose the Darker setting and reshoot.

Adjusting the Ambience and Light/Scene Type settings

The options described in the preceding two sections determine your final photo colors and exposure when you shoot in the scene modes. So being able to preview the possible combinations of settings without having to take a bunch of shots to experiment would be great, yes?

Luckily, you can enjoy that advantage in Live View mode. As you vary the available settings, the Live View display updates to show you how the subject will be rendered. (Note that the Live View preview isn't always 100-percent accurate, especially in terms of image brightness, but it's fairly close.) After you choose the settings you want to use, you can exit Live View mode and take the picture using the viewfinder if you want.

The following steps provide an overview of this process. Note that when you shoot in a scene mode that offers both Ambience and Lighting/Scene Type adjustments (that is, Portrait, Landscape, Sports, and Close-up modes), Canon recommends that you tackle the Lighting/Scene type setting first, so that's the approach I take in the steps.

1. **Set the Mode dial to Close-up mode.**

 More about how things work in the other scene modes later; for now, stick with Close-up.

2. **Press the Live View button to shift to Live View mode.**

3. **Press the Q button to shift to the Quick Control display.**

4. **Select the Light or Scene Type option, as shown on the left in Figure 3-12.**

 Remember that this setting is available only in Close-up, Portrait, Sports, and Landscape modes. Assuming that you're using one of those modes, the name of the current setting is shown on the left side of the screen. For example, in the first screen in Figure 3-12, the Default setting is selected. The text at the bottom of the screen reminds you that you're adjusting the light/scene type setting.

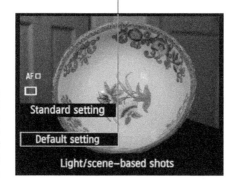
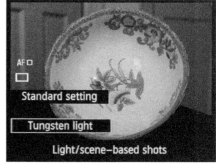

FIGURE 3-12: This control enables you to adjust the Lighting or Scene Type setting.

5. **Rotate the Main dial to cycle through the settings.**

TIP

 Depending on the lighting conditions, you may not see significant changes for some settings. In the example, the Default setting added a slight warm color cast, which I eliminated by shifting to the Tungsten Light option. If your subject is lit by multiple light sources, choose the most prominent one or just keep experimenting until colors look the most accurate.

6. **Press the up or down cross key to select the Ambience option, labeled in Figure 3-13.**

By default, the Standard setting is used.

7. **Rotate the Main dial to change the setting.**

As soon as you rotate the dial, you see the impact of the newly selected ambience setting on the scene. For example, on the left side of Figure 3-14, the preview shows the result of changing from the Standard setting to the Vivid setting. In addition, the Effect setting, which determines the level at which the adjustment is applied, becomes available. I labeled this option on the right side of Figure 3-14.

Ambience setting

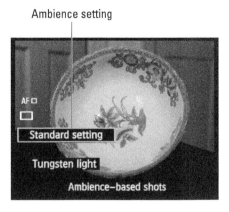

FIGURE 3-13:
After highlighting the Ambience option, rotate the Main dial to change the setting and display the Effect control.

Ambience setting Effect setting

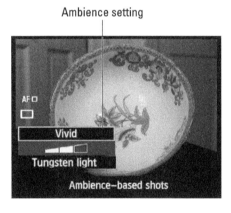
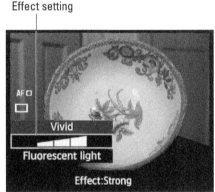

FIGURE 3-14:
Use the Quick Control screen to access the Ambience setting, too.

8. **Use the cross keys to select the Effect setting and rotate the Main dial or press the left/right cross keys to set the level of the adjustment.**

The Effect display indicates the adjustment level. For example, in the left screen in Figure 3-14, the Effect level is Standard; on the right, I raised the setting to Strong (three notches).

9. **Exit the Quick Control screen by pressing the Q button.**

You're now ready to take the picture. Again, you can exit Live View mode if you prefer; the settings you just dialed in stay in force for both Live View and viewfinder shooting until you change them.

Now for the promised details about adjusting these settings in modes other than Close-up:

>> **Portrait, Landscape, and Sports:** Things work just as they do for Close-up mode (described in the preceding steps). However, Landscape does not offer the Fluorescent and Tungsten options for the Lighting or Scene Type setting.

>> **Night Portrait and Food:** You lose access to the Lighting or Scene Type option. In Food mode, however, you can adjust colors through the Color Tone option, as outlined in the preceding section. Use the cross keys to select that option and then press the right and left cross keys or rotate the Main dial to move the slider toward the blue or red side of the color bar, depending on whether you want colors cooler or warmer.

TIP

If you already know what settings you want to use, you can get the job done more quickly by staying out of Live View mode and just using the Quick Control screen to adjust the options. The left screen in Figure 3-15 shows you where to look for the Ambience and Lighting or Scene Type options. Again, the latter is not available in Night Portrait mode, and in Food mode, it's replaced by the Color Tone option, shown on the right in the figure.

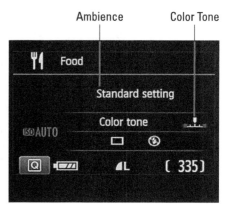

FIGURE 3-15:
When you're
not using
Live View,
the selected
scene-mode
adjustments
appear as
shown here.

For the Ambience and Lighting or Scene Type options, you also can highlight the option on the Quick Control screen and then press Set to display a list of all the available settings. After highlighting the setting you want to use, press Set to return to the Quick Control screen.

Gaining More Control with Creative Auto

 Creative Auto mode, represented on the Mode dial by the letters CA, offers a bit more control over the look of your pictures than is possible in the scene modes or Auto and Flash Off modes. If you check the monitor after taking a shot and don't like the results, you can make the following adjustments for your next shot:

>> Adjust color, sharpness, contrast, and exposure through the Ambience option, as explained in the preceding sections.

>> Enable or disable the flash.

>> Use the Background Blur setting to manipulate *depth of field,* or the distance over which focus appears acceptably sharp.

Figure 3-16 shows you where to look for the relevant controls in the Shooting Settings and Live View displays. You adjust all the settings via the Quick Control screen.

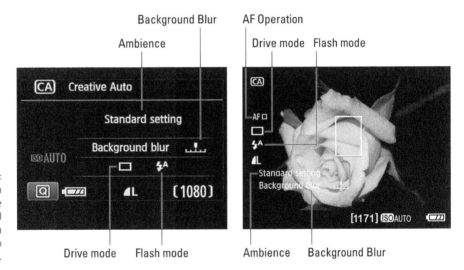

FIGURE 3-16: You can adjust these additional settings in Creative Auto mode.

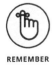 The settings you choose remain in effect from shot to shot. If you turn the camera off or switch to a different exposure mode, though, the settings return to their defaults.

REMEMBER

Here's what you need to know about each option:

>> **Ambience:** This setting enables you to alter how the camera processes the photo, enabling you to tweak color, contrast, and exposure slightly. The earlier section "Taking a look at Ambience options" explains this feature.

>> **Flash:** You can choose from three flash settings:

- *Auto:* The camera fires the flash automatically if it thinks extra light is needed to expose the picture.

- *On:* The flash fires regardless of the ambient light.

- *Off:* The flash doesn't fire.

For the Auto and On settings, you can use the Red-Eye Reduction flash feature, found on Shooting Menu 1. See Chapter 2 for more information about flash photography.

>> **Background Blur:** This feature is somewhat mislabeled. You can blur the background by adjusting the setting, but any objects in front of your subject may also become blurry. So apply this feature with caution and do some test shots to find the right amount of blurring.

WARNING

Unfortunately, this feature doesn't play nice with the flash. If you set the flash mode to On, the Background Blur bar becomes dimmed and out of your reach when the flash pops up. Ditto if you set the Flash mode to Auto and the camera sees a need for flash.

Assuming that you can go flash-free, selecting the Background Blur option displays the scale shown on the left in Figure 3-16. Use the Main dial or right/left cross keys to move the indicator to the left to increase blurring; move it to the right for less blurring.

To find out more about manipulating depth of field, see Chapter 5. In the meantime, note these easy ways to tweak this aspect of your photos beyond using the Background Blur slider:

- *For blurrier backgrounds,* move the subject farther from the background, get closer to the subject, and zoom in to a tighter angle of view, if you use a zoom lens.

- *For sharper backgrounds,* do the opposite of the above.

Again, remember that depth of field affects anything in front of your subject as well as objects behind it.

2
Taking Creative Control

Find out how to control exposure and shoot in the advanced exposure modes (P, Tv, Av, and M).

Master the focusing system and discover how to control depth of field.

Manipulate color by using White Balance and other color options.

Get pro tips for shooting portraits, action shots, landscapes, close-ups, and more.

Take advantage of your camera's HD movie-recording features.

Chapter **4**

Taking Charge of Exposure

Understanding exposure is one of the most intimidating challenges for a new photographer — and for good reason. Discussions of the topic are loaded with technical terms — *aperture, metering, shutter speed,* and *ISO,* to name just a few — and your camera offers many exposure controls, all sporting equally foreign names.

I fully relate to the confusion you may be feeling — I've been there. But I can also promise that when you take things nice and slow, digesting a piece of the exposure pie at a time, the topic is not as complicated as it seems on the surface. The payoff will be worth your time, too: You'll not only gain the know-how to solve just about any exposure problem but also discover ways to use exposure to put your creative stamp on a scene.

To that end, this chapter provides everything you need to know about controlling exposure, from a primer in exposure terminology (it's not as bad as it sounds) to tips on using the P, TV, Av, and M exposure modes, which are the only ones that offer access to all exposure features.

Note: The one exposure-related topic not covered in this chapter is flash. I discuss flash in Chapter 2 because it's among the options you can access in all exposure modes, even Scene Intelligent Auto mode. Also, this chapter deals with still photography; see Chapter 8 for information on movie-recording exposure issues.

Introducing the Exposure Trio: Aperture, Shutter Speed, and ISO

Any photograph, whether taken with a film or digital camera, is created by focusing light through a lens onto a light-sensitive recording medium. In a film camera, the film negative serves as the medium; in a digital camera, it's the image sensor, which is a sophisticated electrical component that measures the light in a scene and then passes that information to the camera's data-processing center so that an image can be created. (Yes, a digital camera is essentially a computer with a lens.)

Between the lens and the sensor are two barriers, the *aperture* and *shutter,* which together control how much light makes its way to the sensor. The actual design and arrangement of the aperture, shutter, and sensor vary depending on the camera, but Figure 4-1 offers an illustration of the basic concept.

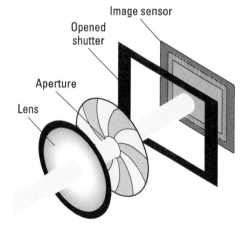

FIGURE 4-1: The aperture size and shutter speed determine how much light strikes the image sensor.

The aperture and shutter, along with a third feature, ISO, determine exposure — what most people would describe as picture brightness. This three-part exposure formula works as follows:

» **Aperture (controls amount of light):** The *aperture* is an adjustable hole in a diaphragm set inside the lens. By changing the size of the aperture, you control the size of the light beam that can enter the camera. Aperture settings are stated as *f-stop numbers,* or simply *f-stops,* and are expressed with the letter *f* followed by a number: f/2, f/5.6, f/16, and so on. The lower the f-stop number, the larger the aperture, as illustrated in Figure 4-2. The range of available aperture settings varies from lens to lens.

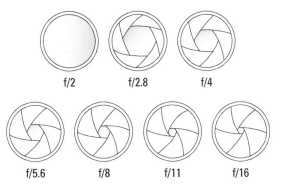

FIGURE 4-2:
The smaller the f-stop number, the larger the aperture.

» **Shutter speed (controls duration of light):** Set behind the aperture, the shutter works something like, er, the shutters on a window. When you aren't taking pictures, the camera's shutter stays closed, preventing light from striking the image sensor. When you press the shutter button, the shutter opens briefly to allow light that passes through the aperture to hit the image sensor. The exception to this scenario is when you compose in Live View mode — the shutter remains open so that your image can form on the sensor and be displayed on the monitor. When you press the shutter release in Live View mode, the shutter first closes and then reopens for the actual exposure.

The length of time that the shutter is open is the *shutter speed* and is measured in seconds: 1/250 second, 1/60 second, 2 seconds, and so on. Shutter speed is also referred to as the *exposure time.*

» **ISO (controls light sensitivity):** ISO, which is a digital function rather than a mechanical structure on the camera, enables you to adjust how responsive the image sensor is to light. The term *ISO* is a holdover from film days, when a photography group called the International Organization for Standards rated each film stock according to light sensitivity: ISO 100, ISO 200, ISO 400, ISO 800, and so on. (No, I don't know why the settings aren't called IOS values instead of ISO, but it turned out to be a good thing because now iOS is used to refer to the Apple operating system.) At any rate, a higher ISO rating means greater light sensitivity.

On a digital camera, the sensor doesn't get more or less sensitive when you change the ISO — rather, the light "signal" that hits the sensor is either amplified or dampened through electronics wizardry, sort of like how raising the volume on a radio boosts the audio signal. But the upshot is the same as changing to a more light-reactive film stock: A higher ISO means that less light is needed to produce the image, enabling you to use a smaller aperture, faster shutter speed, or both.

Distilled to its essence, the image-exposure formula is this simple:

>> Aperture and shutter speed together determine the quantity of light that strikes the image sensor.

>> ISO determines how much the sensor reacts to that light.

The tricky part of the equation is that aperture, shutter speed, and ISO settings affect your pictures in ways that go *beyond* exposure:

>> Aperture affects *depth of field,* or the distance over which focus appears acceptably sharp.

>> Shutter speed determines whether moving objects appear blurry or sharply focused.

>> ISO affects the amount of image *noise,* which is a defect that looks like tiny specks of sand.

You need to be aware of these side effects, explained in the next sections, to determine which combination of the three exposure settings will work best for your picture. If you're already familiar with this stuff and just want to know how to adjust exposure settings, skip ahead to the section "Setting ISO, f-stop, and Shutter Speed."

Aperture affects depth of field

The aperture setting, or f-stop, affects *depth of field,* which refers to how far in front of and behind your point of focus — which, presumably, is your subject — appears acceptably sharp. With a shallow depth of field, your subject appears more sharply focused than background and foreground objects; with a long depth of field, the sharp-focus zone spreads over a greater distance.

When you reduce the aperture size — "stop down the aperture," in photo lingo — by choosing a higher f-stop number, you increase depth of field. As an example, see Figure 4-3. For both shots, I established focus on the fountain statue. Notice

that the background in the first image, taken at f/13, is sharper than in the right example, taken at f/5.6. Aperture is just one contributor to depth of field, however; the focal length of the lens and the distance between that lens and your subject also affect how much of the scene stays in focus. See Chapter 5 for the complete story on depth of field.

f/13, 1/25 second, ISO 200 f/5.6, 1/125 second, ISO 200

FIGURE 4-3: Widening the aperture (choosing a lower f-stop number) decreases depth of field.

TIP

One way to remember the relationship between f-stop and depth of field is to think of the *f* as *focus:* The higher the *f*-stop number, the larger the zone of sharp *focus.* (Please *don't* share this tip with photography elites, who will roll their eyes and inform you that the *f* in *f-stop* most certainly does *not* stand for focus but, rather, for the ratio between aperture size and lens focal length — as if *that's* helpful to know if you aren't an optical engineer. Chapter 1 explains focal length, which *is* helpful to know.)

Shutter speed affects motion blur

At a slow shutter speed, moving objects appear blurry, whereas a fast shutter speed captures motion cleanly. This phenomenon has nothing to do with the actual focus point of the camera but rather on the movement occurring — and being recorded by the camera — while the shutter is open.

Compare the photos in Figure 4-3, for example. The static elements are perfectly focused in both images, although the background in the left photo appears sharper because that image was shot using a higher f-stop, increasing depth of field. But how the camera rendered the moving portion of the scene — the fountain water — was determined by shutter speed. At 1/25 second (left photo), the water blurs, giving it a misty look. At 1/125 second (right photo), the droplets appear more sharply focused, almost frozen in mid-air. How fast a shutter speed you need to freeze action depends on the speed of your subject.

If your picture suffers from overall image blur, like the picture shown in Figure 4-4, where even stationary objects appear out of focus, the camera moved during the exposure — which is always a danger when you handhold the camera at slow shutter speeds. The longer the exposure time, the longer you have to hold the camera still to avoid the blur caused by camera shake.

FIGURE 4-4:
If both stationary and moving objects are blurry, camera shake is the usual cause.

How slow a shutter speed can you use before camera shake becomes a problem? The answer depends on a couple factors, including your physical abilities and lens — the heavier the lens, the harder it is to hold steady. Camera shake also affects your picture more when you shoot with a lens that has a long focal length. You may be able to use a slower shutter speed with a 55mm lens than with a 200mm lens, for example. Finally, it's easier to detect slight blurring in an image that shows a close-up view of a subject than in one that captures a wider area. Moral of the story: Take test shots to determine the slowest shutter speed you can use with each of your lenses.

Of course, to avoid the possibility of camera shake altogether, mount your camera on a tripod. If you must handhold the camera, investigate whether your lens offers *image stabilization,* a feature that helps compensate for small amounts of camera shake. The 18–55mm kit lens does provide that feature; enable it by moving the Stabilizer switch on the lens to the On position.

Freezing action isn't the only way to use shutter speed to creative effect. When shooting waterfalls, for example, many photographers use a slow shutter speed to give the water even more of a blurry, romantic look than you see in the fountain example. With colorful moving subjects, a slow shutter can produce some

cool abstract effects and create a heightened sense of motion. Chapter 7 offers examples of both effects.

ISO affects image noise

As ISO increases, making the image sensor more reactive to light, you increase the risk of *noise*. Noise is similar in appearance to film *grain*, a defect that often mars pictures taken with high ISO film. Figure 4-5 offers an example.

Ideally, then, you should always use the lowest ISO setting on your camera to ensure top image quality. But sometimes the lighting conditions don't permit you to do so. Take the rose photos in Figure 4-6 as an example. When I shot these pictures, I didn't have a tripod, so I needed a shutter speed fast enough to allow a sharp handheld image.

I opened the aperture to f/5.6, which was the widest setting on the lens I was using, to allow as much light as possible into the camera. At ISO 100, the camera needed a shutter speed of 1/40 second to expose the picture, and that shutter speed wasn't fast enough for a successful handheld shot. You see the blurred result on the left in Figure 4-6. Raising the ISO to 200 allowed a shutter speed of 1/80 second, which was fast enough to capture the flower cleanly, as shown on the right in the figure.

ISO 100, f/5.6, 1/40 second ISO 200, f/5.6, 1/80 second

 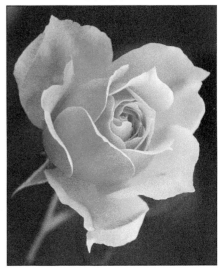

FIGURE 4-6:
Raising the
ISO allowed a
faster shutter
speed, which
produced
a sharper
handheld shot.

Fortunately, you don't encounter serious noise on the T7/2000D until you really crank up the ISO, which is why the one-step bump from ISO 100 to ISO 200 produces no noticeable change in the amount of noise in the examples shown in Figure 4-6. In fact, most people probably wouldn't even notice the noise in the left image in Figure 4-5 unless they were looking for it. But as with other image defects, noise becomes more apparent as you enlarge the photo, as shown on the right in that same figure. Noise is also easier to spot in shadow areas of your picture and in large areas of solid color.

How much noise is acceptable (and, therefore, how high an ISO is safe) is a personal choice. Even a little noise isn't acceptable for pictures that require the highest quality, such as images for a product catalog or a travel shot that you want to blow up to poster size.

WARNING

It's also important to know that a high ISO isn't the only cause of noise: A very slow shutter speed — an exposure time of, say, 1 second or longer — can also produce the defect. So if you combine a high ISO with a slow shutter speed, expect a double-whammy in the noise department.

Your camera offers tools that combat both types of noise; check out the sidebar titled "Dampening noise," later in this chapter, for information.

Doing the exposure balancing act

REMEMBER

Aperture, shutter speed, and ISO combine to determine image brightness. So changing any one setting means that one or both of the others must also shift to maintain the same image brightness.

Suppose that you're shooting a soccer game and you notice that although the overall exposure looks great, the players appear slightly blurry at the current shutter speed. If you raise the shutter speed, you have to compensate with either a larger aperture, to allow in more light during the shorter exposure, or a higher ISO setting, to make the camera more sensitive to the light. Which way should you go? Well, it depends on whether you prefer the reduced depth of field that comes with a larger aperture or the increased risk of noise that accompanies a higher ISO. Of course, you can also adjust both settings to get the exposure results you need, per-haps upping ISO slightly and opening the aperture a bit as well.

All photographers have their own approaches to finding the right combination of aperture, shutter speed, and ISO, and you'll no doubt develop your own system when you become more practiced at using the advanced exposure modes. In the meantime, here are my general recommendations:

>> Use the lowest ISO setting unless the lighting conditions are such that you can't use the aperture and shutter speed you want without raising the ISO.

>> If your subject is moving, give shutter speed the next highest priority in your exposure decision. Choose a fast shutter speed to ensure a blur-free photo or, on the flip side, select a slow shutter speed to intentionally blur that moving object, an effect that can create a heightened sense of motion.

>> For nonmoving subjects, make aperture a priority over shutter speed, setting the aperture according to the depth of field you have in mind. For portraits, for example, try using a wide-open aperture (a low f-stop number) to create a short depth of field and a nice, soft background for your subject.

WARNING

Be careful not to go *too* shallow with depth of field when shooting a group portrait. Unless all the subjects are the same distance from the camera, some may be outside the zone of sharp focus. A shallow depth of field also makes action shots more difficult because you have to be spot on with focus. With a greater depth of field, the subject can move closer or farther away from you before leaving the sharp-focus area, giving you a bit of a safety net.

Keeping all this information straight may be a little overwhelming at first, but the more you work with your camera, the more the whole exposure equation will make sense to you. You can find tips in Chapter 7 for choosing exposure settings for specific types of pictures; keep moving through this chapter for details on how to monitor and adjust aperture, shutter speed, and ISO settings.

Stepping Up to Advanced Exposure Modes (P, Tv, Av, and M)

With your camera in Creative Auto mode, covered in Chapter 3, you can affect picture brightness and depth of field to some extent by using the Ambience and Background Blur features. The scene modes let you request a slightly brighter or darker exposure via the Ambience setting, but that's pretty much it. So if you're really concerned with these picture characteristics — and you should be — set the Mode dial to one of its four advanced exposure modes (highlighted in Figure 4-7): P, Tv, Av, or M. In official Canon lingo, these modes are called *Creative Zones*.

Chapter 2 introduces the P, Tv, Av, and M modes, but because they're critical to your control of exposure, I want to offer some additional information here. First, a recap of how the four modes differ:

Advanced exposure modes

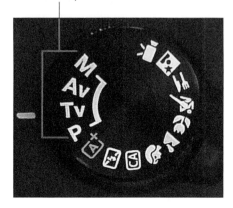

FIGURE 4-7:
To fully control exposure and other picture properties, choose one of these exposure modes.

>> **P (programmed autoexposure):** The camera selects the aperture and shutter speed to deliver a good exposure at the current ISO setting. But you can choose from different combinations of the two for creative flexibility (which is why this mode is sometimes referred to generically as *flexible programmed autoexposure*).

>> **Tv (shutter-priority autoexposure):** You select a shutter speed, and the camera chooses the aperture setting that produces a good exposure at that shutter speed and the current ISO setting.

Why *Tv?* Well, shutter speed controls exposure time; *Tv* stands for time value.

TECHNICAL
STUFF

>> **Av (aperture-priority autoexposure):** The opposite of shutter-priority autoexposure, this mode asks you to select the aperture setting — thus *Av,* for aperture value. The camera then selects the appropriate shutter speed to properly expose the picture — again, based on the selected ISO setting.

>> **M (manual exposure):** In this mode, you specify both shutter speed and aperture.

REMEMBER

To sum up, the first three modes are semiautomatic modes that offer exposure assistance while still providing you with some creative control. Note one important point about these modes, however: In extreme lighting conditions, the camera may not be able to select settings that will produce a good exposure, and it doesn't stop you from taking a poorly exposed photo. You may be able to solve the problem by using features designed to modify autoexposure results, such as Exposure Compensation (explained later in this chapter) or by adding flash, but you get no guarantees.

Manual mode puts all exposure control in your hands. If you're a longtime photographer who comes from the days when manual exposure was the only game in town, you may prefer to stick with this mode. If it ain't broke, don't fix it, as they say. And in some ways, manual mode is simpler than the semiautomatic modes — if you're not happy with the exposure, you just change the aperture, shutter speed, or ISO setting and shoot again. By contrast, when you use the Av, Tv, and P modes, you have to experiment with features that modify autoexposure results, such as the aforementioned Exposure Compensation.

But even when you use the M exposure mode, you're never really flying without a net: The camera assists you by displaying the exposure meter, explained next.

Monitoring Exposure Settings

When you press the shutter button halfway, the current f-stop, shutter speed, and ISO setting appear in the viewfinder display, as shown in Figure 4-8. If you're looking at the Shooting Settings or Live View display, the settings appear as shown in Figure 4-9.

REMEMBER

In the viewfinder and on the monitor in Live View mode, shutter speeds are presented as whole numbers, even if the shutter speed is set to a fraction of a second. For example, for a shutter speed of 1/50 second, you see just the number 50 in the display, as shown in Figure 4-8 and in the Live View example in Figure 4-9 (right screen in the

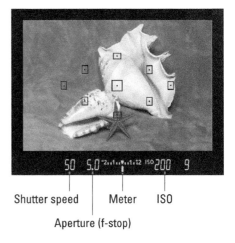

Shutter speed Meter ISO

Aperture (f-stop)

FIGURE 4-8:
The shutter speed, f-stop, and ISO speed appear in the viewfinder.

figure). When the shutter speed slows to 1 second or more, you see quotation marks after the number — 1″ indicates a shutter speed of 1 second, 4″ means 4 seconds, and so on.

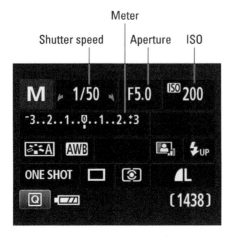

Shutter speed Meter Aperture ISO

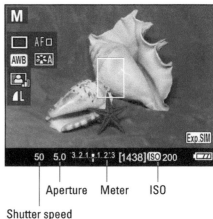

Aperture Meter ISO

Shutter speed

FIGURE 4-9:
You also can view the settings in the Shooting Settings display (left) and Live View display (right).

The viewfinder, Shooting Settings display, and Live View display also offer an *exposure meter,* labeled in Figures 4-8 and 4-9. This graphic appears slightly different in the viewfinder than in the other two displays. Because of the limited display area, the viewfinder meter shows an exposure range of −2 to +2, as shown in Figure 4-8, while the other two displays go from −3 to +3 (refer to Figure 4-9).

TECHNICAL STUFF

Of course, if you're new to exposure and the standard exposure metering system, those numbers don't mean much yet. So first things first: The numbers on the meter represent *exposure stops.* A *stop* is simply the photography term for an increment of exposure. To increase exposure by one stop means to adjust the aperture or shutter speed to allow twice as much light into the camera as the current settings permit. To reduce exposure by one stop, you use settings that allow half as much light. (Doubling or halving the ISO value also adjusts exposure by one stop.)

While the numbers on the meter represent whole stops, the bars in-between represent exposure changes of one-third of a stop. If you prefer, you can tweak the meter so that any exposure changes occur in half-stop increments through Custom Function 1. Chapter 11 has details on this option, found with the other Custom Functions on Setup Menu 3.

You also need to understand that the meter serves different functions depending on your exposure mode, as follows:

>> **In M (manual) exposure mode, the meter indicates whether your settings will properly expose the image.** Figure 4-10 gives you three examples. When the *exposure indicator* (the bar under the meter) aligns with the center point of the meter, as shown in the middle example, the current

settings will produce a proper exposure. If the indicator moves to the left of center, toward the minus side of the scale, as in the left example in the figure, the camera is alerting you that the image will be underexposed. If the indicator moves to the right of center, as in the right example, the image will be overexposed. The farther the indicator moves toward the plus or minus sign, the greater the potential exposure problem.

Exposure indicator

>> **In the other exposure modes (P, Tv, and Av), the meter displays the current Exposure Compensation setting.** Remember, in these exposure modes, the camera sets the shutter speed, aperture, or both, to produce a good exposure. Because you don't need the meter to tell you whether exposure is okay, the meter instead indicates whether you enabled *Exposure Compensation,* a feature that forces a brighter or darker exposure than the camera thinks is appropriate. (Look for details later in this chapter.) When the exposure indicator is at 0, no compensation is being applied. If the indicator is to the right of 0, you applied compensation to produce a brighter image; when the indicator is to the left, you asked for a darker photo.

In some lighting situations, the camera *can't* select settings that produce an optimal exposure in the P, Tv, or Av modes, however. Because the meter indicates the exposure compensation amount in those modes, the camera alerts you to exposure issues as follows:

WARNING

● *Av mode (aperture-priority autoexposure):* The shutter speed value blinks to let you know that the camera can't select a shutter speed that will produce a good exposure at the aperture you selected. Choose a different f-stop or adjust the ISO.

Keep in mind, though, that it's rare that you'll see a blinking shutter speed in Av mode, because the camera can select a shutter speed as slow as 30 seconds — a long enough exposure time to do the job at almost any aperture setting. But a long exposure time creates the risk of blurring due to camera shake or subject movement during the exposure. Unfortunately, the camera doesn't alert you when the shutter speed drops into the danger zone. Long story short: Don't assume that you're good to go even if the shutter speed isn't blinking in the displays. Always keep an eye on

shutter speed to make sure it doesn't drop below what you need for a blur-free shot.

- *Tv mode (shutter-priority autoexposure):* The aperture value blinks to tell you that the camera can't open or stop down the aperture enough to expose the image at your selected shutter speed. Your options are to change the shutter speed or ISO.

- *P mode (programmed autoexposure):* In P mode, both the aperture and shutter speed values blink if the camera can't select a combination that will properly expose the image. Your only recourse is to either adjust the lighting or change the ISO setting. My earlier warning about a slow shutter speed in Av mode applies for P mode as well.

REMEMBER

No matter what the exposure mode, the camera bases its exposure analysis on the metering mode, explained next.

Choosing an Exposure Metering Mode

The *metering mode* determines which part of the frame the camera analyzes to calculate the proper exposure. Your camera offers three metering modes, described in the following list and represented in the Shooting Settings screen and other displays by the icons you see in the margin.

REMEMBER

You can access all three modes only in the advanced exposure modes (P, Tv, Av, and M) and only during regular, through-the-viewfinder shooting. In Live View mode, as well as in the fully automatic exposure modes, the camera always uses Evaluative metering.

>> **Evaluative metering:** The camera analyzes the entire frame and then selects exposure settings designed to produce a balanced exposure.

>> **Partial metering:** The camera bases exposure only on the light that falls in the center 10 percent of the frame.

>> **Center-Weighted Average metering:** The camera bases exposure on the entire frame but puts extra emphasis — or *weight* — on the center.

In most cases, Evaluative metering does a good job of calculating exposure. But it can get thrown off when a dark subject is set against a bright background, or vice versa. For example, in the left image in Figure 4-11, the amount of bright background caused the camera to select exposure settings that underexposed the statue, which was the point of interest for the photo. Switching to Partial metering properly exposed the statue.

Evaluative

Partial

FIGURE 4-11:
In Evaluative mode, the camera underexposed the statue; switching to Partial metering produced a better result.

TIP

Of course, if the background is very bright and the subject is very dark, the exposure that does the best job on the subject typically overexposes the background. You may be able to reclaim some lost highlights by turning on Highlight Tone Priority, a Custom Function explored later in this chapter. For outdoor portraits in which your subject is backlit, adding flash can help illuminate the subject without blowing out the background. (See the Chapter 2 section related to using flash outdoors for tips on this strategy.) As for metering mode, use either of these options to change the setting:

>> **Quick Control screen:** After displaying the screen, highlight the Metering mode symbol, which is the one selected on the left in Figure 4-12. You can then rotate the Main dial to cycle through the three settings or press the Set button to display all three options on one selection screen, as shown on the right in the figure.

>> **Shooting Menu 2:** You also can find the Metering Mode option at the menu address shown in Figure 4-13. Note that although the camera displays this menu option in Live View mode (and even allows you into the metering-mode selection screen), as soon as you press OK to exit the settings screen, the camera resets the mode to Evaluative regardless of whether you selected one of the other two settings. (I agree, that's stupid, but that's the way it is.)

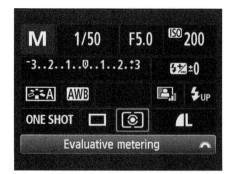

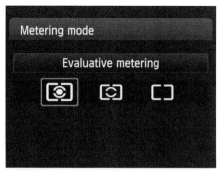

TIP

In theory, the best practice is to check the Metering mode before each shot and choose the mode that best matches your subject, framing, and lighting. But in practice, it's a pain, not just in terms of having to adjust yet one more setting but also in terms of having to *remember* to adjust one more setting. So until you're comfortable with all the other controls on your camera, just stick with Evaluative metering. It produces good results in most situations and, after all, if you don't like what you see in the monitor when you view the image, you can always adjust exposure settings and reshoot. This option makes the whole Metering mode issue a lot less critical than it is when you shoot with film.

FIGURE 4-13:
You also can access the Metering mode from Shooting Menu 2.

The one exception might be when you're shooting a series of images in which a significant difference in lighting exists between subject and background. Then, switching to Center-Weighted metering or Partial metering may save you the time spent having to adjust the exposure for each image. Many portrait photographers, for example, rely on Center-Weighted or Partial metering exclusively because they know their subject is usually going to be hovering near the center of the frame.

Setting ISO, F-stop, and Shutter Speed

REMEMBER

If you want to control ISO, aperture (f-stop), or shutter speed, set the camera to one of the advanced exposure modes: P, Tv, Av, or M. Then check out the next several sections to find the steps to follow in each of these modes.

Controlling ISO

To recap the basic exposure information presented at the start of this chapter, your camera's ISO setting controls how sensitive the image sensor is to light. At a higher ISO value, you need less light to expose the image. Remember the downside to raising ISO, however: The higher the ISO, the greater the possibility of noisy images. Refer to Figure 4-5 for a reminder of what that defect looks like.

You can control ISO only in the P, Tv, Av, and M exposure modes for still photography and in M mode for movie recording. In all other modes, the camera adjusts ISO automatically.

If you're shooting in an exposure mode that offers ISO control, you have the following choices:

>> **Select a specific ISO setting.**
Normally, you can choose ISO settings ranging from 100 to 6400. Or if you really want to push things, you can amp ISO up to 12800. In order to take advantage of that option, open Setup Menu 3, select Custom Functions, and then navigate to Custom Function 2, ISO Expansion. Change the setting to On, as shown in Figure 4-14. Now when you adjust ISO, an H (for High) appears as a possible setting; select that setting for ISO 12800.

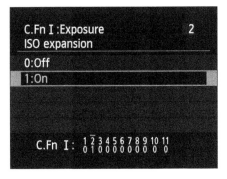

FIGURE 4-14:
By enabling Custom Function 2, you can push the available ISO range to 12800.

REMEMBER

A few complications to note: If you enable Highlight Tone Priority, an exposure feature covered later in this chapter, you lose the option of using ISO 100 as well as the expanded ISO setting (H, 12800).

>> **Let the camera choose (Auto ISO).**
You can ask the camera to adjust ISO for you if you prefer. By default, the camera has the option to raise the ISO as high as 3200, but you can choose a different limit if you prefer. Make the change via the ISO Auto setting on Shooting Menu 3, as shown in Figure 4-15. The low limit is

FIGURE 4-15:
This setting enables you to specify the maximum ISO setting the camera can use in Auto ISO mode.

TIP

ISO 400; the high limit, ISO 6400, regardless of whether you turn on ISO Expansion.

Using Auto ISO is especially handy when the light is changing fast or your subject is moving from light to dark areas quickly. In these situations, Auto ISO can save the day, giving you properly exposed images without any ISO futzing on your part.

You can view the current ISO setting in Shooting Settings and Live View displays, as shown in Figure 4-16, as well as in the viewfinder, as shown in Figure 4-17. (If you don't see the value in Live View mode, press the DISP button to switch to a display mode that presents the data.)

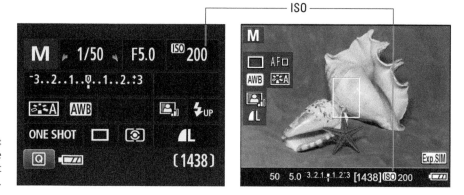

FIGURE 4-16:
Look here for the current ISO setting.

TIP

In Auto ISO mode, the Shooting Settings and Live View displays initially show Auto as the ISO value, as you would expect. But when you press the shutter button halfway, which initiates exposure metering, the value changes to show you the ISO setting the camera has selected. You also see the selected value rather than Auto in the viewfinder.

Note: When you view shooting data during playback, you may see a value reported that isn't on the list of "official" ISO settings — ISO 320, for example. This happens because in Auto mode, the camera can select values all along the available ISO range, whereas if you select a specific ISO setting, you're restricted to specific notches within the range.

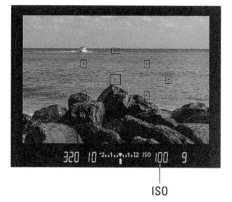

ISO

FIGURE 4-17:
The viewfinder also shows the ISO setting.

To adjust the ISO setting, you have these options:

 » **Use the Quick Control screen.** After highlighting the ISO option, as shown on the left in Figure 4-18, rotate the Main dial to cycle through the available ISO settings. You also can press Set to display a screen containing all available options, as shown on the right.

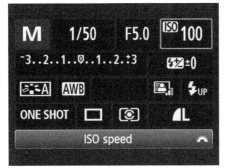 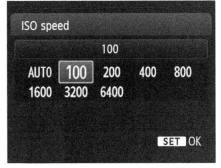

FIGURE 4-18:
Press the Q button to change the ISO setting via the Quick Control screen.

Figure 4-18 shows you how the screens appear during viewfinder shooting; in Live View mode, the ISO option appears in the lower-left corner of the monitor after you press the Q button to shift to the Quick Control display. Again, highlight the ISO setting and either rotate the Main dial to change the ISO value or press Set to see all the available options onscreen at once.

» **Press the top cross key, labeled ISO (not available in Live View mode).** You then see the screen shown on the right in Figure 4-18, where you can choose your desired setting.

 » **Reconfigure the Flash button to act as an ISO button.** For one-button access to the ISO setting during Live View shooting, you can set the Flash button to bring up the ISO setting screen. Make the change via Custom Function 10 (one of the Custom Functions options found on Setup Menu 3). Obviously, if you plan to use the built-in flash, this isn't a good solution because you then have no way to raise the flash. Assigning the ISO function to the Flash button may be helpful if you're shooting with an external flash, in which case you don't need to use the button for any flash-related purpose. But again, you only need to consider this option if you're shooting in Live View mode because for viewfinder shooting, the top cross key whisks you to the ISO setting screen.

DAMPENING NOISE

Noise, the digital defect that gives your pictures a speckled look (refer to Figure 4-5), can occur for two reasons: a long exposure time and a high ISO setting. Your camera offers two noise-removal filters, one to address each cause of noise. The camera applies the filters as it's processing your images and recording the data to the memory card.

Both filters are provided through Custom Functions, which means that you can control whether and how they're applied only in the P, Tv, Av, and M exposure modes. Here are the available settings for each option:

- **Long Exposure Noise Reduction (Custom Function 4):** At the default setting, Off, no noise reduction is applied. If you select Auto, noise reduction is applied when you use a shutter speed of 1 second or longer, but only if the camera detects the type of noise that's caused by long exposures. At the On setting, noise reduction is always applied at exposures of 1 second or longer. (*Note:* Canon suggests that this setting may result in more noise than either Off or Auto when the ISO setting is 1600 or higher.)

 This feature works fairly well, but at a cost: Using it doubles the processing time for any frames shot at a shutter speed of 1 second or longer. Say that you make a 30-second exposure. After the shutter closes at the end of the exposure, the camera takes a *second* 30-second exposure to measure just the noise in the frame, and then it subtracts that noise from your *real* exposure. You can't shoot another frame until the process is complete.

- **High ISO Speed Noise Reduction (Custom Function 5):** This filter offers four settings: Standard, which is the default setting; Low, which applies just a touch of noise removal; Strong, which goes after noise in a more dramatic way; and Disable, which turns off the filter. High ISO noise-reduction filters work primarily by applying a slight blur to the image. Don't expect this process to eliminate noise entirely, and expect some resulting image softness. Also, enabling the feature at the Strong setting reduces the maximum frames-per-second rate you can achieve when using the Continuous Drive mode.

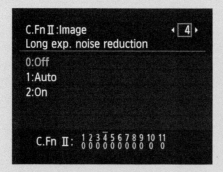 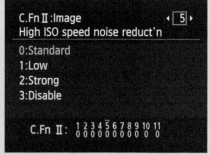

Adjusting aperture and shutter speed

REMEMBER

You can adjust aperture and shutter speed only in P, Tv, Av, and M exposure modes. To wake up the exposure meter and view the current f–stop and shutter speed in the displays, press the shutter button halfway. Then use these techniques to adjust the settings, depending on your exposure mode:

>> **P (programmed autoexposure):** The camera displays its recommended combination of aperture and shutter speed. To select a different combination, rotate the Main dial.

>> **Tv (shutter-priority autoexposure):** Rotate the Main dial to set the shutter speed. When not using flash, you can select from a shutter-speed range of 30 seconds to 1/4000 second. As you change the shutter speed, the camera automatically adjusts the aperture setting.

>> **Av (aperture-priority autoexposure):** Rotate the Main dial to change the f-stop setting. As you do, the camera adjusts the shutter speed to produce the proper exposure. How many f-stops are available depend on your lens and, if you're using a zoom lens, the current focal length (zoom position).

WARNING

After changing the aperture, make sure that the shutter speed hasn't dropped so low that handholding the camera or capturing a moving subject won't be possible. If this problem arises, use a higher ISO setting, which will enable the camera to select a faster shutter speed.

>> **M (manual exposure):** Select aperture and shutter speed like so:

- *Adjust shutter speed.* Rotate the Main dial.

TIP

 In Manual mode, you can access one option not available in Tv mode: Rotate the Main dial one notch past the 30-second setting to access Bulb mode. This setting keeps the shutter open for as long as you hold down the shutter button. Bulb mode is great for night photography, catching lightning in action, and photographing thunderstorms or starry skies. It enables you to experiment with different shutter speeds simply by holding the shutter button down for different lengths of time — you don't have to fiddle with changing the shutter speed between each shot.

- *Adjust aperture.* Press and hold the Exposure Compensation button while rotating the Main dial. (See the *Av* label on the button? That's your clue to the aperture-related function of the button — *Av* stands for *aperture value*.)

REMEMBER

In M, Tv, and Av modes, the setting that's available for adjustment appears in the Shooting Settings display with little arrows at each side. Your camera manual refers to this display as the Main dial pointer, and it's provided as a reminder that you use the Main dial to change the setting. For example, in M mode, the shutter speed is bordered by the arrows until you hold down the Exposure Compensation

button, at which point the marker shifts to the aperture (f-stop) value, as shown in Figure 4-19.

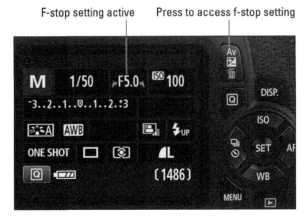

F-stop setting active Press to access f-stop setting

FIGURE 4-19:
To set the
aperture in M
mode, press
the Exposure
Compensation
button while
you rotate the
Main dial.

It's easy to get confused when you shoot in the Av and Tv modes because as you rotate the Main dial to change the f-stop or shutter speed, the camera changes the other setting automatically. It helps to remember that the pointer arrows indicate the setting that you're controlling. If the other setting doesn't change in tandem, you reached the limits of the shutter-speed or aperture range.

 When the Shooting Settings screen is displayed, you also can use the Quick Control screen to adjust the settings in the M, Tv, and Av modes. This technique is more cumbersome but comes in handy in M mode because you can adjust the f-stop setting without having to remember what button to push to do the job. The Quick Control method doesn't work in Live View mode.

A few more words of wisdom related to aperture and shutter speed:

» When using Manual exposure, don't forget that you can check the exposure meter to get the camera's take on your exposure settings (when in Live View, look at the monitor for a preview). Of course, you don't have to follow the camera's guidance — you can take the picture using any settings you like, even if the meter indicates that the image will be under- or overexposed.

REMEMBER

» In P, Tv, and Av mode, the shutter speed or f-stop value blinks if the camera isn't able to select settings that produce a good exposure. If the problem is too little light, try raising the ISO or adding flash to solve the problem. If there's too much light, lower the ISO value or attach an ND (neutral density) filter, which is sort of like sunglasses for your lens — it simply cuts the light entering the lens. (The *neutral* part just means that the filter doesn't affect image colors, just brightness.)

>> When you use P, Tv, and Av modes, the settings that the camera selects are based on what it thinks is the proper exposure. If you don't agree with the camera, you have two options. Switch to manual exposure (M) mode and dial in the aperture and shutter speed that deliver the exposure you want. Or if you want to stay in P, Tv, or Av mode, try using exposure compensation, one of the exposure-correction tools described in the next section.

Sorting Through Your Camera's Exposure-Correction Tools

In addition to the normal controls over aperture, shutter speed, and ISO, your camera offers a collection of tools that enable you to solve tricky exposure problems. The next four sections give you the lowdown on these features.

Overriding autoexposure results with Exposure Compensation

REMEMBER

In the P, S, and A exposure modes, you have some input over exposure. In P mode, you can rotate the Main dial to choose from different combinations of aperture and shutter speed; in Tv mode, you can dial in the shutter speed; and in Av mode, you can select the aperture setting. But because these are semiautomatic modes, the camera ultimately controls the final exposure. If your picture turns out too bright or too dark in P mode, you can't simply choose a different f-stop/shutter speed combo because they all deliver the same exposure — which is to say, the exposure that the camera has in mind. And changing the shutter speed in Tv mode or adjusting the f-stop in Av mode won't help either because as soon as you change the setting that you're controlling, the camera automatically adjusts the other setting to produce the same exposure it initially delivered.

Not to worry: You actually do have final say over exposure in these exposure modes. The secret is Exposure Compensation, a feature that tells the camera to produce a brighter or darker exposure on your next shot.

Best of all, this feature is probably one of the easiest on the camera to understand. Here's all there is to it:

>> Exposure compensation is stated in EV values, as in +2.0 EV. Possible values range from +5.0 EV to –5.0 EV.

TECHNICAL STUFF

» Each full number on the EV scale represents an exposure shift of one *full stop*. In plain English, it means that if you change the Exposure Compensation setting from EV 0.0 to EV –1.0, the camera adjusts either the aperture or the shutter speed to allow half as much light into the camera as it would get at the current setting. If you instead raise the value to EV +1.0, the settings are adjusted to double the light.

» A setting of EV 0.0 results in no exposure adjustment.

» For a brighter image, raise the EV value. The higher you go, the brighter the image becomes.

» For a darker image, lower the EV value. The picture becomes progressively darker with each step down the EV scale.

TIP

Exposure compensation is especially helpful when your subject is much lighter or darker than its surroundings. For example, take a look at the image on the left in Figure 4-20. Because of the very bright sky, the camera chose an exposure that I thought made the tree too dark. Setting the Exposure Compensation value to EV +1.0 resulted in a brighter image, allowing the details of the tree to be more visible.

EV 0.0 EV +1.0

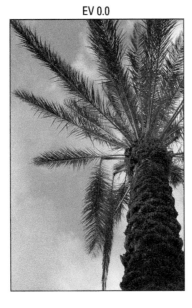
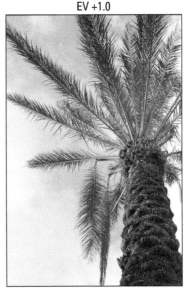

FIGURE 4-20: For a brighter exposure than the autoexposure mechanism chooses, dial in a positive Exposure Compensation value.

Sometimes you can cope with situations like this one by changing the Metering mode, as discussed earlier in this chapter. But in cases like the shot in Figure 4-20, the results would have been much the same in all the metering modes because the brightest part of the frame — the area that caused the original underexposure — is

in the center. That area would have been part of the exposure calculation in all three metering modes. Also, I find that it usually takes more time to experiment with metering modes than to simply adjust exposure compensation to get the results I'm after.

You can take several roads to applying exposure compensation:

>> **Exposure Compensation button:** The fastest option is to press and hold the Exposure Compensation button while rotating the Main dial. The exposure meter in the Shooting Settings and Live View displays indicates the current Exposure Compensation amount. For example, in Figure 4-21, the amount of adjustment is +1.0. The viewfinder meter also displays the amount of adjustment.

Exposure Compensation amount

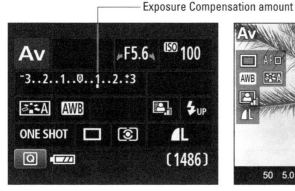
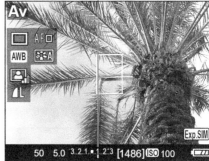

FIGURE 4-21:
In the P,
Tv, and Av
exposure
modes, the
meter indicates
the amount
of Exposure
Compensation
adjustment.

Note that even though the meters initially show a range of just +/– three stops, you can access the entire five-stop range. Just keep rotating the Main dial to display the far ends of the range.

>> **Quick Control screen (not available in Live View mode):** Highlight the exposure meter in the Quick Control display and rotate the Main dial to move the exposure indicator left or right along the meter.

>> **Shooting Menu 2:** Select Expo. Comp./AEB, as shown on the left in Figure 4-22, and press Set to display the screen shown on the right in the figure. You can access this same screen by pressing Set when the meter is highlighted on the Quick Control screen.

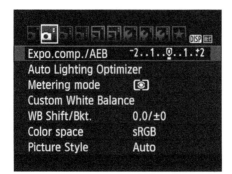 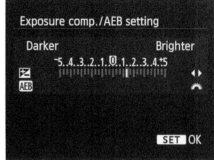

FIGURE 4-22:
Be careful that
you adjust
Exposure
Compensation
and not AEB
(Automatic
Exposure
Bracketing).

WARNING

Either way, this is a tricky screen, so pay attention:

- The screen has a double purpose: You use it to enable automatic exposure bracketing (AEB) as well as exposure compensation. If you're not careful, you can wind up changing the wrong setting.

- To apply exposure compensation, press the left/right cross keys to move the exposure indicator (the red line on the meter) along the scale.

 Notice the +/– symbol at the left end of the meter and the triangles at the right end? They're there to remind you to use the left/right cross keys to make the Exposure Compensation adjustment. The lower pair of symbols, AEB and a jagged half circle, indicate that you use the Main dial to adjust automatic exposure bracketing (AEB).

REMEMBER

When you dial in an Exposure Compensation adjustment of greater than two stops, the notch under the viewfinder meter disappears and is replaced by a little triangle at one end of the meter — at the right end for a positive Exposure Compensation value and at the left for a negative value. However, the meter on the Shooting Settings and Live View screens and on Shooting Menu 2 adjust to show the proper setting.

Whatever Exposure Compensation setting you select, the way that the camera arrives at the brighter or darker image you request depends on the exposure mode:

- >> In Av (aperture-priority) mode, the camera adjusts the shutter speed but leaves your selected f-stop in force.

- >> In Tv (shutter-priority) mode, the opposite occurs: The camera opens or stops down the aperture, leaving your selected shutter speed alone.

- >> In P (programmed autoexposure) mode, the camera decides whether to adjust aperture, shutter speed, or both to accommodate the Exposure Compensation setting.

These explanations assume that you have a specific ISO setting selected rather than Auto ISO. If you do use Auto ISO, the camera may adjust that value instead.

Again, remember that the camera can adjust the aperture only so much, according to the aperture range of your lens. The range of shutter speeds is limited by the camera; when you use flash, the fastest available shutter speed is 1/200 second. (Otherwise, the shutter speed can go up to 1/4000 second.) If you reach the end of those ranges, you have to compromise on either shutter speed or aperture, or adjust ISO.

WARNING

A final, and critical, point about exposure compensation: When you power off the camera, it doesn't return you to a neutral setting (EV 0.0). The setting you last used remains in force for the P, Tv, and Av modes until you change it. It's always a good idea to zero out the setting at the end of a shoot so that you don't spend time on your next outing trying to figure out why your pictures are over- or underexposed.

Improving high-contrast shots with Highlight Tone Priority

When a scene contains both very dark and very bright areas, achieving a good exposure can be difficult. If you choose exposure settings that render the shadows properly, the highlights are often overexposed, as in the left image in Figure 4-23. Although the dark lamppost in the foreground looks fine, the white building behind it has become so bright that all detail has been lost. The same thing occurred in the highlight areas of the green church steeple.

Your camera offers an option that can help produce a better image in this situation — Highlight Tone Priority — which was used to produce the image on the right in Figure 4-23. The difference is subtle, but if you look at that white building and steeple, you can see that the effect does make a difference. Now the windows in the building are at least visible, the steeple has regained some of its color, and the sky, too, has a bit more blue.

REMEMBER

This feature is available only in the P, Tv, Av, and M modes. It's turned off by default, which may seem like an odd choice after looking at the improvement it made to the scene in Figure 4-23. What gives? The answer is that to accomplish its magic, Highlight Tone Priority needs to play with a few other camera settings, as follows:

>> **The ISO range is reduced to ISO 200–6400.** The camera starts out with this more limited range because the way it prevents highlights from being overexposed is by slightly underexposing the initial image capture. To achieve that darker exposure, it drops the ISO down one notch. If you were to set the ISO to 100, there would be no lower setting to use.

Highlight Tone Priority off

Highlight Tone Priority on

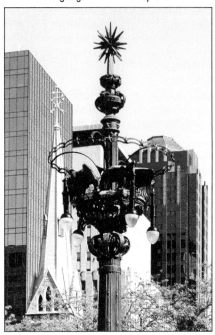
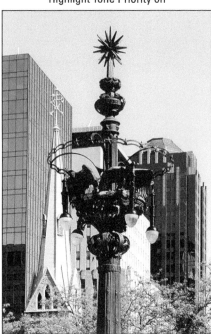

FIGURE 4-23:
The Highlight Tone Priority feature can help prevent overexposed highlights.

>> **Auto Lighting Optimizer is automatically disabled.** This feature, which attempts to improve image contrast, is incompatible with Highlight Tone Priority. Read the next section, which explains Auto Lighting Optimizer, to determine which of the two exposure tweaks you want to use.

>> **You can wind up with slightly more noise in shadow areas of the image.** Again, noise is the defect that looks like speckles in your image. And now you may be able to guess why you can't use the H (12800) ISO setting with Highlight Tone Priority: The noise created by that uber-high ISO combined with the noise produced by the feature itself would likely make you a very unhappy camper.

The only way to enable Highlight Tone Priority is via Custom Function 6, found on Setup Menu 3 and shown in Figure 4-24.

As a reminder that Highlight Tone Priority is enabled, a D+ symbol appears near the ISO value in the Shooting Settings and Live View displays, as shown in

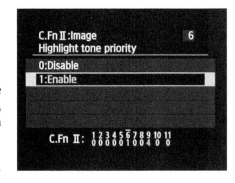

FIGURE 4-24:
Enable Highlight Tone Priority from Custom Function 6.

Figure 4-25. The same symbol appears with the ISO setting in the viewfinder and in the shooting data that appears in Playback mode. (See Chapter 9 to find out more about picture playback.) Notice that the symbol that represents Auto Lighting Optimizer is dimmed because that feature is automatically disabled as soon as you turn on Highlight Tone Priority. I labeled the Auto Lighting Optimizer symbol in the figure as well.

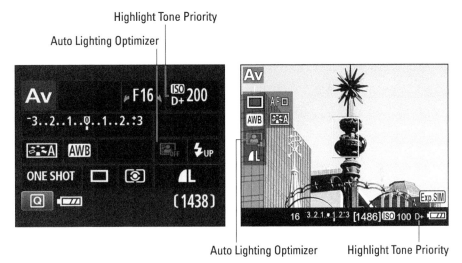

Experimenting with Auto Lighting Optimizer

When you select an Image Quality setting that results in a JPEG image file — that is, any setting other than Raw — also experiment with the Auto Lighting Optimizer feature. Unlike Highlight Tone Priority, which concentrates on preserving highlight detail only, Auto Lighting Optimizer tries to improve underexposed or low-contrast shots by adjusting both shadows and highlights. The adjustment is made as the image is captured.

In the fully automatic exposure modes as well as in Creative Auto, you have no control over how much adjustment is made. But in P, Tv, Av, and M modes, you can decide whether to enable Auto Lighting Optimizer. You also can request a stronger or lighter application of the effect than the default setting. Figure 4-26 offers an example of the type of impact of each Auto Lighting Optimizer setting.

Off

Low

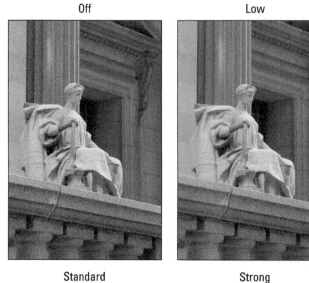

Standard

Strong

FIGURE 4-26:
For this image,
Auto Lighting
Optimizer
brought more
life to the shot.

Given the level of improvement that the Auto Lighting Optimizer correction made to this photo, you may be thinking that you'd be crazy to ever disable the feature. But it's important to note a few points:

>> **The level of shift that occurs between each Auto Lighting Optimizer setting varies depending on the subject.** This particular example shows a fairly noticeable difference between the Strong and Off settings. But you don't always see this much impact from the filter. Even in this example, it's difficult to detect much difference between Off and Low.

>> **Although the filter improved the scene in Figure 4-26, at times you may not find it beneficial.** For example, maybe you're purposely trying to shoot a backlit subject in silhouette or produce a low-contrast image. Either way, you don't want the camera to insert its opinions on the exposure or contrast you're trying to achieve.

>> **Enabling Auto Lighting Optimizer may slow your shooting rate.** The slowdown occurs because the filter is applied after you capture the photo, while the camera is writing the data to the memory card.

>> **In some lighting conditions, Auto Lighting Optimizer can produce an increase in image noise.** As shown near the start of this chapter, in Figure 4-5, noise becomes more apparent when you enlarge a photo. It also tends to be most visible in areas of flat color.

WARNING

>> **The corrective action taken by Auto Lighting Optimizer can make some other exposure-adjustment features less effective.** Turn the option off if you don't see the results you expect when you're using the following features:

- Exposure compensation, discussed earlier in this chapter

- Flash compensation, discussed in Chapter 2

- Automatic exposure bracketing, discussed later in this chapter

>> **You can't use this feature while Highlight Tone Priority (explained in the preceding section) is enabled.** In fact, as soon as you turn on Highlight Tone Priority, the camera automatically disables Auto Lighting Optimizer.

You can adjust the Auto Lighting Optimizer setting in two ways:

>> **Quick Control screen:** Press the Q button to enter Quick Control mode and then highlight the Auto Lighting Optimizer symbol, labeled in Figure 4-27. Then rotate the Main dial to cycle through the four options. You also can press Set to display a screen showing all the available settings.

>> **Shooting Menu 2:** Select Auto Lighting Optimizer from the menu and press Set to display the selection screen, as shown in Figure 4-28.

TIP

Notice the vertical bars in the graphic that represents the Auto Lighting Optimizer setting. The number of bars tells you how much adjustment is being applied. Two bars, as in Figure 4-27, represent the Standard setting, which is the default; three bars, Strong; and one bar, Low. The bars are replaced by the word *Off* when the feature is disabled.

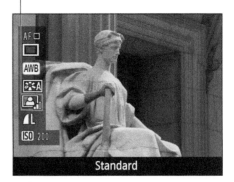

Auto Lighting Optimizer

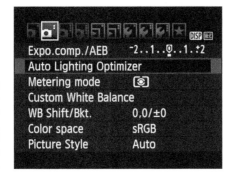

FIGURE 4-27: These symbols tell you the status of the Auto Lighting Optimizer setting.

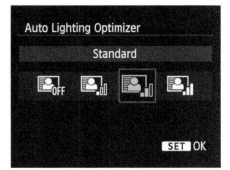

FIGURE 4-28: The menu option appears only in the P, Tv, Av, and M exposure modes.

Correcting lens vignetting with Peripheral Illumination Correction

Some lenses produce pictures that appear darker around the edges of the frame than in the center, even when the lighting is consistent throughout. This phenomenon goes by several names, but the two heard most often are *vignetting* and *light fall-off.* How much vignetting occurs depends on the lens, your aperture setting, and the lens focal length.

To help compensate for vignetting, your camera offers Peripheral Illumination Correction, which adjusts image brightness around the edges of the frame. Figure 4-29 shows an example. In the left image, just a slight amount of light fall-off occurs at the corners, most noticeably at the top of the image. The right image shows the same scene with Peripheral Illumination Correction enabled.

This "before" example hardly exhibits serious vignetting — it's likely that most people wouldn't even notice if it weren't shown next to the "after" example. But if your lens suffers from stronger vignetting, Peripheral Illumination Correction can help correct the problem.

Peripheral Illumination
Correction off

Peripheral Illumination
Correction on

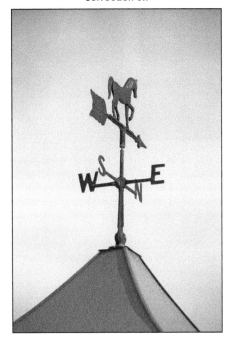
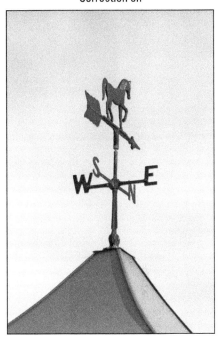

FIGURE 4-29:
Peripheral
Illumination
Correction
tries to correct
the corner
darkening that
can occur with
some lenses.

The adjustment is available in all your camera's exposure modes. But a few factoids need spelling out:

» **The correction is available only for photos captured in the JPEG file format.** For Raw photos, you can choose to apply the correction and vary its strength if you use Canon Digital Photo Professional to process your Raw images. Chapter 10 talks more about Raw processing. See Chapter 2 to find out how to select the file format, which you do via the Image Quality setting.

» **For the camera to apply the proper correction, data about the specific lens must be included in the camera's *firmware* (internal software).** You can determine whether your lens is supported by opening Shooting Menu 1 and selecting Peripheral Illumination Correction, as shown on the left in Figure 4-30. Press Set to display the right screen in the figure. If the screen reports that correction data is available, as in the figure, the feature is enabled by default.

TECHNICAL
STUFF

If your lens isn't supported, you may be able to add its information to the camera; Canon calls this step *registering your lens.* You do this by using a USB cable to connect the camera to your computer and then using tools included with Canon EOS Utility software. (The software is available for free download from the Canon website; look for the download links in the support section of the site.) I must refer you to the software manual for help on this bit of business because of the limited number of words that can fit in these pages.

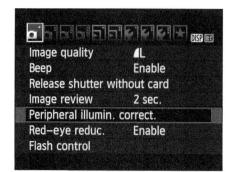
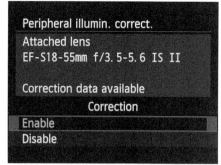

FIGURE 4-30:
Access the feature through Shooting Menu 1.

WARNING

» **For non-Canon lenses, Canon recommends disabling Peripheral Illumination Correction even if correction data is available.** You can still apply the correction in Digital Photo Professional when you shoot in the Raw format.

» **In some circumstances, the correction may produce increased noise at the corners of the photo.** This problem occurs because exposure adjustment can make noise more apparent. Also, at high ISO settings, the camera applies the filter at a lesser strength — presumably to avoid adding even more noise to the picture. (See the earlier "ISO affects image noise" section and "Dampening noise" sidebar for an understanding of noise and its relationship to ISO.)

Locking Autoexposure Settings

To help ensure a proper exposure, your camera continually meters the light until the moment you press the shutter button fully to shoot the picture. In autoexposure modes — that is, any mode but M — the camera also keeps adjusting exposure settings as needed.

For most situations, this approach works great, resulting in the right settings for the light that's striking your subject when you capture the image. But on occasion, you may want to lock in a certain combination of exposure settings. For example, perhaps you want your subject to appear at the far edge of the frame. If you were to use the normal shooting technique, you would place the subject under a focus point, press the shutter button halfway to lock focus and set the initial exposure, and then reframe to your desired composition to take the shot. The problem is that exposure is then recalculated based on the new framing, which can leave your subject under- or overexposed.

REMEMBER

The easiest way to lock in exposure settings is to switch to M (manual exposure) mode and use the f-stop, shutter speed, and ISO settings that best expose your subject. In manual exposure mode, the camera never overrides your exposure decisions; they're locked until you change them, even if you reframe after focusing.

If you prefer to stay in P, Tv, or Av mode, you can lock the current autoexposure settings by using AE (autoexposure) Lock. Here's how to do it:

1. **Press the shutter button halfway.**

 If you're using autofocusing, focus is locked at this point.

2. **Press the AE Lock button.**

 Exposure is now locked and remains locked for 4 seconds, even if you release the AE Lock button and the shutter button.

 To remind you that AE Lock is in force, the camera displays an asterisk at the left end of the viewfinder or, in Live View mode, in the lower-left corner of the display. If you need to relock exposure, just press the AE Lock button again.

Note: If your goal is to use the same exposure settings for multiple shots, you must keep the AE Lock button pressed during the entire series of pictures. Every time you let up on the button and press it again, you lock exposure anew based on the light that's in the frame.

REMEMBER

One other critical point to remember about using AE Lock: The camera establishes and locks exposure differently depending on the metering mode, the focusing mode (automatic or manual), and on an autofocusing setting called AF Point Selection mode. (Chapter 5 explains this option thoroughly.) Here's the scoop:

>> **Evaluative metering and automatic AF Point Selection:** Exposure is locked on the focusing point that achieved focus.

>> **Evaluative metering and manual AF Point Selection:** Exposure is locked on the selected autofocus point.

>> **All other metering modes:** Exposure is based on the center autofocus point, regardless of the AF Point Selection mode.

>> **Manual focusing:** Exposure is based on the center autofocus point.

Bracketing Exposures Automatically

Many photographers use a strategy called *bracketing* to ensure that at least one shot of a subject is properly exposed. They shoot the same subject multiple times, slightly varying the exposure settings for each image. To make bracketing easy, your camera offers *Automatic Exposure Bracketing* (AEB). When you enable this feature, your only job is to press the shutter button to record the shots; the camera automatically adjusts the exposure settings between each image.

TIP

Aside from cover-your, uh, "bases" shooting, bracketing is useful for *HDR imaging* (also called *HDR photography*). HDR stands for *high dynamic range,* with dynamic range referring to the spectrum of brightness values in a photograph. The idea behind HDR is to capture the same scene multiple times, using different exposure settings for each image. You then use HDR imaging software, sometimes called *tone mapping software,* to combine the exposures in a way that uses specific brightness values from each shot. By using this process, you get a shot that contains more detail in both the highlights and shadows than a camera could ever record in a single image.

Whether you're interested in automatic exposure bracketing for HDR or just want to give yourself an exposure safety net, keep these points in mind:

REMEMBER

>> **Exposure mode:** AEB is available only in the P, Tv, Av, and M exposure modes.

>> **Flash:** AEB isn't available when you use flash.

>> **Bulb shutter speed:** Nor can you use AEB when you select Bulb (available only in the M exposure mode) as the shutter speed.

>> **Bracketing amount:** You can request an exposure change of up to two stops from the auto bracketing system.

>> **Exposure Compensation:** You can combine AEB with exposure compensation if you want. The camera simply applies the compensation amount when it calculates the exposure for the three bracketed images.

>> **Auto Lighting Optimizer:** Because that feature is designed to automatically adjust images that are underexposed or lacking in contrast, it can render AEB ineffective. So it's best to disable the feature when bracketing. See the section "Experimenting with Auto Lighting Optimizer," earlier in this chapter, for information on where to find and turn off the feature.

The next two sections explain how to set up the camera for automatic bracketing and how to record a series of bracketed shots.

Turning auto bracketing on and off

The following steps show you how to turn on Automatic Exposure Bracketing via Shooting Menu 2. (I explain more about another option for enabling the feature momentarily.)

1. **Display Shooting Menu 2 and highlight Expo. Comp./AEB, as shown on the left in Figure 4-31.**

FIGURE 4-31:
Automatic
Exposure
Bracketing
records your
image at three
different
exposure
settings.

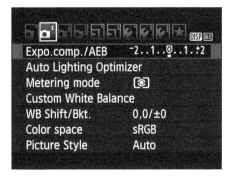 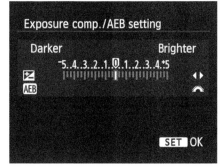

2. **Press Set.**

 You see the screen shown on the right in Figure 4-31. This is the same dual-natured screen that appears when you apply exposure compensation, as explained earlier in this chapter. In M mode, exposure compensation isn't relevant — if you want a darker or brighter image, you just adjust the f-stop, shutter speed, or ISO. So the Exposure Compensation controls are dimmed on the Exposure Comp/AEB screen if the Mode dial is set to M.

3. **Rotate the Main dial to establish the amount of exposure change you want between images.**

 What you see onscreen after you rotate the dial depends on your exposure mode:

 - *M mode:* The screen changes to look similar to the one on the left in Figure 4-32, with only the AEB setting active. On the meter, each whole number represents one stop of exposure shift. The red lines under the meter show you the amount of shift that will occur in your bracketed series of shots. For example, the settings in Figure 4-32 represent one stop of adjustment.

 No matter what the settings, the first image is captured at the actual exposure settings; the second, at settings that produce a darker image; and the third, at settings that produce a brighter photo.

Exposure Compensation disabled in Manual mode

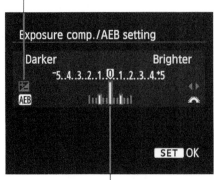
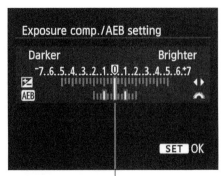

—— Autoexposure bracketing (AEB) amount ——

FIGURE 4-32:
The bracketing control appears different in M mode (left) than in the other advanced exposure modes (right).

- *P, Tv, or Av modes:* For these modes, both the Exposure Compensation and AEB features are enabled, as shown in Figure 4-32. Rotate the Main dial to set the bracketing increment; press the right or left cross keys to add Exposure Compensation to the mix. The bracketing meter scoots left or right in tandem as you adjust the Exposure Compensation setting.

TIP

If you're familiar with the Exposure Compensation feature, you may notice something different about the top meter in the right screen in Figure 4-32: It indicates a maximum Exposure Compensation adjustment of plus or minus 7 stops instead of the usual 5. What gives? Well, if you set Exposure Compensation to +5.0 and set the bracketing amount to +2.0, your brightest shot is captured at EV +7.0, the neutral shot at EV +5.0, and the darkest shot at EV +3.0.

4. **Press Set.**

AEB is now enabled. To remind you of that fact, the exposure meter in the Shooting Settings shows the three exposure indicators to represent the exposure shift you established, as shown in Figure 4-33. (For this example, no Exposure Compensation is in effect.) You see the same markers on Shooting Menu 2, on the viewfinder meter, and on the meter that appears at the bottom of the screen in Live View mode.

Bracketing indicators

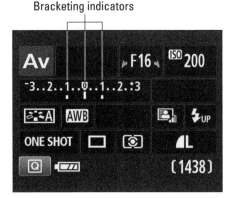

For viewfinder photography, you can also enable AEB through the Quick Control screen. In P, Tv, and Av expo-sure modes, press the Q button to enter

FIGURE 4-33:
The three bars under the meter remind you that Automatic Exposure Bracketing is enabled.

Quick Control mode, highlight the exposure meter, and press Set to display a screen that works just like the one you get through the menu. After setting the bracketing amount, press the shutter button halfway to exit to shooting mode. In the M exposure mode, shift to Quick Control mode, highlight the meter, and just rotate the Main dial to set the bracketing amount. You can skip the step of bringing up the menu screen. Again, press the shutter button halfway to return to shooting mode.

To turn off Automatic Exposure Bracketing, change the AEB setting back to 0.

REMEMBER

AEB is also turned off when you power down the camera, enable the flash, replace the camera battery, or replace the memory card. You also can't use the feature in manual exposure (M) mode if you set the shutter speed to the Bulb option. (At that setting, the camera keeps the shutter open as long as you press the shutter button.)

Shooting a bracketed series

After you enable auto bracketing, the way you record your trio of bracketed exposures depends on the selected Drive mode. This setting, described in Chapter 2, determines whether the camera records a single image or multiple images with each press of the shutter button. (Press the left cross key to access the screen that enables you to change this setting.)

Here's how things shake out as far as shooting a bracketed series in each Drive mode:

TIP

>> **AEB in Single mode:** You take each exposure separately, pressing the shutter button fully three times to record your trio of images.

If you forget which exposure you're taking, look at the exposure meter. After you press the shutter button halfway to lock focus, the meter shows just a single indicator bar instead of three. If the bar is at 0, you're ready to take the first capture. If it's to the left of 0, you're on capture two, which creates the darker exposure. If it's to the right of 0, you're on capture three, which produces the brightest image. My advice assumes that you haven't also applied exposure compensation, in which case the starting point is at a notch other than zero.

>> **AEB in Continuous mode:** Press and hold the shutter button down to record three continuous frames. (Be sure to wait for the camera to record all three frames before you release the shutter button.) To record another series, release and then press the shutter button again. In other words, when AEB is turned on, the camera doesn't keep recording images until you release the

shutter button as it normally does in Continuous mode — you can take only three images with one press of the shutter button.

» **Self-Timer modes:** In the two standard Self-Timer modes (10-second and 2-second delays), all three exposures are recorded with a single press of the shutter button. But you don't need to hold down the shutter button as you do in Continuous mode — just press and release. If you set the Drive mode to Self-Timer: Continuous, the camera captures multiple bracketed series, according to how many frames you select for the Self-Timer setting. Set the Self-Timer option to capture 4 frames, for example, and you get four brack-eted series, for a total of 12 frames.

Chapter **5**

Controlling Focus and Depth of Field

To many people, the word *focus* has just one interpretation when applied to a photograph: The subject is in focus or blurry. But an artful photographer knows that there's more to focus than simply getting a sharp image of a subject. You also need to consider *depth of field*, or the distance over which other objects in the scene appear sharply focused. This chapter explains how to manipulate both aspects of an image.

After a reminder of how to set your lens to auto or manual focusing, the first part of the chapter details focusing options available for viewfinder photography. Following that, you can get help with focusing during Live View photography and movie recording. A word of warning: The two systems are quite different, and mastering them takes time. If you start feeling overwhelmed, simplify things by following the steps laid out at the beginning of Chapter 3, which show you how to take a picture in the Scene Intelligent Auto exposure mode, using the default autofocus settings. Then return another day to study the focusing options discussed here.

Things get much easier (and more fun) at the end of the chapter, where I explain how to control depth of field. Thankfully, the concepts related to that subject apply no matter whether you're using the viewfinder, taking advantage of Live View photography, or shooting movies.

Setting the Lens Focus Mode

REMEMBER

Regardless of whether you're using the viewfinder or Live View, your first focus task is to set the lens to auto or manual focusing (assuming that your lens supports autofocusing with the T7/2000D). On most lenses, including the 18–55mm kit lens, you find a switch with two settings: AF for autofocusing and MF for manual focusing, as shown in Figure 5-1. The position of the manual focusing ring varies from lens to lens; Figure 5-1 shows you where to find it on the kit lens.

Some Canon lenses do enable you to adjust focus manually when the lens switch is set to AF. Usually, the focus-method switches on this type of lens are marked AF/M, and the feature is referred to as *autofocus with manual override* or something similar. See your lens instruction guide to find out if your lens offers this option (the kit lenses available with the camera do not). With lenses that do not offer autofocus with manual override, never turn the focusing ring without first setting the lens switch to the manual-focusing position.

Manual focusing ring Auto/Manual focus switch

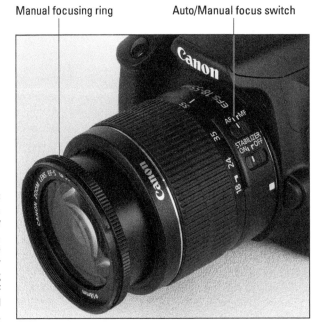

FIGURE 5-1:
On this kit lens, as on many Canon lenses, you set the switch to AF for autofocusing and to MF for manual focusing.

Exploring Viewfinder Focusing Options

Chapters 1 and 3 offer brief primers in focusing, but in case you're not reading the book from front to back, here's a quick recap of focusing basics. Remember, these instructions apply only when you use the viewfinder to compose your image; details for focusing in Live View and Movie modes come later in this chapter.

>> **To autofocus:** Frame your subject so that it appears under one of the nine focus points, one of which is labeled in Figure 5-2. Then press and hold the shutter button halfway.

Focus point

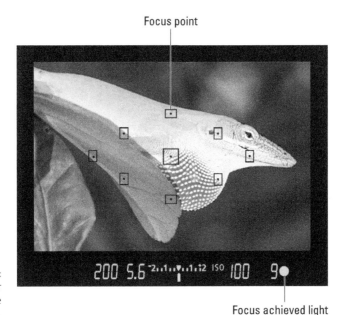

FIGURE 5-2: The viewfinder offers these focusing aids.

Focus achieved light

What happens next depends on your exposure mode:

- *Scene Intelligent Auto, Auto Flash Off, and Creative Auto:* With stationary subjects, one or more of the focus points turn red briefly to indicate the points the camera used to set the focusing distance. Then you see the viewfinder focus-achieved light, also labeled in the figure, and hear a beep. Focus remains locked as long as you hold down the shutter button halfway.

 If the camera detects subject motion, the focus indicators don't appear; instead focus is continuously adjusted as needed to track the subject until you snap the picture. The beep sounds each time the camera re-establishes focus.

For continuous autofocusing to work properly, you must adjust framing as necessary to keep the subject under the area covered by the autofocus points.

- *Sports mode:* The continuous-autofocusing setup is used.

- *All other Scene modes and P, Tv, Av, and M modes:* The camera assumes that you're shooting a stationary subject and so locks focus when you press the shutter button halfway. In the P, Tv, Av, and M exposure modes, you can vary this autofocusing behavior; see the next sections for how-to's.

» **To focus manually:** After setting the lens switch to the manual focusing position, rotate the focusing ring on the lens.

Even when focusing manually, you can confirm focus by pressing the shutter button halfway. The focus point or points that achieve focus flash for a second or two, the viewfinder's focus lamp lights, and you hear the focus-achieved beep.

By the way, if you find the focusing beep annoying, you can disable it via the Beep option on Shooting Menu 1.

Adjusting autofocus performance

In P, Tv, Av, and M exposure modes, you can tweak autofocusing behavior through the following two AF (autofocus) controls:

» **AF Point Selection:** This setting determines which focus points the camera uses to establish the focusing distance. At the default setting (Automatic Selection), all nine focus points are in play, and the camera typically focuses on the closest object. By setting this option to Manual Selection mode, you can base focus on a specific point.

SHUTTER SPEED AND BLURRY PHOTOS

A poorly focused photo isn't always related to the issues discussed in this chapter. Any movement of the camera or subject can also cause blur. Both problems relate to shutter speed, an exposure control I cover in Chapter 4. To prevent blurring caused by camera movement, mount the camera on a tripod or otherwise steady it. To prevent blurring of a moving subject, switch to the Tv (shutter-priority autoexposure) mode and dial in a faster shutter speed. (Sports mode may also solve the problem.) Also visit Chapter 7, which provides additional tips for capturing moving objects without blur.

>> **AF Operation:** This option determines whether the camera locks focus when you press the shutter button halfway or continues to adjust focus from the time you press the shutter button halfway to the time you press the button the rest of the way to take the shot.

The next sections explain both options and how to combine them to best suit your subject.

AF Point Selection: One focus point or many?

For this setting, you have two options: Automatic and Manual. With Automatic, which is the default, the camera looks at all nine focus points when establishing the focusing distance. Typically, it chooses the focus point that falls over the object closest to the lens. If you change the setting to Manual, you can base focus on a single focus point that you select.

You can change this autofocus setting only in the P, Tv, Av, and M exposure modes. Take these steps to see which option is in force and change the setting:

1. **Press and release the AF Point Selection button, highlighted in Figure 5-3.**

 You see the AF Point Selection screen on the monitor. In Automatic AF Point Selection mode, all focus points appear in color, as shown in Figure 5-4. In Manual AF Point Selection mode, only one focus point is selected and appears in color, as shown in Figure 5-5. In the figure, the center focus point is selected.

 If nothing happens when you press the AF Point Selection button, the camera may have gone to sleep to conserve battery power. Wake the camera up by pressing the shutter button halfway down and releasing it.

AF Point Selection button

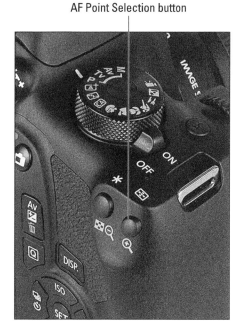

FIGURE 5-3:
Press and release the AF Point Selection button to select a focus point.

TIP

You can check the current AF Point Selection mode by looking through the viewfinder, too. When you press and release the AF Point Selection button, all nine focus points turn red in the viewfinder if you're in Automatic AF Point Selection mode. A single focus point turns red if you're in Manual AF Point Selection mode. (Again, you may need to press the shutter button halfway to wake up the viewfinder display in order for the focus points to light.)

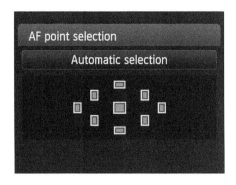

FIGURE 5-4:
In Automatic mode, all nine focus points are active.

2. **To choose a single focus point, set the camera to Manual AF Point Selection mode.**

After pressing and releasing the AF Point Selection button, you can shift from Automatic to Manual focus-point selection in two ways:

- *Rotate the Main dial.* This option is easiest when you're looking through the viewfinder.

- *Press the Set button.* Pressing the button toggles the camera between Automatic AF Point Selection and Manual AF Point Selection with the center focus

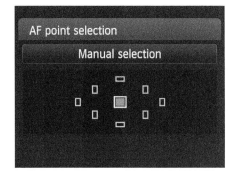

FIGURE 5-5:
You also can base autofocus on a single focus point; here, the center focus point is selected.

point activated. When Manual AF Point is active and an AF point outside the center is selected, the first press of the Set button moves the active AF point back to the center. Press Set again to switch to Automatic selection mode.

3. **If you set the camera to Manual AF Point Selection, specify which AF Point you want to use.**

After you see the screen shown in Figure 5-5 (or its counterpart in the viewfinder), rotate the Main dial or press the cross keys to select a focus point. When all focus points again turn red, you've cycled back to Automatic mode. Rotate the Main dial or press a cross key to switch back to Manual Point Selection.

Exit the point selection screen by pressing the AF Point Selection button or by pressing the shutter button halfway and releasing it.

Changing the AF Operation mode

The other autofocusing option you can control in the P, Tv, Av, and M modes is the AF Operation mode, which determines if and when the camera locks focus. You have the following choices:

>> **One-Shot AF:** In this mode, which is geared to shooting stationary subjects, the camera locks focus when you press the shutter button halfway down. Focus remains locked as long as you hold the shutter button at the halfway position.

WARNING

If the camera can't achieve focus, the focus indicator at the right end of the viewfinder display blinks. Until you fix the problem, you can't take the picture, even if you press the shutter button all the way down. The camera won't release the shutter in One-Shot AF mode until focus is achieved.

The following scene modes use the One-Shot AF mode: Portrait, Landscape, Close-Up, Food, and Night Portrait.

>> **AI Servo:** In this mode (the *AI* stands for *artificial intelligence*), the camera adjusts focus continually from the time you press the shutter button halfway until you press the button the rest of the way to take the picture. This mode makes focusing on moving subjects easier, which is why it's the option used by the Sports scene mode.

REMEMBER

If the camera is set to Automatic AF Point Selection (all nine focus points are active), the camera initially bases focus on the center focus point. So frame the shot initially with your subject under that point. If the subject moves away from the point, focus should still be okay as long as you keep the subject within the area covered by one of the other focus points. With Manual AF Point Selection, be sure to adjust framing as needed to keep your subject under the selected focus point. (Remember, Sports mode always uses Automatic AF Point selection, so frame your subject initially so that it falls under the center focus point.)

Regardless of the AF Point Selection setting, the focus-achieved light in the viewfinder blinks rapidly if the camera can't track focus successfully. If all is going well, on the other hand, the focus dot doesn't light at all, and you don't hear the beep that normally sounds when focus is achieved. (You can hear the autofocus motor whirring a little when the camera adjusts focus.)

>> **AI Focus:** This mode automatically switches the camera from One-Shot to AI Servo as needed. When you first press the shutter button halfway, focus is locked on the active focus point (or points), as usual in One-Shot mode. But if the subject moves, the camera shifts into AI Servo mode and adjusts focus as it thinks is warranted. AI Focus is always in force when you shoot in the Scene Intelligent Auto, Flash Off, and Creative Auto exposure modes.

I prefer not to use AI Focus because I don't want to rely on the camera to figure out whether I'm interested in a moving or stationary subject. So I stick with One-Shot for stationary subjects and AI Servo for focusing on moving subjects.

TIP

One way to remember which mode is which: For still subjects, you only need *one shot* at setting focus. For moving subjects, think of a tennis or volleyball player *serving* the ball — so AI *Servo* for action shots.

The Shooting Settings screen displays the current AF Operation setting in the area labeled in Figure 5-6. Change the setting as follows:

>> **AF Operation button (right cross key):** Your fastest move is to press this button, labeled in Figure 5-7. It takes you directly to the settings screen shown in the figure. Highlight your choice and press the Set button.

>> **Quick Control screen:** After activating the Quick Control screen, highlight the AF mode setting (labeled in Figure 5-6). The selected AF mode setting appears toward the bottom of the screen. Rotate the Main dial to cycle through the three mode options. Or press Set to access the same selection screen shown on the camera monitor in Figure 5-7.

AF Operation mode

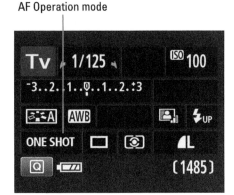

FIGURE 5-6:
Look here for the current AF Operation setting.

Press to display AF Operation screen

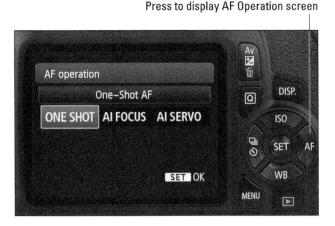

FIGURE 5-7:
The fastest way to access the AF Operation setting is to press the right cross key.

Choosing the right autofocus combo

TIP

You'll get the best autofocus results if you pair your chosen AF Operation mode with the most appropriate AF Point Selection mode because the two settings work in tandem. Here are the combinations that I suggest:

>> **For still subjects: One-Shot AF Operation and Manual AF Point Selection.** Select a focus point and then frame your subject so that it's under that point. Or go the other direction, framing your subject and then moving a focus point over it. Either way, press the shutter button halfway to set the focusing distance. As long as you keep the button pressed halfway, the focusing distance remains the same, even if you reframe the shot before pressing the shutter button all the way to take the picture.

>> **For moving subjects: AI Servo AF Operation and Automatic AF Point Selection.** Begin by framing your subject so that it's under the center focus point. (Remember, when you combine AI Servo with Automatic AF Point Selection, the camera chooses the center focus point to establish the initial focusing distance.) Press the shutter button halfway to set the starting focusing distance and then reframe as needed to recompose the shot or to follow your subject's movement. As long as you keep the shutter button pressed halfway, focus is adjusted to track your subject's movement up to the time you take the shot.

TIP

Although I most often use the setup just described when shooting moving subjects, on some occasions, Manual AF Point Selection — which activates only a single focus point — can be a better option than Automatic (all nine points active). For example, if you're photographing a tuba player in a marching band, you want the camera to track focus on just that musician. With Automatic AF Point Selection, the camera may have a hard time figuring out which moving subject to follow, so focus may drift to a nearby band member.

The difficulty with having just one focus point active is that you must reframe as needed to keep your subject under the point you selected. I like to use the center focus point with this setup; I find it more intuitive because I just reframe as needed to keep my subject in the center of the frame. (You can always crop your image to achieve a different composition after the shot.)

Keeping these autofocusing combos in mind should improve your focusing accuracy. But sometimes, no combination of the two autofocus settings will enable speedy or correct autofocusing. For example, very reflective subjects and subjects under water (such as koi swimming in a pond) don't provide the sharp edges and visual contrast that the camera uses to determine focusing distance. As a result, the camera may hunt for a focus point forever. And if you try to focus on a subject behind a screened or glass enclosure, such as when photographing animals at the

zoo, the autofocus system may insist on focusing on the screen or window and not your intended subject. In such scenarios, don't waste time fooling around with the autofocus settings — switch to manual focusing and set the focusing distance yourself.

Focusing During Live View and Movie Shooting

As with viewfinder photography, you can opt for autofocusing or manual focusing during Live View and movie shooting, assuming that your lens supports autofocusing. But focus options and techniques differ from those you use for viewfinder photography.

One big difference is that Live View and Movie mode enable you to make just one adjustment to autofocusing performance, via a setting called AF Method. In addition, there is no such thing as continuous autofocusing in Live View or Movie mode.

WARNING

It's also important to understand that the camera typically takes longer to autofocus in Live View mode than it does during viewfinder photography — the difference is because of the type of autofocusing the camera must use when in Live View. For the fastest autofocusing response during still photography, take the camera out of Live View mode. Unfortunately, Live View is the only game in town for movie recording; you can't use the viewfinder to frame and focus movie shots.

The next several sections provide details on Live View and Movie mode auto focusing and also discuss an option that can come in handy for both autofocusing and manual focusing.

Choosing the AF Method

Remember, for Live View and Movie shooting, you have to pay attention to just one autofocusing setting: AF Method. You get three choices:

AF ▢ » **FlexiZone-Single mode:** This mode is easiest to use and is the default setting. You simply place an onscreen focus frame over your subject to specify where the camera should establish focus.

AF ☺ » **(Face Detection) Live mode:** If the camera detects a face, it automatically focuses on that face. When no face is detected, the camera operates as it does in FlexiZone-Single mode.

AF Quick

» **Quick mode:** This mode, which works similarly to the 9-point focus system used for viewfinder shooting, offers the fastest Live View autofocusing. The downside is that the Live View display turns off temporarily as the camera sets focus.

To see which setting is currently in force, look in the area highlighted in Figure 5-8. This icon represents the AF Method setting; the symbol shown in the figure is for the FlexiZone-Single mode.

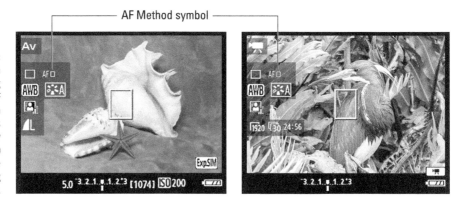

FIGURE 5-8: An icon representing the AF Operation mode appears for Live View shooting (left) and Movie recording (right).

REMEMBER

Don't see the icon? Press DISP to cycle through the various display modes until one appears. What other data shows up depends both on the display mode and your exposure mode.

You can choose which setting you want to use in any exposure mode — you're not limited to using only the P, Tv, Av, or M exposure modes as you are with many camera settings. To change the AF Method setting, use either of these methods:

» **Quick Control screen:** After pressing the Q button, select the icon that represents the AF Method, as shown on the left in Figure 5-9. The name of the current setting appears at the bottom of the screen. Rotate the Main dial to cycle through the available settings or press Set to display the selection screen shown on the right in the figure. (The figure shows the Live View version of the screen, but things work similarly in Movie mode.)

» **Menus:** For still photography in the P, Tv, Av, and M exposure modes, look for the AF Method option on Shooting Menu 4, as shown on the left in Figure 5-10. In other still photography modes, the setting is on Shooting Menu 2. For Movie recording, the option lives on Movie Menu 1, as shown on the right in the figure.

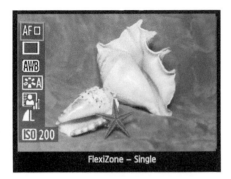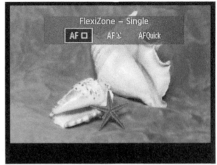

FIGURE 5-9:
You can adjust
the AF Method
via the Quick
Control screen.

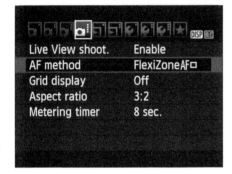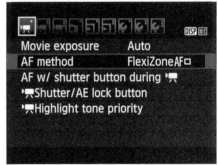

FIGURE 5-10:
You also can
adjust the AF
Method setting
via the menus.

The next sections provide more details on focusing using each AF Method.

FlexiZone-Single autofocusing

In this autofocus mode, you see a focus frame at the center of the screen, as shown on the left in Figure 5-11. The figure shows the Live View display; in Movie mode, the focus frame looks the same. Either way, use the cross keys to move the frame over your subject.

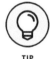

TIP

Press the Set button to immediately move the focus frame back to the center position. *Note:* If you use Custom Function 9 to reassign the Set button's function to any option but the default (Normal), you must press and hold the Erase button while pressing Set to center the focus frame. See Chapter 11 to find out how to change the function of the Set button.

After positioning the focus frame, press the shutter button halfway to start autofocusing. The focus frame turns green when focus is achieved, as shown on the right in the figure. (I moved the frame over the starfish before setting focus.) The camera also emits a beep, unless you turned off that function (through the Beep option on Shooting Menu 1). If the camera can't focus on the spot you selected, the frame turns red.

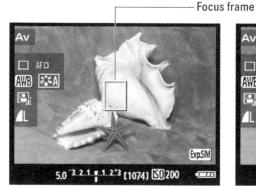

Focus frame

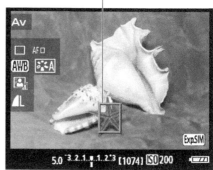

(Face Detection) Live mode

AF 😊 When you enable this mode, the camera searches for faces in the frame. You may need to give the shutter button a quick press and release to wake up the camera before the face-detection feature engages. If a face is detected, the camera displays a focus frame over the face, as shown on the left in Figure 5-12. In a group shot where more than one face is recognized by the camera, you see arrows on either side of the focus frame. To choose a different face as the focusing target, press the cross keys to move the target frame over the face.

Face-detection focus frame

Focus achieved

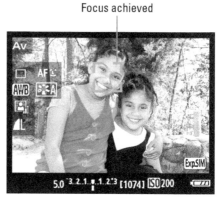

FIGURE 5-12:
The white frame represents the face chosen for focusing; the frame turns green when focus is achieved.

To focus, press and hold the shutter button halfway down. When focus is locked, the focus frame turns green, as shown on the right in the figure, and the camera emits a tiny beep. If focus isn't successful, the focus frame turns red.

When the conditions are just right in terms of lighting, composition, and phase of the moon, this setup works fairly well. However, it has a number of issues:

» People must be facing the camera to be detected — the feature is based on the camera recognizing the pattern created by the eyes, nose, and mouth. So if you're shooting the subject in profile, don't expect face detection to work.

» The camera may mistakenly focus on an object that has a similar shape, color, and contrast to a face.

» Face detection sometimes gets tripped up if the face isn't just the right size with respect to the background, is tilted at an angle, is too bright or dark, or is partly obscured.

» Autofocusing isn't possible when a subject is very close to the edge of the frame. The camera alerts you to this issue by displaying a gray frame instead of a white one over your subject. You can always temporarily reframe to put the subject within the acceptable autofocus area, press and hold the shutter button halfway to lock focus, and then reframe to your desired composition.

If the camera can't detect a face, the autofocus system operates as it does when FlexiZone-Single mode is active. You also can press the Set button to display the FlexiZone-Single focus frame at any time. On occasion, you may need to set initial focus using the focus frame before the camera can detect a face. (This scenario can occur if the subject is seriously out of focus when you switch to the face-detection autofocusing mode.)

Quick mode autofocusing

As its name implies, Quick mode offers the fastest autofocusing during Live View or movie shooting — not so much in terms of the time it takes you to set things up, but in terms of how fast the camera can lock onto a focus target. In fact, Canon recommends that you use this mode when shooting with certain EF lenses; the list of affected lenses is provided in the camera manual. With those lenses, the other autofocus modes can be problematic.

In addition, this mode has one other benefit: It's based on the same nine-point focusing grid used for viewfinder photography, so it may feel more familiar to you than the other Live View and Movie mode AF methods. I labeled two of the nine focus points in the left screen in Figure 5-13. (The large rectangle in the center of the frame is *not* a focus point in this case; instead, it's used to magnify a portion of the subject to check focus. See the section "Zooming in for a focus check," later in this chapter, for details.)

Quick Mode focus points

Quick Control screen selection box

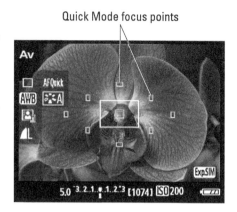

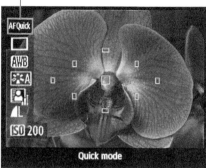

So why isn't Quick mode the default setting? Well, it's a little more complex to use. In addition, the monitor display goes dark during the time the camera is focusing, which can throw off the unsuspecting photographer. If those limitations don't affect you, here's what you need to know about using Quick mode.

First, press the Q button to enter Quick Control mode and set the AF mode to Quick. You then see nine autofocus points in the center of the screen.

At this point, things differ depending on your exposure mode. In Scene Intelligent Auto, Flash Off, Creative Auto, and the scene modes (Portrait, Landscape, and so on), the camera automatically selects which of the nine points to use when focusing. Typically, focus is established on the closest object.

In P, Tv, Av, or M exposure mode, you can stick with the automatic point selection or choose one of the nine points. After setting the AF Method to Quick, take these steps to establish your preference:

1. **Press the Q button to activate the Quick Control screen.**

2. **Highlight the AF Quick option, as shown in Figure 5-14.**

3. **Press the up cross key to activate the focus-point display.**

 The active focus points turn red. By default, the Automatic mode is selected, and all nine points are active, as shown on the left in Figure 5-14. The name of the setting appears at the bottom of the screen.

4. **To change to single-point selection, rotate the Main dial.**

 All focus points but one turn gray, as shown on the right in Figure 5-14. The selected focus point remains red — the center point, in the figure.

5. **To choose a different point, rotate the Main dial.**

 When you cycle through all the points, the camera shifts back to the 9-point, Automatic mode.

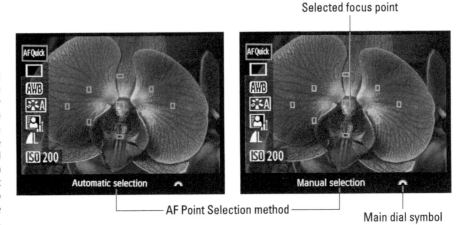

Selected focus point

FIGURE 5-14:
Press the up command key to activate the point selection screen; rotate the Main dial to switch from Automatic mode (left) to Manual mode (right).

Automatic selection

Manual selection

AF Point Selection method

Main dial symbol

6. **To exit the focus-point screen and return to the Quick Control screen, press the down cross key.**

7. **To exit the Quick Control screen, press the Q button.**

TIP

The most confusing (and aggravating) aspect about this autofocusing setup is remembering that you have to press the up cross key to access the option that enables you to switch between auto and manual focus-point selection. And after you get to the selection screen, you have to remember not to use the cross keys to choose a different point — which at least to me, seems to be the natural way to go. Instead, you rotate the Main dial to select a different focus point. The wheel icon at the right end of the mode name, labeled in Figure 5-14, reminds you of this fact. But there's no hint to help you remember that it's the up cross key that activates the focus point selection screen. As I said, this mode is a little more complex to use than the others.

Anyway, after you choose to use all points (Automatic selection) or a single point (Manual selection), set focus by pressing and holding the shutter button halfway down. The monitor turns off, and the autofocusing mechanism kicks into gear. (It may sound as though the camera took the picture, but don't worry — that isn't actually happening.) When focus is achieved, the Live View display reappears, and in Automatic selection mode, one or more of the focus points appears green to tell you which areas of the frame are in focus. For Manual selection, just your chosen point turns green. Focus remains locked as long as you keep the shutter button pressed halfway; press the button the rest of the way to take the picture.

If the camera can't find a focusing target, the focus point (or points) turns red and blinks. Try using manual focusing, explained next, or getting a little farther from your subject — you may be so close that you're exceeding the minimum focusing distance of the lens.

Manual focusing in Live View and Movie modes

Manual focusing is the easiest of the Live View focusing options — and in most cases, it's faster, too.

After setting the lens to the manual focusing position, rotate the lens focusing ring to set focus. Note that the monitor data provides no indication that you changed to manual focusing: The AF Method option still appears (depending on the data-display mode you select), and you can even change the AF Method setting. But when you press the shutter button halfway, autofocusing doesn't occur.

TIP

Most people who shy away from manual focusing do so because they don't trust their eyes to judge focus. But thanks to a feature that enables you to magnify the Live View preview, you can feel more confident in your manual focusing skills. See the next section for details.

Zooming in for a focus check

Here's a cool focusing feature not available during viewfinder photography: You can magnify the Live View display to ensure that focus is accurate. This trick works during manual focusing or in any AF mode except (Face Detection) Live mode.

After setting focus, follow these steps to magnify the display:

1. **Use the cross keys to move the focusing frame over your subject if needed.**

 I labeled the frame Magnification (focus) frame on the left in Figure 5-15. In FlexiZone-Single autofocusing mode or when you use manual focusing, this is the only frame you see. But in Quick autofocusing mode, this frame plays no role in autofocusing — it's simply used for the magnification feature. (You can see the frame in the left screen in Figure 5-13.)

2. **Press the AF Point Selection button to magnify the display.**

 After you press the button, you see a magnification frame somewhere on the screen plus a white box in the lower-right corner, as shown on the right in Figure 5-15. The white rectangle is a thumbnail representing the entire image area.

 The value x5 appears above the thumbnail to show you that you're viewing the image at five times its regular size. Press the AF Point Selection button again to zoom the view to 10 times magnification. You can scroll the display as needed by pressing the cross keys.

3. **To exit magnified view, press the AF Point Selection button again.**

Magnification (focus) frame Magnified area

FIGURE 5-15:
Press the AF
Point Selection
button to
magnify the
display and
check focus.

Pretty cool, yes? Just a couple of tips on using this feature:

>> Press the Set button to quickly shift the magnification frame back to the center of the screen.

>> Exit magnified view before you actually take the picture. Otherwise exposure may be off. However, if you *do* take the picture in magnified view, the entire frame is captured — not just the area currently displayed on the monitor.

Manipulating Depth of Field

Getting familiar with the concept of depth of field is one of the biggest steps you can take to becoming a better photographer. The section in Chapter 4 that explains the aperture setting introduces you to depth of field, but here's a quick recap:

>> *Depth of field* refers to the distance over which objects in a photograph appear acceptably sharp.

>> With a shallow depth of field, the subject is sharp, but objects both in front of and behind it appear blurry. The farther an object is from the subject, the blurrier it looks.

>> With a large depth of field, the zone of sharp focus extends to include objects at a greater distance from your subject.

Which arrangement works best depends on your creative vision and your subject. In portraits, for example, a classic technique is to use a shallow depth of field, as in the example shown in Figure 5-16. But for landscapes, you might choose to use a large depth of field, as shown in Figure 5-17. Because the historical marker, the lighthouse, and the cottage are all sharp, they have equal visual weight in the scene.

Again, though, which part of the scene appears blurry when you use a shallow depth of field depends on the spot at which you establish focus. Consider the lighthouse scene: Suppose you opted for a short depth of field and set focus on the lighthouse. In that case, both the historical marker in the foreground and the cottage in the background might be outside the zone of sharp focus.

Shallow Depth of Field

FIGURE 5-16:
A shallow depth of field blurs the background and draws added attention to the subject.

REMEMBER

So how do you manipulate depth of field? You have three points of control: aperture, lens focal length, and subject-to-camera distance. Here's what you need to know about each factor:

>> **Aperture setting (f-stop):** The aperture is one of three main exposure settings, all explained fully in Chapter 4. Depth of field increases as you stop down the aperture (by choosing a higher f-stop number). For shallow depth of field, open the aperture (by choosing a lower f-stop number).

Figure 5-18 offers an example. Notice that the tractor in the background is much sharper in the first image, taken at a setting of f/20, than in the second version, shot at f/2.8. For both pictures, I used the same focal length (93mm).

>> **Lens focal length:** *Focal length,* which is measured in millimeters, determines what the lens "sees." As you increase focal length, the angle of view narrows, objects appear larger in the frame, and — the important point in this discussion — depth of field decreases. Additionally, the spatial relationship of objects changes as you adjust focal length.

For example, Figure 5-19 compares the same scene shot at focal lengths of 138mm and 255mm. The aperture setting was f/22 for both examples.

Whether you have any focal-length flexibility depends on your lens: If you have a zoom lens, you can adjust the focal length by zooming in or out. If your lens offers only a single focal length — a *prime* lens in photo-speak — scratch this means of manipulating depth of field (unless you want to change to a different prime lens, of course).

>> **Camera-to-subject distance:** When you move the lens closer to your subject, depth of field decreases. This statement assumes that you don't zoom in or out to reframe the picture, thereby changing the focal length. If you do, depth of field is affected by both the camera position and focal length.

Large depth of field

FIGURE 5-17:
A large depth of field keeps both near and far subjects in sharp focus.

f/20, 93mm

f/2.8, 93mm

FIGURE 5-18: Lowering the aperture setting from f/20 to f/2.8 decreased depth of field.

138mm, f/22 255mm, f/22

REMEMBER

Together, these three factors determine the maximum and minimum depth of field that you can achieve, as follows:

>> **To produce the shallowest depth of field:** Open the aperture as wide as possible (select the lowest f-stop number), zoom in to the maximum focal length of your lens, and move as close as possible to your subject.

>> **To produce maximum depth of field:** Stop down the aperture to the highest possible f-stop setting, zoom out to the shortest (widest) focal length your lens offers, and move farther from your subject.

Here are a few additional tips related to depth of field:

>> **Aperture-priority autoexposure mode (Av) enables you to easily control depth of field while enjoying exposure assistance from the camera.** In this mode, you rotate the Main dial to set the f-stop, and the camera selects the appropriate shutter speed to produce a good exposure. The range of available aperture settings depends on your lens.

WARNING

If you adjust aperture to affect depth of field, keep an eye on shutter speed as well. To maintain the same exposure, shutter speed must change in tandem with aperture, and you may encounter a situation where the shutter speed is too slow to permit handholding the camera or capturing a moving subject

without blur. You can raise the ISO setting to make the image sensor more reactive to light, which enables a faster shutter speed, but remember that higher ISO settings can produce noise.

>> **In Creative Auto mode, you can use the Blur Background slider to adjust depth of field.** See Chapter 3 for details about this exposure mode. Note that the Blur Background feature is disabled if you use flash.

>> **For greater background blurring, move the subject farther from the background.** The extent to which background focus shifts as you adjust depth of field also is affected by the distance between the subject and the background.

>> **You can assign the Set button to provide a depth-of-field preview.** When you view your image through your viewfinder or on the Live View screen, you can see the effect of focal length and the camera-to-subject distance. But because the aperture doesn't actually stop down to your selected f-stop until you take the picture, the displays can't show you how that setting will affect depth of field.

Through Custom Function 9, however, you can assign the Set button to provide a depth-of-field preview. Choose option 4, as shown in Figure 5-20, to take advantage of this feature. Remember, you can access Custom Functions only in the P, Tv, Av, and M exposure modes.

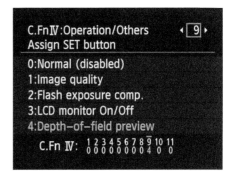

FIGURE 5-20:
If you select this Custom Function setting, you can press the Set button to display a depth-of-field preview.

Depending on the selected f-stop, the scene in the viewfinder or Live View display may get darker when you initiate the preview. This effect doesn't mean that your picture will be darker; it's just a function of how the preview works. The camera shows the effect of the aperture setting on the exposure — remember that a higher f-stop setting results in less light entering the camera. But the depth-of-field preview doesn't take into account the role that shutter speed or ISO will have on the final exposure. In Live View mode, the Exp Sim (Exposure Simulation) symbol blinks to let you know that you're not seeing an accurate display of the final exposure.

Chapter **6**

Mastering Color Controls

ompared with understanding certain aspects of digital photography — resolution, aperture, shutter speed, and so on — making sense of your camera's color options is easy-breezy. First, color problems aren't that common, and when they are, they're usually simple to fix by changing the White Balance setting. And getting a grip on color requires learning only a few new terms, an unusual state of affairs for an endeavor that often seems more like high-tech science than art.

This chapter explains the White Balance control along with other features that enable you to fine-tune colors, whether you're shooting photos or recording movies.

Understanding the White Balance Setting

Every light source emits a particular color cast. The old-fashioned fluorescent lights found in most public restrooms, for example, put out a bluish-green light, which is why our reflections in the mirrors in those restrooms look so sickly. And if you think that your beloved looks especially attractive by candlelight, you aren't imagining things: Candlelight casts a yellow-red glow that's flattering to the skin.

Science-y types measure the color of light, or *color temperature,* on the Kelvin scale, which is named after its creator. You can see an illustration of the Kelvin scale in Figure 6-1.

When photographers talk about "warm light" and "cool light," though, they aren't referring to the position on the Kelvin scale — or at least not in the way we usually think of temperatures, with a higher number meaning hotter. Instead, the terms describe the visual appearance of the light. Warm light, produced by candles and incandescent lights, falls in the red-yellow spectrum you see at the bottom of the Kelvin scale; cool light, in the blue-green spectrum, appears at the top of the scale.

FIGURE 6-1:
The Kelvin scale measures the color temperature of light sources.

At any rate, most of us don't notice these fluctuating colors of light because our eyes automatically compensate for them. Except in extreme lighting conditions, a white tablecloth appears white to us no matter whether we view it by candlelight, fluorescent light, or sunlight. Similarly, a digital camera compensates for different colors of light through a feature known as *white balancing.*

Simply put, white balancing neutralizes light so that whites are always white, which in turn ensures that other colors are rendered accurately. If the camera senses warm light, it shifts colors slightly to the cool side of the color spectrum; in cool light, the camera shifts colors in the opposite direction.

Your camera's Automatic White Balance (AWB) setting tackles this process well in most situations. If your subject is lit by a variety of light sources, however, the camera may stumble, resulting in an unwanted color cast. Whether you can adjust camera settings for better results on your next shot depends on your exposure mode, as follows:

>> **Auto and Flash Off:** Sorry, you can't access any color adjustments in these modes.

>> **Scene modes:** In all scene modes except Food, you can use the Ambience option to make colors warmer or cooler. Food mode offers a Color Tone slider that provides the same warming or cooling adjustment. In Portrait, Close-up, Sports, and Landscape modes, you can do further color tweaking via the Lighting or Scene Type setting. I detail these options in Chapter 3.

>> **Creative Auto:** This mode gives you access to the Ambience option.

>> **P, Tv, Av, and M:** Instead of providing the features I just mentioned, these exposure modes enable you to choose a setting other than Auto for the White Balance option. You also get a number of ways to fine-tune any white-balance setting. The next few sections explain these choices.

Adjusting the White Balance setting

An icon representing the current White Balance setting appears in the Shooting Settings and Live View displays, in the areas labeled in Figure 6-2. Figure 6-3 offers a guide to the symbols used to represent each setting.

Upcoming sections provide details on a quirk regarding the Auto setting and on how to create a custom White Balance setting. For now, familiarize yourself with the ways you can access the White Balance setting.

TIP

CREATING A RAW SAFETY NET

When color accuracy is vital, you can give yourself a safety net by setting the picture file type to Raw (Image Quality option, Shooting Menu 1). With Raw capture, your image file contains "uncooked" data, with none of the color, exposure, and sharpness adjustments that occur when capturing images using the other file type available on your camera, JPEG. (Which adjustments the camera makes to a JPEG file depends on such settings as your exposure mode, White Balance setting, and Picture Style setting.)

To enable you to view Raw pictures during picture playback, the camera creates a JPEG preview of the image, and that preview is based on the settings that would have been used if you shot the photo in the JPEG format. But exposure, color, and other picture characteristics aren't finalized until you convert the Raw file into a standard file format. Raw files also contain slightly more original image data than a JPEG file.

In short, working with Raw data gives you a better chance of being able to correct color and exposure problems than if you start with a JPEG file. It's no guarantee that you can rescue a picture that has serious issues, but it's definitely a better starting point than JPEG.

This chapter covers the White Balance and Picture Style options. Chapter 2 explains Raw and JPEG in detail; Chapter 10 shows you the Raw file-conversion process. Also check out Chapter 11, which explains a third color-related option, Color Space.

White Balance setting

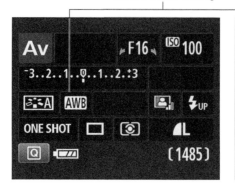
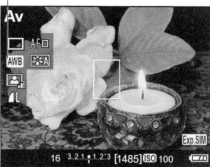

FIGURE 6-2:
AWB stands
for Auto White
Balance.

Auto Daylight Cloudy White Fluorescent Custom

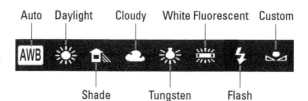

FIGURE 6-3:
These symbols
represent
the available
White Balance
settings.

Shade Tungsten Flash

For viewfinder photography — that is, Live View is not engaged — you can use
either of the following methods:

>> **Press the WB button (down cross key, labeled in Figure 6-4):** You see the
selection screen shown on the camera monitor in the figure. Use the cross
keys or Main dial to scroll through the available settings. The text label atop
the row of symbols tells you the name of each setting. In some cases, as in the
figure, you also see the approximate Kelvin value that the setting is designed
to handle.

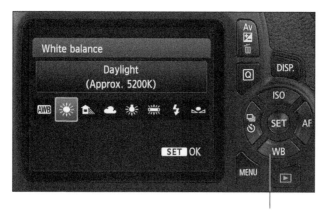

FIGURE 6-4:
The WB button
takes you to
the White
Balance setting
screen but
isn't available
for Live View
photography
or Movie
recording.

Press to display White Balance options

>> **Use Quick Control screen:** Press the Q button to shift to Quick Control mode and then highlight the White Balance option (refer to Figure 6-2 for its location). After you highlight the option, the name of the current setting appears at the bottom of the screen. You can either rotate the Main dial to change the setting or press the Set button to access the same selection screen shown in Figure 6-4.

REMEMBER

During Live View shooting, the WB button performs a function related to focusing, so you must use the Quick Control screen to change the setting. But Live View gives you a White Balance feature not available for viewfinder shooting: As you adjust White Balance, the monitor updates to show you the effect of the setting on the subject colors. So go this route if you're not sure which White Balance option will produce the best results. (You can always switch back to viewfinder mode to take the picture.)

A few other details to remember:

WARNING

>> Your selected White Balance setting remains in force until you change it. So this is one option you should check before each shoot. I usually start out in Auto mode, take a test shot, and then modify the setting if needed.

>> If your scene is lit by several sources, the White Balance setting that corresponds to the strongest light source usually works best unless you're using flash. In that case, the flash setting typically produces more accurate colors.

>> When your light source is in the incandescent color range — some household bulbs fit this category — the default Auto mode may leave colors slightly warmer than neutral. See the next section to find out why and, more importantly, how to resolve the issue.

>> If none of the settings produce accurate colors, try using the advanced White Balance options outlined in the next three sections. You can create a custom setting and store it in the camera's memory or fine-tune any of the existing settings. Also consider setting the Image Quality option to Raw, as discussed in the sidebar "Creating a Raw safety net," elsewhere in this chapter.

Changing the Auto "priority" setting

As if your photographic life weren't complicated enough, Canon recently added a wrinkle to its automatic white-balancing system: You can set the Auto option to perform in one of two ways. However, the difference matters only when you shoot in incandescent lighting or light sources that emit a similarly warm hue, such as tungsten studio lights. (Refer to the Kelvin chart in Figure 6-1.)

The two Auto White Balance (AWB) settings are Ambience Priority Auto and White Priority Auto. They work as follows:

>> **Ambience Priority AWB retains a little of the warm color cast when rendering colors in your image.** The idea, I suppose, is that the warming of colors is usually flattering to skin tones, which makes people happier with portrait results. At any rate, Ambience Priority AWB produces the same results that Auto White Balance delivered in previous versions of Canon dSLR cameras, which is why it's the default setting for the P, Tv, Av, and M exposure modes and for all other exposure modes except Food.

>> **White Priority AWB eliminates the warm color cast.** In other words, this setting produces the results that most people expect from Auto mode, which is an accurate rendition of colors. Whites appear white instead of slightly yellow, for example. This mode is used by the Food scene mode, which is part of the reason that Food mode makes your meal look "bright and appetizing," per the Canon instruction manual.

If you use flash, the White Priority AWB deal is off. Even if you select White Priority, the camera uses the same color-compensating formula as it does in Ambience Priority mode. Oh, and just to confuse matters more, the displays still indicate that White Priority AWB is in effect.

The good news is that in most cases, the AWB setting you select won't make a whit of difference. Again, it only tweaks colors if you're shooting in incandescent lighting. Even then, how much your picture is affected depends on your subject, the intensity of the incandescent light, and whether any other lights that have different color temperatures are also hitting the subject. In Figure 6-5, the orchid was lit only by incandescent light, so the Ambience Priority example (left image) does have warmer colors than the White Priority example (right image). Yellow parts of the petals became more so, and the white and red areas take on a slight golden cast as well. But sometimes, it's difficult to detect any difference between the results of the two settings.

To specify which priority you want to use, first select Auto (AWB) from the White Balance setting screen, as shown on the left in Figure 6-6. You can get to this screen by pressing the WB button (viewfinder shooting only) or by displaying the Quick Control screen, highlighting the White Balance option, and pressing the Set button. After making sure that the AWB symbol is selected, press the DISP button to bring up the screen shown on the right in Figure 6-6. (Notice the label at the bottom of the left screen in the figure; it reminds you to use the DISP button to access the AWB adjustment screen.) After you get to the adjustment screen, called Detail Settings (huh?), highlight your choice and press Set. You're returned to the main settings screen; press Set again to exit to the Quick Control screen. To return to shooting, press the shutter button halfway and release it.

Ambience Priority Auto

White Priority Auto

FIGURE 6-5:
When you shoot in incandescent light, Ambience Priority AWB may result in warmer colors than White Priority AWB.

FIGURE 6-6:
With the Auto (AWB) setting selected, press the DISP button to access the control for setting the Auto White Balance mode to White Priority or Ambience Priority.

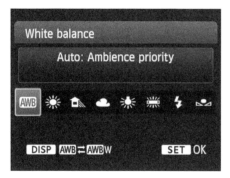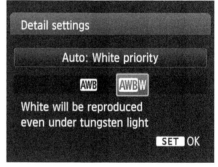

Creating a custom White Balance setting

Through the Custom White Balance option, you can create a White Balance setting that's based on the color of the light hitting your subject, whether that light comes from one or many sources. To use this technique, you need a piece of neutral gray card stock. You can buy reference cards made for this purpose in many camera stores.

The following steps take you through the process of creating a custom White Balance setting for still photography:

1. **Position the reference card in the lighting you plan to use for your subject.**

2. **Set the camera to the P, Tv, Av, or M exposure modes.**

 You can't use this feature in other modes.

3. **Take a picture of the reference card.**

 Frame the shot so that the reference card fills the viewfinder or, if you're using Live View, the monitor. For best results, focus manually. (The camera may not be able to autofocus because the reference card is all one color.)

4. **Display Shooting Menu 2 and highlight Custom White Balance, as shown on the left in Figure 6-7.**

5. **Press Set to display the screen shown on the right in Figure 6-7.**

 The reference image you just captured should appear in the display, along with a message that tells you that the camera will display only that image and others that are compatible with the Custom White Balance option. If your reference picture doesn't appear on the screen, press the right or left cross key to scroll to it.

 Note that your screen may contain data additional to what you see in the figure, depending on your playback display setting. Press the DISP button to cycle through the various data displays, and see Chapter 9 for more about playback options.

6. **Press Set to select the displayed image as the basis for your custom White Balance reference.**

 You're asked to confirm that you want to use the image to create the Custom White Balance setting.

7. **Press the right cross key to highlight OK and then press Set.**

 A message tells you that the custom setting is stored. The icon in the message area represents the custom setting. (Refer to Figure 6-3.)

8. **Press Set one more time to finalize things.**

You can use your custom setting when shooting movies as well; just select the Custom option as the White Balance setting. If you want to create a new custom setting for your movie lighting, however, use this variation on the process: Follow Steps 1–3 to take your reference picture. Then set the Mode dial (top of the camera) to Movie mode, bring up Movie Menu 3, and select Custom White Balance on that menu. From there, continue on with Steps 5–8.

Either way, your custom setting remains stored until the next time you work your way through the steps.

Using White Balance Correction to fine-tune settings

In addition to creating a custom White Balance setting, you can tell the camera to shift all colors toward a particular part of the color spectrum no matter what White Balance option is in force. If you think that your camera overdoes reds in all your pictures, for example, you can implement this feature to eliminate some of that red bias. Just remember that the adjustment you make applies to *all* White Balance settings, even a custom setting that you create.

With that warning in mind, follow these steps to use the fine-tuning feature:

1. **Set the Mode dial to P, Tv, Av, or M.**

2. **Display Shooting Menu 2 and highlight WB Shift/Bkt, as shown on the left in Figure 6-8.**

 The first two numbers next to the option name indicate the current amount of fine-tuning, or *shift,* and the second value represents the amount of White Balance Bracketing enabled. (See the next section for details on that topic.)

3. **Press Set to display the screen you see on the right in Figure 6-8.**

 The screen contains a grid that's oriented around two color pairs: green and magenta (represented by the G and M labels) and blue and amber (represented by B and A). The little white square indicates the amount of White Balance Shift. When the square is dead center in the grid, as it is initially, no shift is applied.

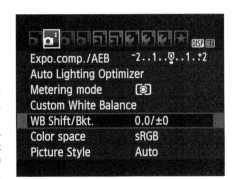
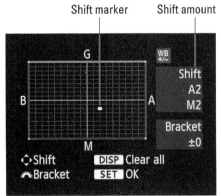

Shift marker Shift amount

G

B A

M

Shift
A2
M2

Bracket
±0

◇Shift DISP Clear all
Bracket SET OK

Expo.comp./AEB -2..1..0..1.:2
Auto Lighting Optimizer
Metering mode
Custom White Balance
WB Shift/Bkt. 0,0/±0
Color space sRGB
Picture Style Auto

FIGURE 6-8:
White Balance
Correction
fine-tunes
the current
White Balance
setting.

4. **Use the cross keys to move the shift indicator marker in the direction of the shift you want to achieve.**

As you do, the Shift area of the display tells the amount of color bias you've selected. For example, in Figure 6-8, the shift is two levels toward amber and two toward magenta.

TECHNICAL STUFF

If you're familiar with traditional lens filters, you may know that the density of a filter, which determines the degree of color correction it provides, is measured in *mireds* (pronounced "my-reds"). The White Balance grid is designed around this system: Moving the marker one level is the equivalent of adding a filter with a density of 5 mireds.

5. **Press Set to apply the change and return to the menu.**

After you apply White Balance Correction, the shift amount appears alongside the WB Shift/Bkt setting on Shooting Menu 2, as shown on the left in Figure 6-9. You also see a +/– sign next to the White Balance symbol in the Shooting Settings display, as shown on the right in the figure. The same symbol appears in the viewfinder, right next to the ISO value. The Live View display offers no such symbol to indicate that the shift is in force, but the onscreen colors update to show you the impact of your change.

You also can see the shift values in the Camera Settings screen. To view that screen, open any menu and then press the DISP button.

WARNING

Your adjustment remains in force for all advanced exposure modes until you change it. And again, remember that the correction is applied no matter which White Balance setting you choose. Check the monitor or viewfinder before your next shoot; otherwise, you may forget to adjust the white balance for the current light.

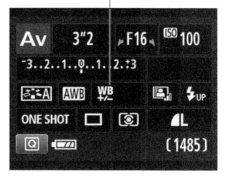

White Balance shift amount White Balance shift enabled

FIGURE 6-9:
The +/– symbol lets you know that White Balance Shift is being applied.

6. **To cancel White Balance Correction, repeat the steps, set the marker to the center of the grid, and then press Set.**

 After you get to the screen shown on the right in Figure 6-8, you can press the DISP button to clear your settings. However, doing so also cancels White Balance Bracketing, which I explain in the next section.

 Before leaving the grid screen, be sure to press Set to lock in your change.

WARNING

Bracketing shots with White Balance

Chapter 4 introduces you to Automatic Exposure Bracketing, which enables you to easily record the same scene with three different exposure settings. Similarly, the camera offers White Balance Bracketing, which records the same image three times, using a slightly different white balance adjustment for each one.

REMEMBER

Note a couple of things about this feature:

>> Because the camera records three images each time you press the shutter button, White Balance Bracketing reduces the maximum capture speed that's possible. Only one photo is taken; however, it's processed and saved three times. This can affect shooting speed no matter what Drive mode you have engaged. (See Chapter 2 for more about Drive modes.) Saving three images instead of one also eats up more space on your memory card.

>> White Balance Bracketing is designed around the same grid used for White Balance Correction, explained in the preceding section. As a reminder, the grid is based on two color pairs: green/magenta and blue/amber.

>> When White Balance Bracketing is enabled, the camera records the first of the three bracketed shots using a neutral White Balance setting — or, at least, what it considers neutral, given its measurement of the light. The second and third shots are recorded using the specified shift along either the green/magenta or the blue/amber axis of the color grid.

If all that is as clear as mud, take a look at Figure 6-10 for an example. These images were shot using a tungsten studio light and the candlelight. White Balance Bracketing was set to work along the blue/amber color axis, with a +3 bias in each direction. As you can see, even at the maximum shift (+/−3), the difference to the colors is subtle.

+3 Blue bias	Neutral	+3 Amber bias
	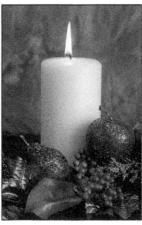	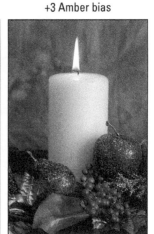

FIGURE 6-10: With White Balance Bracketing enabled, the camera recorded one neutral image, one with a blue bias, and one with an amber bias.

To enable White Balance Bracketing, follow these steps:

1. **Set the Mode dial to P, Tv, Av, or M.**

2. **Display Shooting Menu 2 and highlight WB/Shift Bkt, as shown on the left in Figure 6-11.**

3. **Press Set to display the grid shown on the right in Figure 6-11.**

FIGURE 6-11: These settings represent the maximum (+3) bracketing amount on the Blue to Amber axis.

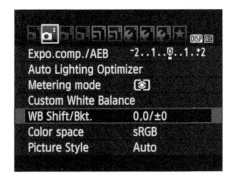

White Balance bracketing direction/amount

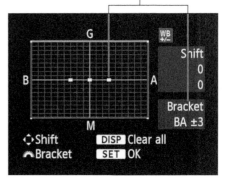

4. **Rotate the Main dial to set the amount and direction of the bracketing shift.**

Rotate the dial as follows to specify whether you want the bracketing applied across the horizontal axis (blue to amber) or the vertical axis (green to magenta).

- *Blue to amber bracketing:* Rotate the dial right.

- *Green to magenta bracketing:* Rotate the dial left.

As you rotate the dial, three markers appear on the grid, indicating the amount of shift that will be applied to your trio of bracketed images. You can apply a maximum shift of plus or minus three levels of adjustment.

The Bracket area of the screen also indicates the shift. For example, in Figure 6-11, the display shows a bracketing amount of plus and minus three levels on the blue/amber axis.

TIP

If you want to get truly fancy, you can combine White Balance Bracketing with White Balance Shift. To set the amount of White Balance Shift, press the cross keys to move the square markers around the grid. Then use the Main dial to adjust the bracketing setting.

5. **Press Set to apply your changes and return to the menu.**

On Shooting Menu 2, the value after the slash shows you the bracketing setting, as shown on the left in Figure 6-12. (The two values to the left of the slash indicate the White Balance Shift direction and amount — zero for each, in the figure.) The Shooting Settings screen also contains a White Balance Bracketing symbol (as shown on the right in the figure), as does the Camera Settings display, which you bring up by pressing DISP when any menu is visible. In the Live View display, the White Balance setting symbol blinks to indicate the bracketing is enabled.

White Balance bracketing setting White Balance bracketing enabled

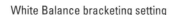

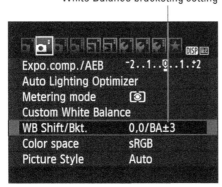
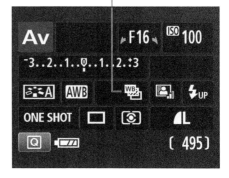

FIGURE 6-12: These symbols indicate that White Balance Bracketing is turned on.

Bracketing remains in effect until you turn off the camera. You can also cancel bracketing by revisiting the grid screen shown in Figure 6-11. Either rotate the Main dial until you see only a single grid marker or press the DISP button. (The DISP button clears any White Balance shift that's in force, too, however.) To wrap up, press Set.

Although White Balance Bracketing is a fun feature, if you want to ensure color accuracy, creating a custom White Balance setting is more reliable than bracketing white balance; after all, you can't be certain that shifting white balance a couple steps is going to produce accurate colors. Shooting the picture in the Raw file format is also advisable, for reasons I explain in the sidebar "Creating a Raw safety net," elsewhere in this chapter.

Taking a Quick Look at Picture Styles

Picture Styles give you an additional way to tweak image colors. But this feature also affects color saturation, contrast, and image sharpening.

Sharpening is a software process that adjusts contrast in a way that creates the illusion of slightly sharper focus. Emphasis on the word *slightly:* Sharpening cannot remedy poor focus, but instead produces a subtle improvement to this aspect of your pictures.

The camera offers the following Picture Styles:

- >> **Auto:** The camera analyzes the scene and determines which Picture Style is the most appropriate. (This setting is the default.)
- >> **Standard:** Produces the image characteristics that Canon considers as suitable for the majority of subjects.
- >> **Portrait:** Reduces sharpening slightly to keep skin texture soft.
- >> **Landscape:** Emphasizes greens and blues and amps up color saturation and sharpness.
- >> **Neutral:** Reduces saturation and contrast slightly compared to how the camera renders images at the Standard setting.
- >> **Faithful:** Just like Neutral except that subjects photographed in sunlight (Kelvin temperature of 5200) are rendered as closely as possible to how they appear to the normal human eye.

>> **Monochrome:** Produces black-and-white photos.

TIP

If you set the Quality option to Raw (or Raw+Large/Fine), the camera displays your image on the monitor in black and white during playback. But during the Raw conversion process, you can go with your black-and-white version or view and save a full-color version. Or even better, you can process and save the image once as a grayscale photo and again as a color image.

WARNING

If you *don't* capture the image in the Raw format, you can't access the original image colors later. In other words, you're stuck with *only* a black-and-white image.

The extent to which Picture Styles affect your image depends on the subject, the exposure settings you choose, and the lighting conditions. Figure 6-13 offers a test subject shot at each setting except Auto to give you a general idea of what to expect. As you can see, the differences are subtle, with the exception of the Mono-chrome option, of course. Note that in Auto mode, the camera will never select Monochrome, so if you do want a black-and-white capture, you have to select that setting yourself.

You have control over the Picture Style setting only in the P, Tv, Av, M, and Movie modes. In the Shooting Settings screen and Live View display, you see a symbol representing the current Picture Style, as shown in Figure 6-14. (In Movie mode, the symbol appears in the same spot as in Live View still-photography mode.)

To change the setting, use these methods:

>> **Quick Control screen:** Press the Q button to shift to Quick Control mode and then highlight the Picture Style icon, as shown on the left in Figure 6-15. Rotate the Main dial to cycle through the available styles. The label at the bottom of the screen indicates the current setting.

TECHNICAL
STUFF

The numbers that appear with the style name at the bottom of the screen represent the four characteristics applied by the style: Sharpness, Contrast, Saturation, and Color Tone, in that order. Sharpness values range from 0 to 7; the higher the value, the more sharpening is applied. At 0, no sharpening is applied. For the other options, a value of 0 represents the default setting for the selected Picture Style. (Using certain advanced options, you can adjust all four settings; more on that momentarily.)

To see all available styles, press Set to display the screen you see on the right in Figure 6-15. Highlight the style you want to use, and the four style values appear along with the style name, as shown in the figure. Press Set to finish up.

Standard	Portrait	Landscape

Neutral	Faithful	Monochrome

FIGURE 6-13: Each Picture Style produces a slightly different take on the scene.

Picture Style setting

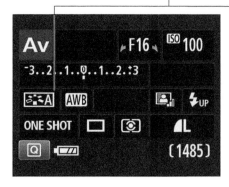
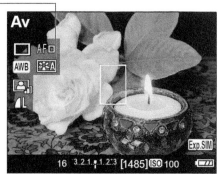

FIGURE 6-14: This symbol represents the Picture Style.

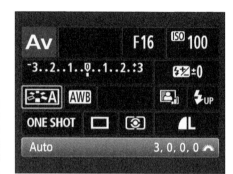

>> **Shooting Menu 2 (P, Tv, Av, or M modes) or Movie Menu 3 (Movie mode):**
Select Picture Style from the menu (the left image in Figure 6-16 shows
Shooting Menu 2) and press Set to display the screen shown on the right. This
screen also shows the four characteristics for each style. Highlight a Picture
Style and press Set to exit that screen. Not all the styles fit on the screen; use
the up/down cross keys to scroll the screen to reveal hidden settings.

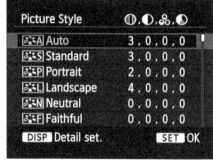

TIP

Unless you're tickled pink by the prospect of experimenting with Picture Styles,
I recommend that you stick with the default setting (Auto). First, you have way
more important camera settings to worry about — aperture, shutter speed, auto-
focus, and all the rest. Why add one more setting to your list, especially when the
impact of changing it is minimal? Second, if you want to mess with the character-
istics that the Picture Style options affect, you're much better off shooting in the
Raw (CR2) format and then making those adjustments on a picture-by-picture
basis in your Raw converter.

In Canon Digital Photo Professional 4 (available for free download from the Canon website), you can even assign any of the existing Picture Styles to your Raw files and then compare how each one affects the image. The camera tags your Raw file with whichever Picture Style is active at the time you take the shot, but the image adjustments are in no way set in stone or even in sand — you can tweak your photo at will. (The selected Picture Style does affect the JPEG preview that's used to display the Raw image thumbnails in Digital Photo Professional and other photo software.)

For these reasons, I opt in this book to present you with just this brief introduction to Picture Styles to make room for more details about functions that do make a big difference in your daily photography life. However, I do want to let you know that the camera does offer the following advanced Picture Style features:

>> You can modify a style, varying the sharpness, contrast, saturation, and color tone adjustment that the style produces. Follow the menu path shown in Figure 6-16, select a picture style, and then press DISP to access the options that enable you to fine-tune that style's characteristics.

>> You can create and store three custom Picture Styles, which are named User Defined 1, 2, and 3.

>> Picture Style übergeeks (you know who you are) can use Canon Picture Style Editor, another free, downloadable program that enables you to create and save Picture Style files to your heart's content. You then download the styles to your camera via the memory card. I'd be remiss if I didn't also mention that some Canon user groups swap Picture Styles with each other online. (I'd be equally remiss if I didn't warn you to play at your own risk any time you download files from persons unknown to you.)

For details on all these features, check the camera instruction manual. You need to download the electronic user manual from the Canon website, though; the paper manual that ships with your camera covers just basic features, and Picture Style information didn't make the cut.

Chapter **7**

Putting It All Together

Earlier chapters break down critical picture-taking features on your camera, detailing how the various controls affect exposure, picture quality, focus, color, and the like. This chapter pulls all that information together to help you set up your camera for specific types of photography.

Keep in mind, though, that there's no one "right way" to shoot a portrait, a landscape, or whatever. So feel free to wander off on your own, tweaking this exposure setting or adjusting that focus control, to discover your own creative vision. Experimentation is part of the fun of photography, after all, and thanks to your camera monitor and the Erase button, it's an easy, completely free proposition.

Recapping Basic Picture Settings

For some camera options, such as exposure mode, aperture, and shutter speed, the best settings depend on your subject, lighting conditions, and creative goals. But for certain basic options, you can rely on the same settings for almost every shooting scenario.

 Table 7-1 offers recommendations for basic settings and lists the chapter where you can find more information about each option. Figure 7-1 shows you where on the Shooting Settings screen you can find the symbols representing some settings, along with a few not included in the table. Don't forget that you can adjust these options via the Quick Control screen. Just press the Q button to shift from the Shooting Settings screen to the Quick Control display. (See Chapter 1 for the full story on using the Quick Control screen.)

TABLE 7-1 ## All-Purpose Picture-Taking Settings

Option	Recommended Setting	See This Chapter
Image Quality	Large/Fine (JPEG), Medium/Fine (JPEG), or Raw (CR2)	2
Drive mode	Action photos, Continuous; all others, Single	2
ISO	100	4
Metering mode	Evaluative	4
AF Operation mode	Moving subjects, AI Servo; stationary subjects, One Shot	5
AF Point Selection mode	Moving subjects, Automatic; stationary subjects, Manual (single point selected)	5
White Balance	Auto (AWB), set to Ambient Priority mode	6
Auto Lighting Optimizer	Standard for P, Tv, and Av modes; Disable for M mode	4
Picture Style	Auto	6

REMEMBER

One key point: Instructions in this chapter assume that you're using one of the advanced exposure modes: P, Tv, Av, or M. The problem with the other modes is that they prevent you from accessing certain settings that can be critical to capturing certain subjects, especially in difficult lighting. Also, this chapter discusses options available for viewfinder photography. For Live View photography, most settings work the same as discussed here, but the autofocus options are quite different.

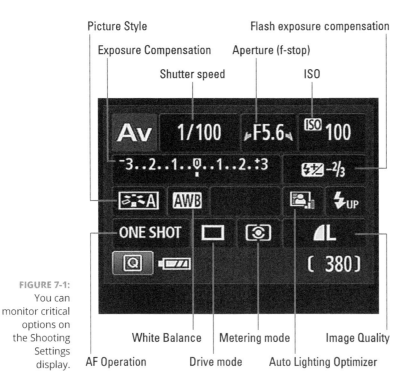

Picture Style

Exposure Compensation

Shutter speed

Flash exposure compensation

Aperture (f-stop)

ISO

FIGURE 7-1:
You can monitor critical options on the Shooting Settings display.

AF Operation

White Balance

Drive mode

Metering mode

Auto Lighting Optimizer

Image Quality

Shooting Still Portraits

By *still portrait*, I mean that your subject isn't moving. For subjects who aren't keen on sitting still, use the techniques given for action photography instead.

Assuming that you do have a subject willing to pose, the classic portraiture approach is to keep the subject sharply focused while throwing the background into soft focus, as shown in Figure 7-2. This artistic choice (known as a *shallow depth of field*) emphasizes the subject and helps diminish the impact of any distracting background objects when you can't remove them or relocate your subject. The following steps show you how to achieve this look:

FIGURE 7-2:
To diminish a distracting background and draw more attention to your subject, use camera settings that produce a short depth of field.

1. **Set the Mode dial to Av and rotate the Main dial to select the lowest f-stop value possible.**

 A low f-stop setting opens the aperture, which not only allows more light to enter the camera but also shortens *depth of field,* or the range of sharp focus. So dialing in a low f-stop value is the first step in softening your portrait background. However, for a group portrait, don't go too low or else the depth of field may not be enough to keep everyone in the sharp-focus zone. Take test shots and inspect the results at different f-stops to find the right setting.

 TIP

 I recommend aperture-priority autoexposure mode (Av) when depth of field is a primary concern because you can control the f-stop while relying on the camera to select the shutter speed that will properly expose the image. But you do need to pay attention to shutter speed also to make sure that it's not so slow that any movement of the subject or camera will blur the image.

 You can monitor the current f-stop and shutter speed in the Shooting Settings display (refer to Figure 7-1). The settings also appear in the viewfinder. (If you don't see the settings, give the shutter button a quick half-press and release to wake up the exposure meter.)

2. **To further soften the background, zoom in, get closer, and put more distance between subject and background.**

 As covered in Chapter 5, zooming to a longer focal length also reduces depth of field, as does moving closer to your subject. And the greater the distance between the subject and background, the more the background blurs.

 WARNING

 Avoid using a short focal length (wide-angle lens) for portraits. It can cause features to appear distorted — sort of like how people look when you view them through a security peephole in a door. On the flip side, a very long focal length can flatten and widen a face.

 When considering focal length, don't forget to multiply the lens's stated focal length by 1.6 to account for the crop factor associated with your camera's image sensor. For example, if you set the 18–55mm kit lens to the 55mm position, the resulting angle of view is equivalent to 88mm on a camera that uses 35mm film — a focal length that happens to work well for portraits, as it turns out. Chapter 1 explains this issue in detail.

3. **Check composition.**

 Just two quick pointers on this topic:

 - *Consider the background.* Scan the entire frame, looking for background objects that may distract the eye from the subject. If necessary, reposition the subject against a more flattering backdrop.

- *Frame the subject loosely to allow for later cropping to a variety of frame sizes.* Your camera produces images that have an aspect ratio of 3:2. That means your portrait perfectly fits a 4-x-6 print size but will require cropping to print at any other proportion, such as 5 x 7 or 8 x 10.

4. **For indoor portraits, shoot flash-free if possible.**

 Shooting by available light rather than flash produces softer illumination and avoids the problem of red-eye. During daytime hours, pose your subject near a large window to get results similar to what you see in Figure 7-3.

Courtesy of Mandy Holmes

 In Av mode, keeping the flash closed disables the flash. If flash is unavoidable, see the tips at the end of the steps to get better results.

5. **For outdoor portraits in daylight, use a flash if possible.**

 Even in daylight, a flash adds a beneficial pop of light to subjects' faces, as illustrated in Figure 7-4. A flash is especially important when the background is brighter than the subjects (as in this example); when the subject is wearing a hat; or when the sun is directly overhead, creating harsh shadows under the eyes, nose, and chin. In Av mode, press the Flash button to enable flash.

WARNING

 One caveat about using flash outdoors: The fastest shutter speed you can use with the built-in flash is 1/200 second, and in extremely bright conditions, that speed may be too slow to avoid overexposing the image even if you use the lowest ISO (light sensitivity) setting. If necessary, move your subject into the

shade. (On some external Canon flashes, you can select a faster shutter speed than 1/200 second; see your flash manual for details.) Your other option is to stop down the aperture (use a higher f-stop setting), but that brings more of the background into sharp focus.

No Flash	With Flash

6. **Press and hold the shutter button halfway to engage exposure metering and, if using autofocusing, to establish focus.**

 REMEMBER

 As spelled out earlier in Table 7-1, the One-Shot AF Operation mode using a Manual AF Point Selection works best for portrait autofocusing. After selecting a focus point, position that point over one of your subject's eyes — preferably the eye closest to the camera — and then press and hold the shutter button halfway to lock focus.

7. **Press the shutter button the rest of the way to capture the image.**

When flash is unavoidable, try these tricks for best results:

» **Pay attention to white balance if your subject is lit by flash and ambient light.** When you mix light sources, photo colors may appear slightly warmer (more red/yellow) or cooler (more blue) than neutral. A warming effect typically looks nice in portraits, giving the skin a subtle glow. If you aren't happy with the result, see Chapter 6 to find out how to fine-tune white balance. Don't forget that your camera offers two Auto settings, one that holds onto a slight warm cast when you shoot in incandescent light (Ambient Priority mode) and one that eliminates that color cast (White Priority mode).

>> **Indoors, turn on as many room lights as possible.** With more ambient light, you reduce the flash power needed to expose the picture. Adding light also causes the pupils to constrict, further reducing the chances of red-eye. (Pay heed to the preceding white-balance warning, however.) As an added benefit, the smaller pupil allows more of the iris to be visible, so you see more eye color in the portrait.

>> **In dim lighting, try enabling Red-Eye Reduction (Shooting Menu 1).** Warn your subject to expect an initial burst of light from the Red-Eye Reduction lamp, which helps constrict pupils of the eyes, followed by the light from the flash. See Chapter 2 for details about this flash option.

WARNING

>> **Pay extra attention to shutter speed.** In dim lighting, the camera may select a slow shutter speed when you enable the built-in flash in Av mode, so keep an eye on that value and use a tripod if necessary to avoid blurring from camera shake. Also warn your subject to remain as still as possible.

>> **For nighttime pictures, try switching to Tv exposure mode and using a slow shutter speed.** The longer exposure time enables the camera to soak up more ambient light, producing a brighter background and reducing the flash power needed to light the subject. Again, though, a slow shutter means that you need to take extra precautions to ensure that neither camera nor subject moves during the exposure.

>> **For professional results, use an external flash with a rotating flash head.** Then aim the flash head up so that the flash light bounces off the ceiling and falls softly down on the subject. (This is called bounced light.) An external flash isn't cheap, but the results make the purchase worthwhile if you shoot lots of portraits. Compare the portraits in Figure 7-5 for an illustration. In the first example, the built-in flash resulted in strong shadowing behind the subject and harsh, concentrated light. Bounced lighting produced the better result on the right.

Make sure that the surface you use to bounce the light is white; otherwise the flash's light will pick up the color of the surface and influence the color of your subject.

>> **Invest in a flash diffuser to further soften the light.** A *diffuser* is simply a piece of translucent plastic or fabric that you place over the flash to soften and spread the light — much like sheer curtains diffuse window light. Diffusers come in lots of different designs, including small, fold-flat models that fit over the built-in flash.

>> **To reduce shadowing from the flash, move your subject farther from the background.** Moving the subject away from the wall helped eliminate the background shadow in the second example in Figure 7-5. The increased distance also softened the focus of the wall a bit (because of the short depth of field resulting from the f-stop and focal length). You may also wish to light the background separately.

Direct flash Bounced flash

FIGURE 7-5:
To eliminate
harsh lighting
and strong
shadows (left),
use bounce
flash and
move the
subject farther
from the
background
(right).

TIP

Positioning subjects far enough from the background that they can't touch it is a good general rule. If that isn't possible, though, try going the other direction: If the person's head is smack against the background, any shadow will be smaller and less noticeable. For example, less shadowing is created when a subject's head is resting against a sofa cushion than if he sits upright with his head a foot or so away from the cushion.

Capturing Action

A fast shutter speed is the key to capturing a blur-free shot of any moving subject, whether it's a spinning Ferris wheel, a butterfly flitting from flower to flower, or in the case of Figures 7-6 and 7-7, a hockey-playing teen.

In Figure 7-6, a shutter speed of 1/125 second was too slow to catch the subject without blur. A shutter speed of 1/1000 second froze the action cleanly, as shown in Figure 7-7. (The backgrounds are blurry in both shots because the images were taken using a lens with a long focal length, which decreases depth of field. Also, in the first image, the skater is farther from the background, blurring the background more than in the second image.)

Shutter speed: 1/125 second

FIGURE 7-6:
A too-slow
shutter speed
(1/125 second)
causes the
skater to
appear blurry.

Shutter speed: 1/1000 second

FIGURE 7-7:
Raising the
shutter speed
to 1/1000
second freezes
the action.

Along with the basic capture settings outlined earlier (refer to Table 7-1), try the techniques in the following steps to photograph a subject in motion:

1. **Set the Mode dial to Tv (shutter-priority autoexposure).**

 In this mode, you control shutter speed, and the camera chooses the aperture setting that will produce a good exposure at the current ISO setting.

2. **Rotate the Main dial to select the shutter speed.**

 You can monitor the shutter speed in the Shooting Settings display (refer to Figure 7-1) and viewfinder.

REMEMBER

 The shutter speed you need depends on how fast your subject is moving, so you have to experiment. Another factor that affects your ability to stop action is the *direction* of subject motion. A car moving toward you can be stopped with a lower shutter speed than one moving across your field of view, for example. Generally speaking, 1/500 second should be plenty for all but the fastest subjects — speeding hockey players, race cars, or boats, for example. For slower subjects, you can even go as low as 1/250 or 1/125 second.

 Remember, though, that when you increase shutter speed in Tv exposure mode, the camera opens the aperture to maintain the same exposure. At low f-stop numbers, depth of field becomes shorter, so you have to be more careful to keep your subject within the sharp-focus zone as you compose and focus the shot, especially if the subject is moving toward or away from your camera.

TIP

 You also can take an entirely different approach to capturing action: Instead of choosing a fast shutter speed, select a speed slow enough to blur the moving objects, which can create a heightened sense of motion and, in scenes that feature very colorful subjects, cool abstract images such as the carnival ride images in Figure 7-8. For the left image, the shutter speed was 1/30 second; for the right version, 1/5 second. In both cases, I used a tripod, but because nearly everything in the frame was moving, the entirety of both photos is blurry — the 1/5 second version is simply more blurry because of the slower shutter.

 For an alternative effect, try panning (moving the camera horizontally or vertically), following the subject. The subject will appear relatively sharp in the photo, even if you use a slower shutter speed. (Lots of practice and experimentation are required to get it right.)

WARNING

 If the aperture value blinks after you set the shutter speed, the camera can't select an f-stop that will properly expose the photo at that shutter speed and the current ISO setting.

3. **Raise the ISO setting to produce a brighter exposure, if needed.**

In dim lighting, you may not be able to create a good exposure at your chosen shutter speed without taking this step. Raising the ISO increases the possibility of noise, but a noisy shot is better than a blurry shot. (The current ISO setting appears in the upper-right corner of the Shooting Settings display, as shown in Figure 7-1.)

If Auto ISO is in force, ISO may go up automatically when you increase shutter speed. Auto ISO can be a big help when you're shooting fast-paced action; just be sure to limit the camera to choosing an ISO setting that doesn't produce an objectionable level of noise. Chapter 4 provides details on Auto ISO.

TIP

Why not just add flash to throw some extra light on the scene? That solution has a number of drawbacks. First, the flash needs time to recycle between shots, which slows down your shooting pace. Second, the fastest possible shutter speed when you enable the built-in flash is 1/200 second, which may not be fast enough to capture a quickly moving subject without blur. (You can use a faster shutter speed with certain Canon external flash units, however.) And finally, the built-in flash has a limited range, so unless your subject is pretty close to the camera, you're just wasting battery power with flash, anyway.

4. **For rapid-fire shooting, set the Drive mode to Continuous.**

In this mode, the camera continues to record images as long as the shutter button is pressed, capturing as many as three frames per second. You can access the Drive mode setting quickly by pressing the Drive button (left cross key).

5. **If possible, use manual focusing; otherwise, select AI Servo AF (autofocus) mode and Automatic AF Point Selection.**

With manual focusing, you eliminate the time the camera needs to lock focus during autofocusing. Chapter 5 shows you how to focus manually, if you need help. Of course, focusing manually gets a little tricky if your subject is moving in

a way that requires you to change the focusing distance quickly from shot to shot. In that case, try these two autofocus settings for best performance:

- *Set the AF (autofocus) Operation mode to AI Servo (continuous-servo autofocus).* Press the AF button (right cross key) or use the Quick Control screen to access this setting.

- *Set the AF Point Selection Mode setting to Automatic.* Press the button shown in the margin to access the setting. Then press the Set button to quickly toggle from Single-Point Selection mode to Automatic Selection mode.

When you use these two autofocus settings, the camera initially sets focus on the center focus point. So frame your subject under that point, press the shutter button halfway to set the initial focusing distance, and then reframe as necessary to keep the subject within the area covered by the focus points. As long as you keep the shutter button pressed halfway, the camera continues to adjust focus up to the time you actually take the shot. Chapter 5 details these autofocus options.

6. **Compose the subject to allow for movement across the frame.**

Don't zoom in so far that your subject might zip out of the frame before you take the shot — frame a little wider than usual. You can always crop the photo later to a tighter composition. (Many examples in this book were cropped to eliminate distracting elements.)

One other key to shooting sports, wildlife, or any moving subject: Before you even put your eye to the viewfinder, spend time studying your subject so that you get an idea of when it will move, where it will move, and how it will move. The more you can anticipate the action, the better your chances of capturing it.

Capturing Scenic Vistas

Providing specific camera settings for landscape photography is tricky because there's no single best approach to capturing a beautiful stretch of countryside, a city skyline, or another vast subject. Depth of field is an example: One person's idea of a super cityscape might be to keep all buildings in the scene sharply focused. Another photographer might prefer to shoot the same scene so that a foreground building is sharply focused while the others are less so, thus drawing the eye to that first building.

That said, here are a few tips to help you photograph a landscape the way *you* see it:

>> **Shoot in aperture-priority autoexposure mode (Av) so that you can control depth of field.** If you want extreme depth of field so that both near and distant objects are sharply focused, select a high f-stop value. Keep in mind that f-stop is just one factor that determines depth of field, though: To extend depth of field, use a wide angle lens (short focal length) and increase the distance between the camera and your subject.

WARNING

The downside to using a high f-stop to achieve greater depth of field is that you need a slower shutter speed to produce a good exposure. If the shutter speed is slower than you can comfortably handhold, use a tripod to avoid picture-blurring camera shake. You also can increase the ISO setting to increase light sensitivity, which in turn allows a faster shutter speed, but that option brings with it the chance of increased image noise. See Chapter 4 for details.

>> **In large landscapes, include a foreground subject to provide a sense of scale.** The bench in Figure 7-9 serves this purpose. Because viewers are familiar with the approximate size of a typical wooden bench, they can get a better idea of the size of the vast mountain landscape beyond.

FIGURE 7-9:
The bench in the foreground helps provide a sense of the vastness of the landscape beyond.

Courtesy of Kristen E. Holmes

>> **For dramatic waterfall and fountain shots, consider using a slow shutter to create that "misty" look.** The slow shutter blurs the water, giving it a soft, romantic appearance, as shown in Figure 7-10. Shutter speed for this shot was 1/15 second. Again, use a tripod to ensure that camera shake doesn't blur the rest of the scene.

In bright light, using a slow shutter speed may overexpose the image even if you stop the aperture all the way down and select the camera's lowest ISO setting. As a solution, consider investing in a *neutral-density filter* for your lens. This type of filter works something like sunglasses for your camera: It simply reduces the amount of light that passes through the lens, without affecting image colors, so that you can use a slower shutter than would otherwise be possible.

>> **At sunrise or sunset, base exposure on the sky.** The foreground will be dark, but you can usually brighten it in a photo editor, if needed. If you base exposure on the foreground, on the other hand, the sky will become so bright that all the color will be washed out — a problem you usually can't easily fix after the fact.

FIGURE 7-10:
For misty water movement, use a slow shutter speed (and tripod).

You can also invest in a graduated neutral-density filter, which is a filter that's dark on one half and clear on the other. You orient the filter so that the dark half falls over the sky and the clear side over the dimly lit portion of the scene. This setup enables you to better expose the foreground without blowing out the sky colors.

Enabling Highlight Tone Priority can also improve your results, so take some test shots using that option, too. Chapter 4 offers more information.

>> **For cool nighttime city pics, experiment with a slow shutter.** Assuming that cars or other vehicles are moving through the scene, the result is neon trails of light, like those you see in Figure 7-11. Shutter speed for this image was 10 seconds. The longer your shutter speed, the blurrier the motion trails. (Don't forget to use a tripod for these and any other slow-shutter shots.)

Rather than change the shutter speed manually between each shot, try *Bulb* mode. Available only in M (manual) exposure mode, access this option by increasing the length of the shutter speed until you see Bulb displayed where the shutter speed should be. Bulb mode records an image for as long as you hold down the shutter button. So just take a series of images, holding down the button for different lengths of time for each shot. And in Bulb mode, you can exceed the camera's normal slow-shutter limit of 30 seconds.

Because long exposures can produce image noise, you also may want to enable the Long Exposure Noise Reduction feature (Custom Function 4). Chapter 4 discusses this option.

>> **For more dramatic lighting, wait for the "golden hours" or "blue hours."** *Golden hours* is the term photographers use for early morning and late afternoon, when the light cast by the sun gives everything a soft, warmed glow. By contrast, the *blue hours,* which occur just after sunset and before sunrise, infuse the scene with a cool, bluish light.

>> **In tricky light, bracket shots.** *Bracketing* simply means to take the same picture at several different exposures to increase the odds that at least one captures the scene the way you envision. Bracketing is especially a good idea in difficult lighting situations such as sunrise and sunset.

REMEMBER

Your camera offers automatic exposure bracketing (AEB). See Chapter 4 to find out how to take advantage of this feature.

FIGURE 7-11:
A slow shutter also creates neon light trails in city-street scenes.

Also experiment with the Auto Lighting Optimizer and Highlight Tone Priority options; capture some images with the features enabled and then take the same shots with the features turned off. See Chapter 4 for help. Remember, though, that you can't use both these tonality-enhancing features concurrently; turning on Highlight Tone Priority disables Auto Lighting Optimizer.

Capturing Dynamic Close-Ups

For great close-up shots, start with the basic capture settings outlined earlier, in Table 7-1. Then try the following additional settings and techniques:

>> **Check your owner's manual to find out the minimum close-focusing distance of your lens.** How "up close and personal" you can be to your subject depends on your lens, not on the camera body.

» **Take control of depth of field by setting the camera mode to Av (aperture-priority autoexposure) mode.** Whether you want a shallow, medium, or extreme depth of field depends on the point of your photo. For the romantic scene shown in Figure 7-12, for example, setting the aperture to f/5.6 blurred the background, helping the subjects stand out more from the similarly colored background. But if you want the viewer to clearly see all details throughout the frame — for example, if you're shooting a product shot for your company's sales catalog — go in the other direction, stopping down the aperture as far as possible.

FIGURE 7-12:
Using a shallow depth-of-field helped the subjects stand apart from the similarly colored background.

» **Remember that both zooming in and getting close to your subject decrease depth of field.** Back to that product shot: If you need depth of field beyond what you can achieve with the aperture setting, you may need to back away or zoom out, or both. (You can always crop your image to show just the parts of the subject that you want to feature.)

» **When shooting flowers and other nature scenes outdoors, pay attention to shutter speed, too.** Even a slight breeze may cause your subject to move, causing blurring at slow shutter speeds.

» **Experiment with flash.** Whether the built-in flash will improve your shot depends on the ambient lighting and how close you are to your subject. So try taking the picture with and without flash and see which one looks better. Remember that you can adjust flash output, via the camera's Flash Exposure Compensation control. Chapter 2 offers details.

Keep in mind that the maximum shutter speed possible when you use the built-in flash is 1/200 second (some Canon Speedlites enable you to use a faster shutter speed). So in extremely bright light, you may need to use a high f-stop setting to avoid overexposing the picture. You also can lower the ISO speed setting, if it's not already all the way down to ISO 100.

If you use flash along with other light sources, you also may need to adjust colors using the White Balance option, covered in Chapter 6.

>> **To get *very* close to your subject, invest in a macro lens or a set of diopters.** A macro lens enables you to focus at a very short distance so that you can capture even the tiniest of critters or, if you're not into nature, details of an object. I used a 90mm macro lens to snap an image of the lady bug in Figure 7-13 just before she got annoyed and flew away home. Notice how shallow the depth of field is: The extreme background blurring is due to the long focal length of the lens and the short distance between the lens and the subject. I used an f-stop of f/10, which may seem high when you're going for a shallow depth of field. But because the focal length and subject distance already combined for a very shallow depth of field, I needed that higher f-stop to keep the entire subject in the focus zone.

FIGURE 7-13:
A macro lens enables you to focus close enough to fill the frame with even the tiniest subjects.

Unfortunately, a good macro lens isn't cheap; prices range from a few hundred to a couple thousand dollars. If you enjoy capturing the tiny details in life, though, it's worth the investment.

For a less-expensive way to go, you can spend about $40 for a set of *diopters,* which are like reading glasses that you screw onto your lens. Diopters come in several strengths — +1, +2, +4, and so on — with a higher number indicating a greater magnifying power. With most sets, you can stack one diopter on top of another for increased power. The downside of a diopter is that it typically produces images that are very soft around the edges, a problem that doesn't occur with a good macro lens.

Coping with Special Situations

A few subjects and shooting situations pose some additional challenges not already covered in earlier sections. So to close this chapter, here's a quick list of ideas for tackling a variety of common tough-shot photos:

>> **Shooting through glass:** To capture subjects that are behind glass, such as animals at a zoo, you can try a couple tricks. First, set your camera to manual

focusing — the glass barrier can give the autofocus mechanism fits. Disable your flash to avoid creating any unwanted reflections, too (it also makes the alligators angry). Then, if you can get close enough, your best odds are to put the lens right up to the glass. (Be careful not to scratch your lens.) If you must stand farther away, try to position your lens at a 90-degree angle to the glass. I used this approach to capture the photo shown in Figure 7-14.

FIGURE 7-14:
To photograph subjects that are behind glass, use manual focusing and disable flash.

>> **Shooting out a car window:** Set the camera to shutter-priority autoexposure or manual mode and dial in a fast shutter speed to compensate for the movement of the car. Also turn on image stabilization, if your lens offers it. Oh, and keep a tight grip on your camera. Do not attempt while driving!

>> **Shooting fireworks:** First off, use a tripod; fireworks require a long exposure, and trying to handhold your camera simply isn't going to work. If using a zoom lens, zoom out to the shortest focal length (widest angle). Switch to manual focusing and set focus at infinity (the farthest focus point possible on your lens). Set the exposure mode to manual, choose a relatively high f-stop setting — say, f/16 or so — and start at a shutter speed of 1 to 5 seconds. From there, it's simply a matter of experimenting with different shutter speeds. Also play with the timing of the shutter release, starting some exposures at the moment the fireworks are shot up, some at the moment they burst open, and so on. For the example featured in Figure 7-15, I set the shutter speed to 5 seconds and began the exposure as the rocket was going up — that's what creates the "corkscrew" of light that rises up through the frame.

FIGURE 7-15:
A shutter speed of 5 seconds captured this fireworks shot.

Be especially gentle when you press the shutter button. With a very slow shutter, you can easily create enough camera movement to blur the image. If you purchased the accessory remote control for your camera, this is a good situation in which to use it. You can also experiment with using your smartphone or tablet to trigger the shutter release, as discussed at the end of Chapter 12. The problem with that solution is that it requires the camera to operate in Live View mode, which can slow the camera's response time.

>> **Shooting in strong backlighting:** When the light behind your subject is very strong, the result is often an underexposed subject. You can try using flash to better expose the subject, assuming that you're shooting in an exposure mode that permits flash. The Highlight Tone Priority feature, which captures the image in a way that retains better detail in the shadows without blowing out highlights, may also help. (Chapter 4 has an example.)

But for another creative choice, you can purposely underexpose the subject to create a silhouette effect, as shown in Figure 7-16. Base your exposure on the brightest areas of the background so that the darker areas of the frame remain dark.

FIGURE 7-16:
Experiment
with shooting
backlit subjects
in silhouette.

Chapter **8**

Shooting and Viewing Movies

I n addition to being a stellar still-photography camera, your T7/2000D enables you to record HD (high-definition) movies. This chapter tells you what you need to know to take advantage of the movie-recording options.

REMEMBER

One feature I don't cover extensively in this chapter is focusing, which works the same way for movie shooting as it does when you use Live View to shoot a still photo. Chapter 5 details Live View focusing. Also see Chapter 12 for information about in-camera movie-editing options and video snapshots, which record a series of brief video clips that are joined into a single recording. Finally, check out Chapter 1 for a list of precautions to take while Live View is engaged. (To answer your question: No, you can't use the viewfinder for movie recording; Live View is your only option.)

Recording Your First Movie Using the Default Settings

Cinematographers in the crowd will appreciate the fact that the T7/2000D offers several ways to control how video and audio are recorded. But most people will be

happy with movies created using the camera's default settings. The defaults produce a full HD (high definition) video with sound. Exposure and color are handled automatically, and all you do to set focus is move a focus box over your subject. Whether you fool with the default settings or not, movies are always recorded in the MOV format, a popular digital-movie file format.

The following steps show you how to record a video using the default settings:

1. **Set the Mode dial to the Movie position, as shown in Figure 8-1.**

 The viewfinder shuts off, and the live preview appears on the monitor.

 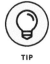
 TIP

 You can change the amount of data that appears onscreen by pressing the DISP button. The left screen in Figure 8-2 shows the maximum data display. I explain what all the symbols mean later in the chapter. For now, just make sure that the value labeled *available recording time* in Figure 8-2 shows at least a minute or two of time. If not, insert a memory card that has more free

 FIGURE 8-1:
 Set the Mode dial to the movie camera icon to record movies.

 space and see the upcoming sidebar "How long a movie can I record?" for more information.

Available recording time

Focus frame

Elapsed recording time Recording symbol

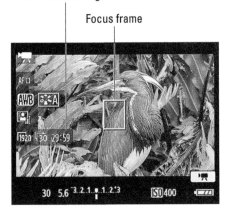

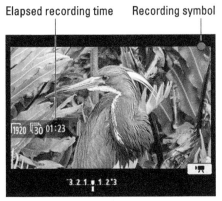

FIGURE 8-2:
Use the cross keys to position the focus frame over your subject.

HOW MANY MINUTES OF VIDEO CAN I RECORD?

When you set the camera to Movie mode and use the data display shown on the right in Figure 8-2, you see the value that I labeled *available recording time*. (Press the DISP button to change the data display.) If the value is 29:59, as in the figure, you would naturally think, "Okay, I can record about 30 minutes of video."

Unfortunately, like many things in the digital-photography world, this data readout isn't as clear-cut as it should be. The real story is that you may or may not be able to capture a 30-minute (minus 1 second) video.

Here's what you need to know to figure out the possible length of your next movie:

- The maximum movie file size is 4GB. When you reach that limit, recording stops automatically.

- How many minutes of video fit in that 4GB file depends on the Movie Recording Size setting you choose. This setting determines the quality and file size of your recording, as explained later in this chapter, in the section "Setting the Movie Recording Size option."

- At the default Movie Recording Size setting, you hit the 4GB limit at about the 11-minute mark.

- If you choose the Movie Recording Size setting that produces the lowest-quality video, a 4GB file can hold roughly 44 minutes of video. But hold on — it turns out, you actually can't create a 44-minute video clip. Because of some technical reasons we don't need to explore, your camera stops recording after 29 minutes and 59 seconds. That's why the highest value you ever see as the available recording time is 29 minutes and 59 seconds.

- When recording stops, you can begin a new recording by simply pressing the movie-record button (Live View button) again.

Of course, the amount of free space on your memory card also determines how many minutes of video you can record and how many recordings you can create. You can check the amount of free space by displaying any menu screen and then pressing the DISP button. The Free Space value appears at the top of the resulting screen. If you do a lot of video recording, invest in a high-capacity card. Also look for a high-speed card — Class 10 is best.

2. **Frame your initial shot.**

3. **Use the cross keys to move the focusing frame over your subject.**

 You can see the focusing frame in Figure 8-2.

4. **Press the shutter button halfway and hold it there until the focus frame turns green.**

 As soon as you press the button halfway, the camera chooses the proper exposure settings and initiates autofocusing. (You may see some exposure settings data at the bottom of the screen.) When focus is achieved, the focus frame turns green. You can then let up on the shutter button; focus remains at the established distance throughout your recording unless you press the shutter button halfway again.

5. **To start recording, press the Movie-record button, also known as the Live View button.**

 The red dot near the button reminds you of the movie-recording function. A red "recording" symbol appears, as shown on the right in Figure 8-2, as does the elapsed recording time. (You can hide the recording time data by pressing the DISP button; each press of the button changes the amount of onscreen data.)

6. **To stop recording, press the Live View button.**

 By default, recording stops automatically when you reach the 11-minute mark. If your memory card has additional free space, you can begin a new recording by pressing the movie-record button.

Customizing Movie Recording Settings

After you set the Mode dial to the Movie position, you can view critical recording settings on the monitor, shown in Figure 8-3. If you don't see this data, press the DISP button to cycle through different display styles. The shutter speed, aperture, and ISO setting may not appear until you press the shutter button halfway to initiate the camera's autoexposure system.

To adjust movie recording options, you can go two routes:

>> **Movie Menus 1, 2, and 3:** The Movie menus appear after you set the Mode dial to the Movie setting and press the Menu button.

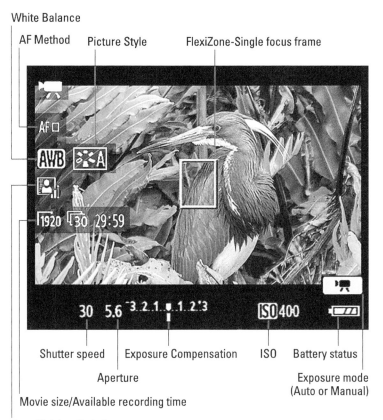

White Balance

AF Method Picture Style FlexiZone-Single focus frame

Shutter speed Exposure Compensation ISO Battery status

Aperture Exposure mode (Auto or Manual)

Movie size/Available recording time

Auto Lighting Optimizer

FIGURE 8-3: Press the DISP button to change the data display.

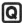

>> **Quick Control screen:** You can also adjust certain options via the Quick Control screen. After you press the Q button, these options appear on the left side of the frame, as shown in Figure 8-4. From top to bottom, the settings are AF Method (detailed in Chapter 5); White Balance (Chapter 6); Picture Style (Chapter 6); Auto Lighting Optimizer (Chapter 4); Movie Recording Size (this chapter); and Video Snapshot (Chapter 12).

Choosing settings works just like it does in Live View mode: After enabling Quick View, highlight an option. The current setting appears

Highlight option to select it

Current setting

FIGURE 8-4: You can adjust these settings via the Quick Control screen.

at the bottom of the screen. Rotate the Main dial to cycle through all the available settings or press the Set button to see a screen listing all settings together.

After you exit the Quick Control screen, the Video Snapshot symbol remains onscreen only if you enabled that feature.

REMEMBER

Movie Menu 1

Start customizing your production with the options on Movie Menu 1, shown in Figure 8-5:

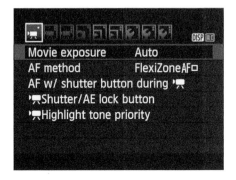

FIGURE 8-5:
Set the Movie Exposure option to Auto to let the camera handle exposure duties.

>> **Movie Exposure:** By default, this option is set to Auto, and the camera controls the aperture, shutter speed, and ISO. The selected settings appear at the bottom of the display, as labeled in Figure 8-3.

If you want to control exposure, set the Movie Exposure option to Manual. This option is best left to experts and involves more details than I have room to cover, so see the camera instruction manual for the full story. (You need to download the full manual from the Canon website; the paper manual provided in the camera box doesn't cover this feature.)

The symbol labeled "Exposure mode" in Figure 8-3 reflects your choice. In Auto mode, the symbol appears as shown in the figure; in Manual mode, the letter M appears with the symbol.

>> **AF Method:** This option enables you to choose from the same three autofocusing options available for Live View photography: FlexiZone-Single, (Face Detection) Live Mode, and Quick Mode. Chapter 5 explains these focusing methods.

The T7/2000D doesn't offer continuous autofocusing during movie recording. If you want to change the focus distance after recording begins, you can press the shutter button halfway to do so, but only if you enabled the AF with Shutter Button During Movie Recording option (discussed in the next bullet item).

WARNING

You also can set the AF Method option via the Quick Control screen (refer to Figure 8-4).

>> **AF with Shutter Button During Movie Recording:** If you enable this option, you can press the shutter button halfway to reset autofocus during movie recording. But doing so can be distracting. The image can drift in and out of

focus, and the sound of the focusing mechanism might be recorded. Long story short, if you don't want to use the same focusing distance for the entire movie, use manual focusing.

» **Shutter/AE Lock button:** This setting enables you to mess with the normal functions of the shutter button and the AE Lock button. Don't.

» **Highlight Tone Priority:** By default, this setting is turned off, just as it is for still photography. Leave the feature turned off until you explore the details in Chapter 4. If you do turn on Highlight Tone Priority, the Auto Lighting Optimizer feature is automatically disabled. (The control for that feature lives on Movie Menu 3.)

Movie Menu 2

Movie Menu 2, shown in Figure 8-6, includes the following settings:

» **Movie Recording Size:** This option determines movie resolution (frame size, in pixels), frames per second (fps), and frame aspect ratio. This setting is a little complex, so see the next section if you don't know what option to choose.

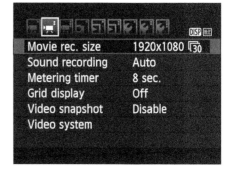

FIGURE 8-6:
Options controlling video quality and sound recording reside on Movie Menu 2.

» **Sound Recording:** Via this menu item, you adjust microphone volume and a couple other sound options. See "Choosing audio recording options," later in this chapter, for help with all the audio settings.

» **Metering Timer:** By default, exposure information such as f-stop and shutter speed disappears from the display after 8 seconds if you don't press any camera buttons. If you want the exposure data to remain visible for a longer period, you can adjust the shutdown time through this menu option. Just keep in mind that the metering mechanism uses battery power, so the shorter the cutoff time, the better.

» **Grid Display:** You can choose to display one of two different grid styles on the monitor to help ensure alignment of vertical and horizontal structures when you're framing the scene.

» **Video Snapshot:** This feature enables you to shoot multiple brief movie clips and then combine the clips into one movie. Turn off this feature for regular movie recording and see Chapter 12 for information about video snapshots.

>> **Video System:** This option sets the camera to one of two video standards, NTSC or PAL. NTSC is the standard in North America and Japan; PAL is used in Europe, China, and many other countries.

Setting the Movie Recording Size option

Through this setting, you set movie frame dimensions (in pixels) and frame rate, measured in frames per second (fps). You can access the option via Movie Menu 2, as shown in Figure 8-7, or the Quick Control screen, as shown in Figure 8-8.

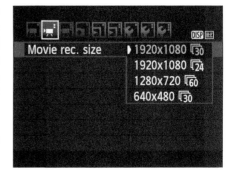

However you get there, you have the following choices:

>> 1920 x 1080 pixels, 30 fps (16:9 aspect ratio)

>> 1920 x 1080 pixels, 24 fps (16:9)

>> 1280 x 720 pixels, 60 fps (16:9)

>> 640 x 480 pixels, 30 fps (4:3)

FIGURE 8-7:
This option determines the frame size and frame rate of your movie.

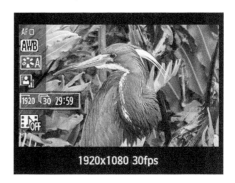

TECHNICAL
STUFF

The frame-rate options depend on the Video System option found at the bottom of Movie Menu 2. If you choose NTSC, you see the recording options shown in Figure 8-7 and in the preceding list. If you select PAL, you can choose frame rates of 24, 25, and 50 instead of 24, 30, and 60.

FIGURE 8-8:
You also can access the setting via the Quick Control screen.

Here's a bit more information to help you choose the best frame size and frame rate combo:

>> **For high-definition (HD) video, choose 1920 × 1080 (Full HD) or 1280 × 720 (Standard HD).** The 640 × 480 setting gives you standard definition (SD) video. This smaller size video is useful if you want to post videos to a website that doesn't permit high-def movies or restricts the size of your video files, a consideration discussed next.

>> **The Movie Recording Size setting determines file size and the maximum length of your movie.** A movie file has a maximum size of 4GB. At any setting except 640 x 480, that limits the recording time to about 11 minutes. When you shoot the movie at the 640 x 480 setting, the maximum recording time is 29 minutes and 59 seconds even though that length of recording doesn't completely fill a 4GB file.

WARNING

Recording stops automatically when the file size or recording time limit is reached. You can start a new recording by pressing the Live View button again. But be aware that movie recording really heats up the camera, and recording may stop before you reach the specified recording-time limits if the camera senses that it's close to overheating.

>> **Frame rate affects playback quality.** Higher frame rates transfer to smoother playback, especially for fast-moving subjects. But the frame rate also influences the crispness of the picture. To give you some reference, 30 fps is the NTSC standard for television-quality video, and 24 fps is the motion-picture standard. Movies shot at 60 fps tend to appear very sharp and detailed — a look that some people like and others find too harsh. It's hard to explain the difference in words, so experiment to see which look you prefer. The über-high frame rate is also good for maintaining video quality if you edit your video to create slow-motion effects. Additionally, if you want to "grab" a still frame from a video to use as a photograph, 60 frames per second gives you more frames from which to choose.

TECHNICAL STUFF

One final note about the Movie Recording Size option: In the camera specifications provided in the user manual, all recording sizes are followed by the letter *p*. This marking refers to *progressive video,* which is one of two technologies used to record the lines of pixels that make up a digital video frame. The other technology is *interlaced video.* With interlaced video, a single frame is split into odd and even *fields,* or lines of pixels. The data from the odd lines is recorded first, followed rapidly by the data from the even lines — so rapidly, in fact, that the picture appears seamless during playback. With progressive video, all the lines are pulled out of the magic video hat in sequential order, in a single pass. Your camera offers only progressive video, but don't fret: Progressive, the newer technology, delivers smoother, cleaner footage than interlaced video when you're shooting fast motion or panning the camera.

Choosing audio recording options

Sound is recorded using the built-in microphone, located on the front of the camera, just above the EOS label. To control audio recording, select Sound Rec from Movie Menu 2, as shown on the left in Figure 8-9, and then press Set to display the screen shown on the right in the figure. At the bottom of this screen, a volume meter appears to guide you in choosing recording levels.

Volume meter

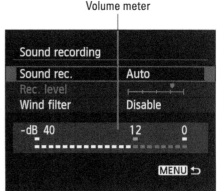

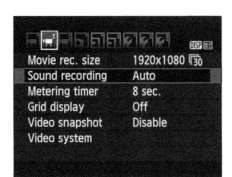

FIGURE 8-9:
Adjust audio
recording
settings here.

TECHNICAL STUFF

Audio levels are measured in decibels (dB). Levels on the volume meter range from −40 (very, very soft) to 0 (as much as can be measured digitally without running out of room). At the ideal recording level, the sound peaks consistently in the −12 range, as shown in Figure 8-9. The indicators on the meter turn yellow in this range, which is good. (The extra space beyond that level, called *headroom*, gives you both a good signal and a comfortable margin of error.) If the sound is too loud, the volume indicators will peak at 0 and appear red — a warning that the audio may sound distorted.

The menu options work as follows:

» **Sound Recording:** At the default setting, Auto, sound is recorded, with the camera automatically adjusting recording volume. To record a silent movie, set the Sound Recording option to Disable.

If you select Manual, as shown on the left in Figure 8-10, the Rec Level (recording level) option becomes available. Select that option and press Set to activate the Rec Level meter, as shown on the right in the figure. Use the right/left cross keys to adjust the setting. As you do, the blue marker shows you the current volume setting; the white marker, your new level. Again, refer to the volume meter at the bottom of the screen for guidance.

If you choose the Manual Sound Recording option, a microphone symbol with the letter M appears in the lower-right corner of the live preview, as shown in Figure 8-11. (Look just above the battery symbol.) When you go with the Auto setting, the symbol disappears.

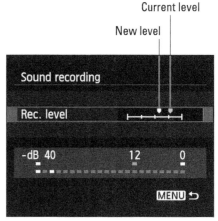

Current level

New level

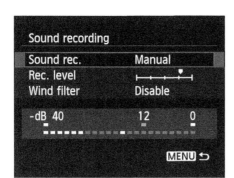

>> **Wind Filter:** Ever seen a newscaster out in the field, carrying a microphone that looks like it's covered with a big piece of foam (or a large squirrel, depending on the style)? That foam thing is a wind filter. It's designed to lessen the sounds that the wind makes when it hits the microphone. You can enable a digital version of the same thing via the Wind Filter menu option. Essentially, the filter works by reducing the volume of noises that are similar to those made by wind. The problem is that some noises *not* made by wind can also be muffled when the filter is enabled. So when you're indoors or shooting on a still day, keep this option set to Disable.

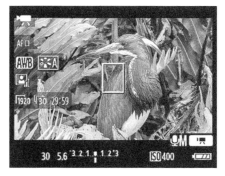

FIGURE 8-11:
This symbol means that you set the recording volume control to Manual mode.

Movie Menu 3

Through Movie Menu 3, shown in Figure 8-12, you can access some of the same advanced exposure and color options that are available when you shoot pictures in the P, Tv, Av, or M exposure modes. Specifically, you can adjust the following settings:

>> **Exposure Compensation:** When you set the Movie Exposure option on Movie Menu 1 to Auto, you can use the Exposure Compensation option to tell the camera to brighten or darken the scene, just as you can when you shoot still

pictures in the P, Tv, or Av exposure modes. Select a higher Exposure Compensation value for a brighter picture; lower the value for a darker image. One quirk: For movies, the camera can produce an exposure shift of only plus or minus three stops, whereas you get a five-stop range for still photography.

For a faster way to adjust this setting, don't bother opening the menu. Just press and hold the Exposure Compensation button while you rotate the Main dial. The exposure indicator moves along the meter at the bottom of the Live View display as you do.

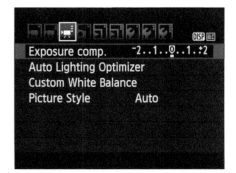

FIGURE 8-12:
These options work just like they do for still photography.

In Figures 8-11 and 8-12, for example, the indicator is at the zero mark, meaning that no compensation is in force.

>> **Auto Lighting Optimizer:** This feature also works just as it does for still photos, as explained in Chapter 4. It's enabled by default; until you have time to dig into the pros and cons of changing the setting, let it be.

>> **Custom White Balance:** You can customize the white balance to match the lighting used for your movie. Chapter 6 explains the steps involved in using this feature.

>> **Picture Style:** By default, movies are recorded using the Auto Picture Style. Changing the Picture Style enables you to tweak color, contrast, and sharpness. For a black-and-white movie, choose the Monochrome setting. Chapter 6 provides complete details about Picture Styles.

Playing Movies

To view movies on the camera monitor, set the camera to Playback mode and then display the movie file in full-frame view. You can spot a movie file by looking for the little movie-camera icon, shown in Figure 8-13, in the upper-left corner of the screen.

If you see thumbnails instead of a full movie frame on the screen, use the cross keys to highlight it and then press Set to display the file in the full-frame view. You can't play movies in thumbnail view.

Use these techniques to start, stop, and control playback:

>> **Start playback.** Press Set once to display the first frame of your movie plus a slew of control icons, as shown in Figure 8-14. Figure 8-15 gives you a close-up look at the control strip and labels each icon.

To start playback, use the cross keys or Main dial to highlight the Play icon, as shown in the figure, and then press Set again. The control icons disappear, and you then see a progress bar and the elapsed playback time at the top of the screen.

>> **Adjust volume.** Although the control strip shown in Figure 8-15 shows a volume level symbol, you don't select that symbol to adjust playback volume. Instead, rotate the Main dial.

TIP

Note the little white wheel and a volume display bar in the bottom-right corner of the display — it reminds you to use the Main dial to adjust volume. Rotating the dial controls volume only for the camera speaker during on-camera playback, however. If you connect the camera to a TV, control the volume using the TV controls instead.

FIGURE 8-13:
In Playback mode, the length of the movie clip appears in the upper-left corner of the screen.

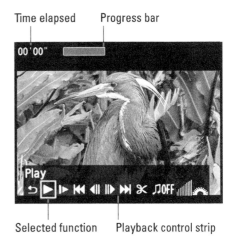

FIGURE 8-14:
Highlight the Play symbol and press Set to begin playing the movie.

>> **Pause playback.** Press the Set button to pause playback and redisplay the movie-control symbols. To resume playback, press Set again.

>> **Play in slow motion.** Select the slow-motion icon and press Set. Press the right cross key to increase playback speed; press the left cross key to decrease it.

>> **Fast forward/fast rewind.** Select the Next Frame icon and then hold down the Set button. To rewind, select the Previous Frame icon and hold down the Set button.

» **Go forward/back one frame while paused.** Highlight the Next Frame or Previous Frame icon and then press the Set button once. Each time you press the button, you go forward or backward one frame.

» **Skip to the first or last frame of the movie.** Highlight the first or last frame icons, respectively, and press Set.

» **Enable background music.** If you recorded a movie without sound, you can enable the Background Music option to play a sound file. In order to use this feature, you must install Canon EOS Utility, which is free software that you can download from the Canon website. Tools provided with the software enable you to copy music files to your camera memory card. See the program's instruction manual, also available for download, for details.

» **Edit the movie.** Press Set to pause the movie and then highlight the scissors symbol and press Set. Then follow the instructions in Chapter 12 to trim frames from the start or end of the movie — the limits of the editing you can do in-camera.

» **Exit playback.** Press the Set button to stop playback and display the control strip. Then highlight the Exit arrow (labeled in Figure 8-15) and press Set again. You also can exit playback mode by pressing the Menu or Playback button.

FIGURE 8-15:
Here's a guide to playback controls; while the movie is playing, press Set to redisplay the controls.

3
After the Shot

Chapter **9**

Picture Playback

Without question, one of the best things about digital photography is being able to view pictures right after you shoot them. No more guessing whether you got the shot you want or need to try again; no more wasting money on developing and printing pictures that stink.

Seeing your pictures is just the start of the things you can do when you switch your camera to playback mode, though. You also can review settings you used to take the picture, display graphics that alert you to exposure problems, and magnify a photo to check details. This chapter introduces you to these playback features and more.

Note: Some information in this chapter applies only to still photographs; if a feature also works for movie files, I spell that out. For specifics on movie playback, see the end of Chapter 8.

Disabling and Adjusting Image Review

After you take a picture, it appears briefly on the monitor. By default, the instant-review period lasts 2 seconds. You can change the display time via the Image Review option on Shooting Menu 1, shown in Figure 9-1.

You can select from the following options:

FIGURE 9-1:
Control the timing of instant picture review through this option on Shooting Menu 1.

>> **A specific review period:** Pick 2, 4, or 8 seconds.

>> **Off:** Disables automatic instant review. Turning off the monitor saves battery power, so keep this option in mind if the battery is running low. You can still view pictures by pressing the Playback button.

>> **Hold:** Displays the current image indefinitely or until the camera automatically shuts off to save power. (The camera shutdown timing is controlled through the Auto Power Off option on Setup Menu 1.)

You can interrupt image review by pressing any camera button.

Viewing Pictures in Playback Mode

 To switch to Playback mode, press the Playback button, labeled in Figure 9-2. The last photo you took appears onscreen, and you also may see some shooting data. In the figure, for example, the shutter speed and f-stop settings appear in the upper-left corner of the monitor, and the folder number and file number appear in the upper-right corner.

Several camera buttons come into play when you're viewing images; I labeled these buttons in Figure 9-2. Note that with the exception of the DISP button, the labels on the buttons are either all blue or partially blue. Canon likes to color-code things, and blue is the color chosen for playback. In the camera menu system, Playback Menus 1 and 2 are decorated in blue as well. (The black-and-white portions of labels refer to shooting functions.)

Here's a quick-start guide to playback features; later sections provide more details on some functions.

>> **Scrolling from one image to the next:** Press the right cross key to go forward one photo; press the left cross key to go back one.

Display fewer thumbnails or magnify photo

Display thumbnails or reduce magnification

Erase button

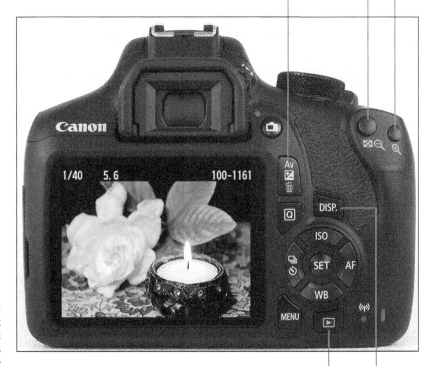

FIGURE 9-2:
The default
Playback
mode displays
one picture
at a time,
with minimal
picture data.

Playback button

Press to change data display

TIP

To skip more quickly through images, rotate the Main dial to enter *Jump mode*. By default, the camera leaps through photos ten at a time, but you can set up a different system if you prefer. I detail the options in the upcoming section "Jumping through images."

>> **Display image thumbnails (Index view):** Instead of viewing a single photo, you can switch to Index view, which displays four or nine thumbnails, as shown in Figure 9-3.

To switch from single-image view to four-image view, press the Index/Reduce button, shown in the margin and labeled "Display thumbnails" in Figure 9-2. Press the button again to display nine thumbnails.

Selected file

Movie file

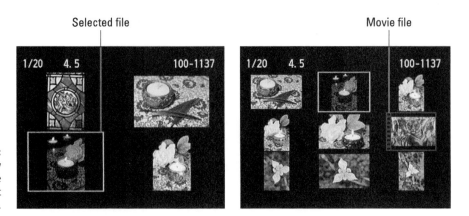

FIGURE 9-3:
You can view
four or nine
thumbnails at
a time.

REMEMBER

In Index view, movie files are indicated by borders that look like the sprocket holes in old film reels (I labeled a movie file in Figure 9-3). To play a movie, you must exit Index view; just press Set to do so. Press Set again to open the movie-playback screen, which you can find out how to navigate in Chapter 8.

>> **Select a file in Index view:** When Index view is active, you can perform some file operations, such as erasing a photo or movie. But you first need to select the file by using the cross keys to place a selection box over the file's thumbnail. In Figure 9-3, I labeled the selected thumbnails. (In single-image view, the image on the monitor is automatically selected.)

>> **Scroll from one page of thumbnails to the next:** Either rotate the Main dial or press the up/down cross keys. (The Main dial doesn't invoke Jump mode in Index view.)

>> **Reduce the number of thumbnails:** Press the Magnify button, labeled "Display fewer thumbnails" in Figure 9-2. Press once to go from nine thumbnails to four; press again to shift from four thumbnails to single-image view.

You also can press the Set button to switch from Index view to single-image view. The image that was highlighted in Index view appears on the monitor after you press Set.

>> **Change the amount of shooting data that appears:** Press the DISP button to cycle through the various playback display modes, each of which presents a different amount of shooting data. Read "Viewing Picture Data," later in this chapter, to find out how to interpret the data in each mode.

Jumping through images

If your memory card contains scads of images, here's a trick you'll love: By using the Jump feature, you can rotate the Main dial to leapfrog through images rather

than press the right or left cross key a bazillion times to get to the picture you want to see. You also can search for the first image shot on a specific date, tell the camera to display only movies or only still shots, or display images with a specific star rating. (See Chapter 10 for details on rating photos.)

You can choose from the following Jump options:

TIP

>> **Display Images One by One:** This option, in effect, disables jumping, restricting you to browsing pictures one at a time. So what's the point? If you select this setting, you can scroll pictures by rotating the Main dial as well as by pressing the right/left cross keys.

>> **Jump 10 Images:** Advance 10 images at a time.

>> **Jump 100 Images:** Advance 100 images at a time.

>> **Display by Date:** If your card contains images shot on different dates, you can jump between dates with this option. For example, if you're looking at the first of 30 pictures taken on June 1, you can jump past all others from that day to the first image taken on, say, June 5.

>> **Display by Folder:** If you create custom folders on your memory card — an option outlined in Chapter 11 — this option jumps you from the current folder to the first photo in a different folder.

>> **Display Movies Only:** Does your memory card contain both still photos and movies? If you want to view only the movie files, select this option. Then rotate the Main dial to jump from one movie to the next without seeing any still photos.

>> **Display Stills Only:** This one is the opposite of the Movies option: Movie files are hidden when you use the Main dial to scroll photos. You scroll one picture at a time, just like when you use the Display Images One by One option.

>> **Display by Image Rating:** With the Rating feature, you can assign each photo or movie a rating of one to five stars, which makes it easy to sort out your best work from your worst. If you take this step, you can set up the Jump feature so that only photos that have a specific rating are displayed.

REMEMBER

You can establish your Jump preference by using the Quick Control screen or Playback Menu 2, as follows:

>> **Quick Control screen:** After displaying a photo in playback mode, press the Q button to display the Quick Control playback icons, as shown in Figure 9-4. (If you're viewing images in Index mode, the camera temporarily shifts to single-image view and displays the image that was highlighted.)

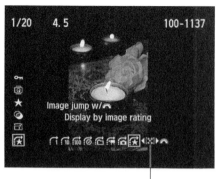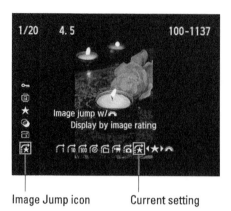

FIGURE 9-4:
You can specify
a Jump method
by using the
Quick Control
screen.

Image Jump icon Current setting Rating/number of stars

Use the up/down cross keys to highlight the Jump icon, labeled on the left in the figure. Along the bottom of the screen, you see the icons representing the available Jump options, with a highlight box around the currently selected setting. (The text above the icon strip tells you what each symbol represents.) Use the left/right cross keys to highlight the icon representing the jump method you want to use.

REMEMBER

If you select the Image Rating option, as shown in the figure, rotate the Main dial to set the number of stars that an image must have in order to be displayed. For example, in the figure, I set the option to five stars. Exit the Quick Control screen by pressing the Q button.

» **Playback Menu 2:** Select Image Jump, as shown on the left in Figure 9-5, and then press Set to display the settings screen shown on the right. Use the cross keys to choose a Jump method. Again, if you select the Display by Image Rating option, rotate the Main dial to specify how many stars qualifies an image for jump viewing. Press Set to lock in your choice and return to the initial menu screen.

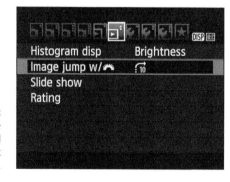

FIGURE 9-5:
Or select the
Jump method
from Playback
Menu 2.

After selecting a Jump method, take the following steps to jump through your photos:

1. **Set the camera to display a single photo.**

 You can use jumping only when viewing a single photo at a time. To leave Index (thumbnails) mode quickly, press the Set button.

2. **Rotate the Main dial.**

 The camera jumps to the next image. The number of images you advance, and whether you see movies as well as still photos, depends on the Jump method you select.

 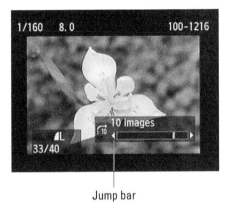

 Jump bar

 If you select any Jump setting but Display Images One by One, a *jump bar* appears for a few seconds at the bottom of the monitor, indicating the current Jump setting, as shown in Figure 9-6. For the Image Rating Jump method, you also see the number of stars you specified.

 FIGURE 9-6:
 Rotate the Main dial to start jumping through pictures.

3. **To return to regular Playback mode, press the right or left cross key.**

Rotating pictures

When you take a picture, the camera can tag the image file with the camera orientation: that is, whether you held the camera horizontally or vertically. When you view the picture, the camera can read the data and rotate the image so that it appears upright in the monitor, as shown on the left in Figure 9-7, instead of on its side, as shown on the right. The image is also rotated automatically when you view it in Canon Digital Photo Professional 4, the free photo software available for download from the Canon website. Some other photo viewing programs and apps also can read the rotation data.

Photographers use the term *portrait orientation* to refer to vertically oriented pictures and *landscape orientation* to refer to horizontally oriented pictures. The terms stem from the traditional way that people and places are photographed — portraits, vertically; landscapes, horizontally.

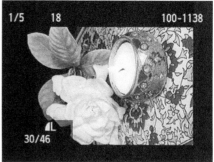

FIGURE 9-7:
You can display vertically oriented pictures upright (left) or sideways (right).

By default, the camera tags the photo with the orientation data and rotates the image automatically both on the camera and on your computer screen. But you have other choices, as follows:

» **Disable or adjust automatic rotation.** Select Auto Rotate on Setup Menu 1, as shown on the left in Figure 9-8. Then choose from these options:

- *On (Camera and Computer):* Labeled in the figure, this option is the default; rotation happens both on the computer and camera. (The camera and computer symbols shown to the right of the word On tell you that rotation will occur on both devices.)

- *On (Computer Only):* Also labeled in the figure, this setting rotates pictures only on a computer monitor. Notice the absence of the camera icon, reminding you that photos won't be rotated when you view them on the camera monitor.

- *Off:* New pictures aren't tagged with the orientation data, and existing photos aren't rotated during playback on the camera, even if they're tagged.

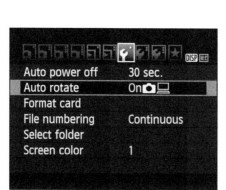
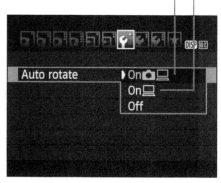

Rotate on computer only

Rotate on camera and computer

FIGURE 9-8:
Go to Setup Menu 1 to disable or adjust automatic image rotation.

» Rotate pictures during playback. If you stick with the default Auto Rotate setting, you can rotate pictures to a different orientation during playback via the Quick Control screen. Highlight the Rotate option, as shown in Figure 9-9, and then press the right or left cross keys to select one of the three orientation icons (labeled in the figure). Press the Q button a second time to exit the Quick Control screen.

The Quick Control method does *not* work if you set the Auto Rotate option on Setup Menu 1 to Off or computer-rotation only. However, you can still rotate pictures via the

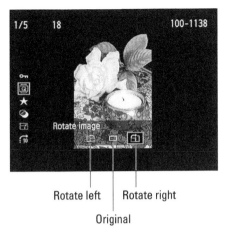

FIGURE 9-9:
The fastest way to rotate individual images is to use the Quick Control screen (on left).

Rotate Image option on Playback Menu 1, shown on the left in Figure 9-10.

FIGURE 9-10: You also can rotate images via Playback Menu 1.

Choose the menu option and then press Set to display your photos. In Index display mode, use the cross keys to select the image that needs rotating. In full-frame display, just scroll to the photo. Either way, press Set once to rotate the image 90 degrees; press again to rotate 180 additional degrees; press once more to return to 0 degrees, or back where you started. Press Menu to return to the menu system or Playback to return to viewing pictures. The photo remains in its rotated orientation only if the Auto Rotate option is set to the default (rotation on for both computer and camera display).

All these rotation features apply only to still photos; you can't rotate movies.

Zooming in for a closer view

During playback, you can magnify a photo to inspect details, as shown in Figure 9-11. In the example photo, I had to zoom way in to reveal the colorful visitor hanging on my rain chain, apparently searching for a tailor. (Get it? He's missing part of his tail, so he needs a *tail* . . . oh never mind. The good news is that his tail will grow back, so you needn't fret for his safety. My sanity is another story.)

FIGURE 9-11:
After displaying your photo in full-frame view (left), press the Magnify button to zoom in for a closer view (right).

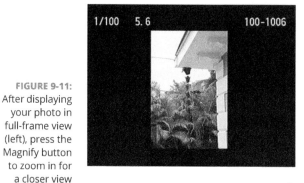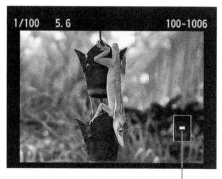

Magnified area

At any rate, you can magnify only photos and only when you're displaying photos one at a time. So if the camera is in Index display mode, press Set to return to full-frame view. Then use these techniques to adjust the image magnification:

>> **Zoom in.** Press and hold the Magnify button until you reach the magnification you want. You can enlarge the image up to ten times its normal display size.

Note the plus sign in the middle of the magnifying glass part of the button icon. That's your reminder to use this button to increase the display magnification.

>> **View another part of the picture.** When the image is magnified, a little thumbnail representing the entire image appears in the lower-right corner of the monitor, as shown in the right image in Figure 9-11. The solid white box indicates the area of the image that is shown on the monitor. Press the cross keys to scroll the display to see another portion of the image.

TIP

>> **View more images at the same magnification.** While the display is zoomed, rotate the Main dial to display the same area of the next photo at the same magnification. (The Jump feature, normally triggered by rotating the dial, is disabled while a photo is magnified.) For example, if you shot a group portrait several times, you can easily check each one for shut-eye problems.

>> **Zoom out.** To zoom out to a reduced magnification, press the Index/Reduce button. Continue holding down the button until you reach the magnification you want.

Here again, the symbol inside the magnifying glass label offers a hint as to the button's purpose: The minus sign indicates that pressing the button decreases the magnification. After you zoom all the way out, pressing the button another time shifts the display to Index (thumbnails) view.

>> **Return to full-frame view when zoomed in.** To exit magnified view, don't keep pressing the Index/Reduce button until you zoom out all the way. Instead, just press the Playback button, which quickly returns you to full-frame view.

Viewing Picture Data

When you're viewing your photos in single-image view, you can press the DISP button to change the amount and type of shooting data that appears with the photo. You have a choice of the displays labeled in Figure 9-12, all of which I detail in the upcoming sections.

REMEMBER

For pictures taken using the Full Auto, Flash Off, Creative Auto, or scene exposure modes, you see less data than appears in Figure 9-12. You get the full complement of data only if you took the picture in P, Tv, Av, or M modes. Also, the screens in Figure 9-12 and throughout the remainder of this chapter show all possible bits of information that can be viewed in each display mode. If you didn't use a particular feature when shooting the picture, the area of the screen devoted to that feature appears empty. For example, at the top of each screen in Figure 9-12, you see a plus/minus symbol with the number –1. That information reflects the Exposure Compensation setting. If you didn't enable Exposure Compensation, that symbol and value don't appear. Finally, note that because I needed to show all possible data, the values shown don't reflect the actual settings I used for the sample image, so don't try to use them as a recipe for getting the same result.

Basic Information

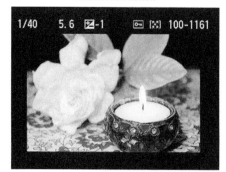

Basic plus Image Quality/Frame Number

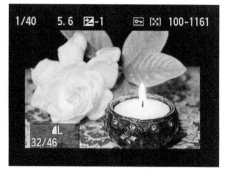

Shooting Information

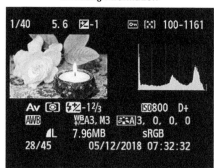

Histogram

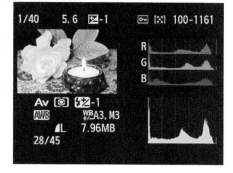

FIGURE 9-12:
Press the
DISP button
to change the
amount of
picture data
displayed with
your photo.

Basic Information display mode

In Basic Information mode, you see the following bits of information (labeled in Figure 9-13):

>> **Shutter speed, aperture, and Exposure Compensation setting:** Chapter 4 explains these exposure settings. If the Exposure Compensation setting was 0 (no compensation), this value doesn't appear.

>> **Protected status:** The key icon appears if you used the Protect feature to prevent your photo from being erased when you use the normal picture-deleting feature. Find out how to protect photos in the next chapter.

>> **Rating:** If you rated the photo, a topic also covered in Chapter 10, you can see how many stars you assigned it (five, in the figure).

>> **Folder number and last four digits of file number:** See Chapter 1 for information about how the camera assigns folder and file numbers. And visit Chapter 11 for details on how you can create custom folders.

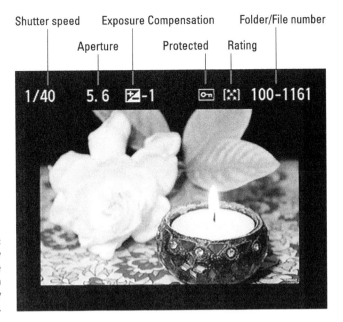

Shutter speed Exposure Compensation Folder/File number

Aperture Protected Rating

1/40 5.6 ⊞-1 ⊙ [:] 100-1161

FIGURE 9-13:
You can view basic exposure and file data in this display mode.

Basic Information plus Image Quality/ Frame Number display mode

This display mode adds two pieces of information to the Basic display, as shown in Figure 9-14:

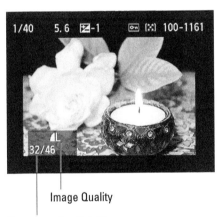

1/40 5.6 ⊞-1 ⊙ [:] 100-1161

32/46 L

Image Quality

Frame number/Total frames

FIGURE 9-14:
You can view the Image Quality setting in this display mode.

>> **Image quality:** These values correspond to the Image Quality setting. In the figure, the symbols indicate that I used the Large/Fine setting (the smooth arc represents the JPEG Fine file type; the L, the Large resolution option). Chapter 2 provides more help with this setting.

>> **Frame number/total frames:** These values show the current file number and the total number of files on the memory card. For example, the candle image is file number 32 out of 46 total files.

Shooting Information display mode

In Shooting Information display mode, the camera presents a thumbnail of your image along with scads of shooting data. You also see a *brightness histogram* — the chart-like thingy on the top-right side of the screen. I labeled the histogram in the right screen in Figure 9-15. You can get schooled in the art of reading histograms in the next section. (Remember, press the DISP button to cycle through the other display modes.)

How much data you see, though, depends on the exposure mode you used to take the picture, as illustrated in Figure 9-15. The screen on the left shows the data dump that occurs when you shoot in the advanced exposure modes, where you can control all the settings indicated on the playback screen. When you shoot in the other exposure modes, you get a far less detailed playback screen. For example, the right screen in Figure 9-15 shows the data that appears for a picture taken in Close-up mode. Here, you can view the Ambience and Lighting or Scene Type settings you used, but not all the individual exposure and color settings that appear for pictures shot in the advanced exposure modes.

Brightness histogram Lighting/Scene Type Ambience

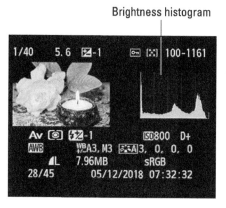
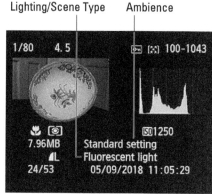

FIGURE 9-15: How much data appears depends on which exposure mode you used to shoot the picture.

REMEMBER

Again, in Figures 9-15 through 9-18, I show all possible shooting data for the purpose of illustration. If a data item doesn't appear on your monitor, it simply means that the feature wasn't enabled when you captured the photo.

At this point, I'm going to assume that if you're interested in the Shooting Information display mode, you're shooting in the advanced exposure modes. So the rest of this section concentrates on that level of playback data. To that end, it helps to break the display shown on the left in Figure 9-15 into five rows of information: the row along the top of the screen and the four rows that appear under the image thumbnail and histogram. Here's what appears in the five rows:

>> **Row 1:** Shows the same data as Basic Information display mode, including the f-stop and shutter speed.

>> **Row 2:** Contains the additional exposure settings labeled in Figure 9-16. Look for details about them in Chapter 4.

FIGURE 9-16:
This row
contains
additional
exposure
information.

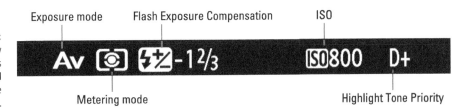

>> **Row 3:** These values, labeled in Figure 9-17, relate to color settings that you can explore in Chapter 6.

FIGURE 9-17:
Look to
this row for
details about
advanced color
settings.

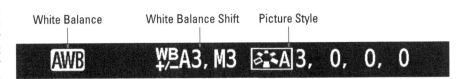

>> **Row 4 and 5:** Wrapping up the smorgasbord of shooting data, the bottom two rows hold the information labeled in Figure 9-18. See Chapter 2 for information about the Image Quality setting and how it affects file size; Chapter 11 explains the Color Space option.

FIGURE 9-18:
The bottom
two rows of
the display
offer this data.

If the date/time information displayed isn't accurate, head for Setup Menu 2 and adjust the camera's clock via the Date/Time/Zone setting. (This change affects only any new pictures you shoot; your existing photos still bear the old date/time information.)

If you use Eye-Fi memory cards, you also see an icon depicting the card's wireless connection status. (It appears to the left of the date and isn't shown in the figure.) See the Chapter 1 section related to using memory cards for more information about Eye-Fi cards.

TIP

WHAT ARE THESE BLINKING SPOTS?

When you view photos in the Shooting Information or Histogram display modes, you may notice some areas of the thumbnail blinking black and white. In the figures here, I captured the left screen as the candle flame blinked "on" (left image) and "off" (right image), for example.

The blinking spots indicate pixels that are completely white. Depending on the number and location of the "blinkies," you may or may not want to retake the photo. For example, if someone's face contains the blinking spots, you should take steps to correct the problem. But if the blinking occurs in, say, a bright window behind the subject, and the subject looks fine, you may choose to simply ignore it — or, if the bright background is bothersome, to relocate your subject. In the case of the candle photo, decreasing exposure to eliminate the blinkies in the flame would have underexposed the rest of the objects, especially the candle holder.

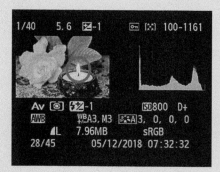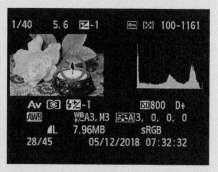

Understanding Histogram display mode

A variation of the Shooting Information display, the Histogram display offers the data you see in Figure 9-19. Again, you see an image thumbnail, but some of the information that you see in the Shooting Information display is left out, making room for an additional histogram, called an RGB histogram. Remember that this figure shows you the playback screen for pictures taken in the advanced exposure modes; in the other exposure modes, you see slightly different data, but you still get two histograms.

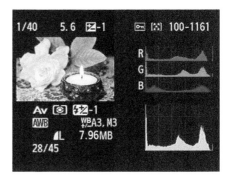

FIGURE 9-19: Histogram display mode replaces some shooting data with an RGB histogram.

The next two sections explain what information you can gain from both types of histograms.

Interpreting a brightness histogram

REMEMBER

One of the most difficult problems to correct in a photo editing program is known as *blown highlights* or *clipped highlights.* Both terms mean that the brightest areas of the image are so overexposed that areas that should include a variety of light shades are instead totally white. For example, in a cloud image, pixels that should be light to very light gray are white, resulting in a loss of detail in those clouds.

In Shooting Information and Histogram display modes, areas that fall into this category blink in the image thumbnail. This warning is a helpful feature because simply viewing the image on the camera monitor isn't always a reliable way to gauge exposure: The brightness of the monitor and the ambient light in which you view it affect the appearance of the image.

The *Brightness histogram,* found in both display modes, offers another analysis of image exposure. The graph, featured in Figure 9-20, indicates the distribution of shadows, highlights, and *midtones* (areas of medium brightness) in an image. Photographers use the term *tonal range* to describe this aspect of their pictures.

The horizontal axis of the graph represents the possible picture brightness values, from black (a value of 0) to white (a value of 255). And the vertical axis shows you how many pixels fall at a particular brightness value. A spike indicates a heavy concentration of pixels. For example, in Figure 9-20, which shows the histogram for the image you see in Figure 9-19, the histogram indicates a broad range of brightness values but with very few at the far right end of the brightness spectrum.

REMEMBER

Keep in mind that there is no "perfect" histogram that you should try to duplicate. Instead, interpret the histogram with respect to the amount of shadows, highlights, and midtones that make up your subject. For example, I wanted to create a slightly dark, moody look in the candle image in Figure 9-19. And I wanted to be certain not to blow out the details in the white gardenia bloom. So I set the Exposure Compensation value to EV –1.0, forcing the camera to deliver an exposure that was one stop darker than it normally would have produced. So my histogram reflects the

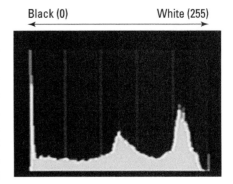

Black (0) White (255)

FIGURE 9-20:
The Brightness histogram indicates the tonal range of an image.

exposure that I was after. The fact that the white end of the scale didn't show a heavy cluster of pixels reassured me that I did not overexpose those important white flower details — something that's often difficult to judge by simply looking at the image on the camera monitor. Although there were a few "blinkies" in the candle flame (indicating fully white pixels), there were none in the gardenia, which was further help in deciding the right exposure settings. See the nearby sidebar "What are these blinking spots?" for an explanation of interpreting the blinkies.

Reading an RGB histogram

In Histogram display mode, you see two histograms: the Brightness histogram (covered in the preceding section) and an RGB histogram, shown in Figure 9-21.

TECHNICAL STUFF

To make sense of an RGB histogram, you first need to know that digital images are known as *RGB images* because they're created from three primary colors of light: red, green, and blue. In the image file, the brightness values for those colors are contained in three separate vats of color data, known as *color channels*. Whereas the

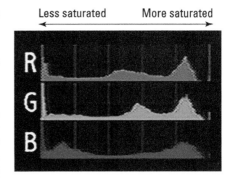

Less saturated More saturated

R
G
B

FIGURE 9-21:
The RGB histogram can indicate problems with color saturation.

Brightness histogram reflects the brightness of all three color channels rolled into one, RGB histograms let you view the values for each individual channel.

When you look at the brightness data for a single channel, though, you glean information about color saturation rather than image brightness. I don't have space in this book to provide a full lesson in RGB color theory, but the short story is that when you mix red, green, and blue light, and each component is at maximum brightness, you create white. Zero brightness in all three channels creates black. If you have maximum red and no blue or green, though, you have fully saturated red. If you mix two channels at maximum brightness, you also create full saturation. For example, maximum red and blue produce fully saturated magenta. And, wherever colors are fully saturated, you can lose picture detail. For example, a rose petal that should have a range of tones from medium to dark red may instead be a flat blob of dark red.

The upshot is that if all the pixels for one or two channels are slammed to the right end of the histogram, you may be losing picture detail because of overly saturated colors. If all three channels show a heavy pixel population at the right end of the histograms, you may have blown highlights — again, because the maximum levels of red, green, and blue create white. Either way, you may want to adjust the exposure settings and try again.

A savvy RGB-histogram reader can also spot color balance issues by looking at the pixel values. But frankly, color balance problems are fairly easy to notice just by looking at the image on the camera monitor.

TIP

If you're a fan of RGB histograms, however, you may be interested in another possibility: You can swap the standard Brightness histogram that appears in Shooting Information playback mode with the RGB histogram. Just set the Histogram Disp option on Playback Menu 2 to RGB instead of Brightness.

For information about manipulating color, see Chapter 6.

IN THIS CHAPTER

» **Deleting unwanted files**

» **Protecting files from accidental erasure**

» **Rating photos and movies**

» **Downloading files to your computer**

» **Processing Raw files in Canon Digital Photo Professional 4**

» **Shrinking files for online use**

Chapter **10**

Working with Picture and Movie Files

E very creative pursuit involves its share of cleanup and organizational tasks. Painters have to wash brushes, embroiderers have to separate strands of floss, and woodcrafters have to haul out the wet/dry vac to suck up sawdust. Digital photography is no different: At some point, you must stop shooting so that you can download and process your files.

This chapter explains these after-the-shot tasks. First up is a review of several in-camera file-management operations: deleting unwanted files, protecting your best work from accidental erasure, and rating files. Following that, you can get help with transferring files to your computer or to a smartphone or tablet, processing files that you shot in the Raw (CR2) format, and preparing images for online sharing. Along the way, I introduce you to free Canon software tools that offer easy ways to handle these jobs.

Deleting Files

When you spot clunkers during your picture and movie review, you can use the following options to erase them from your memory card:

>> **Deleting single images:** To delete photos or movies one at a time, press the Playback button and then display the photo or movie in Single Image view or select it in Index view. Then press the Erase button, labeled in Figure 10-1. The words *Cancel* and *Erase* appear at the bottom of the screen, as shown in the figure. Cancel is highlighted; press the right cross key to highlight Erase instead. Press the Set button to finish the job.

Erase button

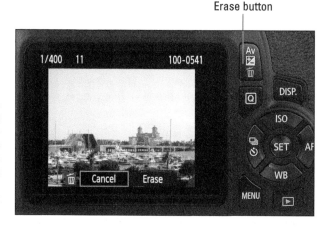

FIGURE 10-1: After pressing the Erase button, press the right cross key to highlight Erase and then press the Set button.

>> **Deleting all images:** To erase all photos on the memory card — with the exception of those you locked by using the Protect feature discussed in the following section — display Playback Menu 1, shown on the left in Figure 10-2. Choose Erase Images to display the screen shown on the right in the figure. Choose All Images on Card and press Set. On the confirmation screen that appears, choose OK and press Set.

TIP

If your card contains multiple folders, you can limit the image dump to a specific folder. Just choose All Images in Folder on the screen shown on the right in Figure 10-2. Press Set to see a list of folders; choose the folder you want to empty and then press Set again.

>> **Deleting selected images:** To erase more than a few but not all photos and movies, choose Erase Images from Playback Menu 1. On the next screen (right screen in Figure 10-2), choose Select and Erase Images.

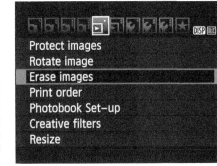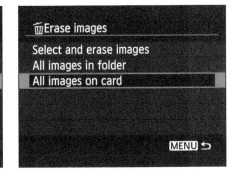

FIGURE 10-2:
Use the Erase
option on
Playback
Menu 1 to
delete multiple
images quickly.

You then see a photo or movie on the monitor, as shown on the left in Figure 10-3. At the top of the screen, a check box appears. To the right of the box is a value showing you how many files are currently tagged for erasure (1, in the figure).

Erase tag Number of images tagged

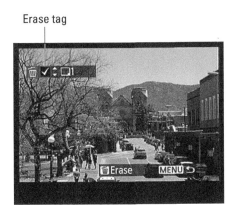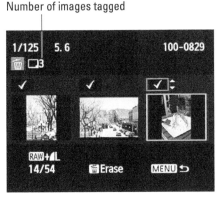

FIGURE 10-3:
Press the
up/down cross
keys to toggle
the Erase
check box on
and off.

To mark the displayed file as trash, press the up or down cross key to put a check mark in the box. (I labeled the check mark "Erase tag" in the figure.) If you change your mind, press up or down again to remove the check mark. To scroll through your images to find the next bad apple, press the right or left cross keys; press up or down to tag that file for erasure.

If you don't need to inspect each image closely, you can display up to three thumbnails per screen. (Refer to the image on the right in Figure 10-3.) Press the Index button to shift into this display. Use the same methods to tag images for erasure and to scroll through photos as you do when viewing them one at a time.

After tagging all images in the three-frame view, press the Magnify button to exit to the regular single-image view.

When you finish tagging images, press the Erase button. You see a confirmation screen asking whether you really want to get rid of the selected images. Highlight OK and press Set.

Protecting Photos and Movies

You can protect pictures and movies from accidental erasure by giving them protected status. After you take this step, the camera doesn't allow you to delete the file from your memory card, whether you press the Erase button or use the Erase Images option on Playback Menu 1.

TIP

You can also save time by using the protection feature when you want to keep a handful of pictures but delete the rest. Instead of using the Select and Erase Images option, which requires that you tag each photo you want to delete, protect the handful that you want to preserve. Then use the Erase All Images option to dump the rest — the protected photos are left intact.

WARNING

Although the Erase functions don't touch protected pictures or movies, formatting your memory card *does* erase them. For more about formatting, see the Chapter 1 section related to Setup Menu 1, which contains the Format Card tool.

To protect a photo, use these techniques:

» **Protect/unprotect a single photo/ movie:** The Quick Control screen offers the fastest option. Display the photo in full-frame view. Or in Index view, select the photo by moving the highlight box over it. Then press the Q button and highlight the Protect Images symbol, labeled in Figure 10-4. Choose Enable at the bottom of the screen, and a little key symbol appears at the top of the frame, as shown in the figure. Press the Q button again to exit the Quick Control display.

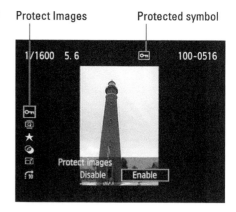

FIGURE 10-4:
You can use the Quick Control screen to protect the current photo.

To remove the protected status, follow the same steps but choose Disable on the Quick Control screen.

» **Protect/unprotect multiple photos/movies:** To apply or remove protected status from more than a couple photos or movies, going through Playback Menu 1 is faster than using the Quick Control screen. From the menu, choose Protect Images, as shown on the left in Figure 10-5. You then can select from these options, shown on the right in Figure 10-5:

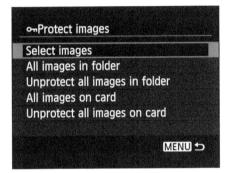

FIGURE 10-5: Go the menu route to protect multiple photos at a time.

- *Select Images:* Choose this option to protect specific photos or movies. An image appears along with a key icon and the Set label in the upper-left corner of the screen, as shown in Figure 10-6. These symbols remind you that you add/remove protection by pressing the Set button. Use the left/right cross keys to scroll to the picture you want to protect and then press the Set button. Now a key icon appears at the top of the screen, as labeled in the figure, indicating that protection is in place. Keep scrolling through your pictures,

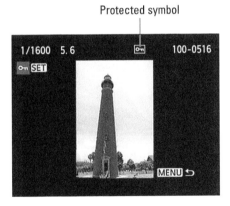
Protected symbol

FIGURE 10-6:
The key icon indicates that the picture is protected.

pressing Set to add the key to each file you want to protect. To remove protection, press Set to make the key disappear.

UNLOCKING PROTECTED FILES AFTER DOWNLOADING

When you download protected files to your computer, they show up as *read-only* files, which means that you can't edit them and then resave them under the original name. Nor can you delete them from your computer.

To remove protection from a file after downloading, use the Windows file browser (Windows File Explorer) or, on a Mac computer, the Finder:

- *Windows File Explorer.* Track down the file, right-click on it to display a pop-up menu, and choose Properties. In the dialog box that appears, uncheck the Read-only box and then click OK. (*Note:* Don't confuse Windows File Explorer, which is the file-management tool, with Windows Internet Explorer, which is a web browser.)

- *Mac Finder:* Click the locked file in the Finder window. Open the File menu and then choose Get Info. At the bottom of the General tab of the Get Info window, look for the Locked check box. Clear that box to remove the file protection.

- *All Images in Folder:* When you choose this option (refer to the right screen in Figure 10-5), you see a list of available folders. Select the one that contains the images you want to protect and then press Set. (Unless you create custom folders, you probably only have one folder on your card.)

- *Unprotect All Images in Folder:* Use this option to unlock all protected images in the folder you select.

- *All Images on Card:* After you select this option, choose OK on the confirmation screen and press Set. All photos and movies on the memory card are now locked.

- *Unprotect All Images on Card:* Select this option to unlock all pictures and movies on the card.

When you finish protecting or unlocking photos, press the Menu button to exit the protection screens.

Rating Photos and Movies

Many image browsers provide a tool that you can use to assign a rating to a picture: five stars for your best shots, one star for those you wish you could reshoot, and so on. But you don't have to wait until you make it to your computer because your

camera offers the same feature. If you later view your pictures in the Canon image software, you can see the ratings you assigned and sort pictures according to rating. Rating your files is also helpful when you create a slide show, as described in Chapter 12; when setting up the show, you can choose to display only your highly rated work. You can assign a rating via the Quick Control screen or Playback Menu 2. For rating just a photo or two, either works fine, but for rating a batch of photos or movies, using the menu is fastest. Here's how the two methods work:

>> **Quick Control screen:** Display your photo in full-screen view; or, in Index view, select it by moving the highlight box over it. Then press the Q button and highlight the Rating icon, as shown in Figure 10-7. Press the right or left cross key to highlight the number of stars you want to give the photo. The assigned rating appears in the upper-right corner of the image, as shown in the figure. If you're happy with your choice, press Q to return to the normal playback screen. You must exit the Quick Control screen before rating a second photo; there's no way to advance to another image while the

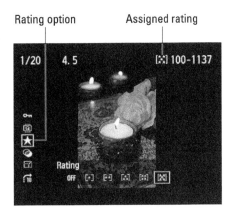

FIGURE 10-7:
You can rate photos via the Quick Control screen.

Quick Control screen is active. To remove a rating, choose the Off option (just to the left of the one-star icon).

>> **Playback Menu 2:** Choose Rating from the menu, as shown on the left in Figure 10-8, and then press Set. You then see the screen shown on the right in Figure 10-8. Above the image, you get a control box for setting the rating of the current picture or movie; just press the up or down cross keys to give the photo anything from one to five stars (cycle back around to turn the rating off for the photo). The values next to the control box indicate how many other photos on the card have been assigned each rating. For example, in the figure, the numbers indicate two one-star images, one four-star image, and five that I thought deserving of five stars. (I grade on a curve.)

You can press the Index button to display three thumbnails at a time, just as you can when deleting files. (Refer to Figure 10-3.) Use the right/left cross keys to highlight a thumbnail; its rating appears in the box right above the thumbnails.

To go back to the single-image display, press the Magnify button.

After rating your photos, press the Menu button to return to the Playback menu.

Rating of current file Number of rated files

 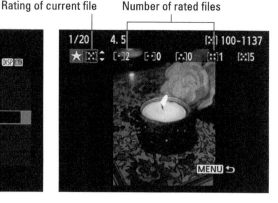

Using Canon's Computer Software

To download, view, and edit your photos on a computer, you can use whatever software you like. But even if you're already perfectly happy with the programs you already use, you may want to also grab the following programs, which Canon makes available free to T7/2000D owners:

» **Canon EOS Utility 3 (Version 3.8.0.1):** This program offers an easy-to-use tool for downloading pictures directly from your camera, which I show you how to do later in this chapter. Additionally, it enables *tethered shooting,* which means that you can connect the camera to the computer via the supplied cable and then operate the camera remotely from the computer.

Tethered shooting is great when you're photographing products or portraits in a studio setting, with clients or colleagues on hand to supervise or collaborate. If you set the camera to Live View mode, you can see the live preview on the computer monitor, as shown in Figure 10-9, giving everyone a larger view of things than the camera monitor provides. You can adjust most camera settings using the control panel shown on the right side of the figure. After the shot, photos can be displayed immediately on the computer monitor and automatically downloaded to the computer.

I don't have room to cover tethered shooting in this book, but you can get details in the program's instruction manual, also available for download from the Canon website. (More about downloading programs and manuals momentarily.)

» **Canon Digital Photo Professional 4 (Version 4.8.30):** This product, featured in Figure 10-10, offers a nice assortment of photo-editing and organizing features. It also has a tool that you can use to process Raw files, which I show you how to do later in this chapter.

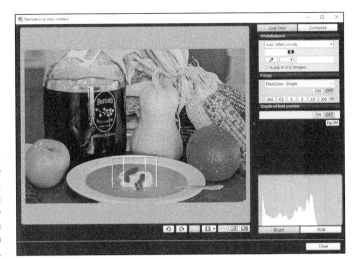

FIGURE 10-9:
The EOS Utility program enables you to operate your camera remotely from your computer.

Selected focus point Picture metadata

FIGURE 10-10:
Digital Photo Professional 4 provides a good, free solution for viewing, organizing, and editing your photos.

Two cool features worth special note:

- *Display metadata:* After you select an image by clicking its thumbnail, you can view its *metadata,* which is hidden data that contains all the camera settings you used to take the shot. To display the metadata panel, labeled in Figure 10-10, open the program's View menu and select Info.

- *Display focus point(s):* You also can display the focus point or points that the camera used to establish the focusing distance for the picture. In the figure, for example, notice the red focus box atop the subject. To enable

the focus-point display, open the program's Preview menu and choose AF Points. If you want a larger view of a single image, open the View menu and choose Vertical Thumbnails. Your window then looks like the one in the figure, with thumbnails of your images on the left and a larger preview on the right.

To download these programs, head for the T7/2000D product page for your country. (The web address is www.USA.Canon.com if you live in the United States.) Then follow the Drivers and Downloads links to the programs. You have the option to download an entire bundle of Canon programs; this download link is provided under the label "Recommended Downloads." The problem is that because the bundle was developed for several different camera models, it contains programs that don't work with the T7/2000D. For that reason, I recommend just downloading the two aforementioned programs. You also can download the user manuals for each program, but you get to those via the Manuals link rather than the software link. (Don't blame me; I just report the news.)

Keep in mind that every time Canon updates the software, the version number changes. So don't be concerned if the links you find at the website have a later version number than listed above. You can't, however, use older versions of these programs with your camera.

Sending Pictures to the Computer

Your camera's built-in Wi-Fi system enables you to send photos wirelessly to a smartphone or tablet — the last section of this chapter gets you started down that path. Unfortunately, you can't use Wi-Fi to download files to a computer, even if your computer is connected to a wireless network. Instead, you need to choose one of these options to download your files:

>> **Connect the camera to the computer via a USB cable and use Canon EOS Utility 3 to download files.** Canon doesn't supply the necessary cable, but it can be had for under $15. Canon refers to the cable as the *interface cable,* which helps to explain the part name: IFC-400PCU.

If you're unfamiliar with the basics of computer file management — tasks such as creating storage folders, organizing files, and so on — this downloading option is easiest because the software is easy to understand. The drawback is that your camera must be turned on during the process, which uses battery power.

>> **Use a memory-card reader.** With a card reader, you pop the memory card out of your camera and into the card reader instead of hooking the camera to the computer. Many computers and printers now have card readers, and you also can buy standalone readers for under $30. I recommend this option for computer-savvy photographers because it doesn't require any camera-battery power.

Note: If you use SDHC (Secure Digital High-Capacity) or SDXC (Secure Digital Extended-Capacity) cards, the card reader must specifically support that type. Many older card readers — including some still on the market — do not.

You can't use Canon EOS Utility 3 to download from a card reader, but you can do the job with any other photo program — even with your Windows or Mac file organization utility.

The next two sections walk you through each process.

Downloading directly from the camera

The following steps show you how to move pictures directly from your camera to your computer using Canon EOS Utility. Again, to use this method, you need to purchase the correct USB cable (Canon IFC-400PCU) and install Canon EOS Utility on your computer.

Don't be put off by the length of the steps — it takes a lot of words to detail the process, but it's actually easy after you work through the steps once or twice.

1. **Make sure the camera battery is fully charged.**

 Running out of battery power during the transfer process can cause problems, including lost picture data. Alternatively, if you have an AC adapter, use it to power the camera during picture transfers.

WARNING

Digital terminal (USB port)

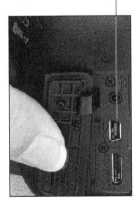

2. **Turn your computer on and give it time to finish its normal startup routine.**

3. **On the camera, open Setup Menu 3 and make sure that the Wi-Fi/NFC function is set to Disable.**

 When that feature is turned on, you can't connect the camera to the computer.

WARNING

4. **Turn the camera off and insert the smaller of the two plugs on the interface cable into the port labeled Digital terminal (USB) in Figure 10-11.**

 This port is hidden behind the rubber door that's just around the corner from the left side of the monitor.

FIGURE 10-11:
Connect the smaller end of the USB cable here to download pictures.

5. **Plug the other end of the cable into a USB port on the computer.**

6. **Turn on the camera.**

At this point, the initial Canon EOS Utility 3 window, shown in Figure 10-12, may appear automatically, or your operating software may offer a link to launch the tool. If neither of those things happens, locate the EOS Utility program and start it yourself. And if some other program comes to life to try to wrestle the downloading job away from the Canon utility, shut down that other program.

WARNING

If you downloaded and installed the entire suite of Canon programs, you probably also have a program titled Canon EOS Utility. Be sure to open the program titled EOS Utility 3; the other one won't work with your camera.

REMEMBER

The figures in this chapter show how things look on a computer running Windows 10. If you use another version of Windows or a Mac computer, the various option boxes follow the design standards of that operating system. But the major program features work the same no matter what the operating system.

7. **Click Download Images to Computer to display the window shown in Figure 10-13.**

8. **Click the Select and Download option, highlighted in Figure 10-13.**

The other setting, Start Automatic Download, may work better for some downloads, so I explain it later. For now, choose Select and Download to display the screen shown in Figure 10-14. On the left side of the screen is a list of all the folders on your memory card (you may have only one folder); on the right, you see thumbnails of the images in the selected folder. To see the contents of all folders, select All, as in the figure.

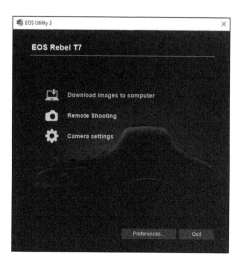

FIGURE 10-12:
Canon EOS Utility is the key to downloading pictures directly from your camera.

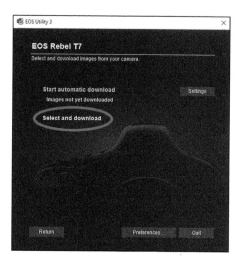

FIGURE 10-13:
Choose this option to preview and select images for downloading.

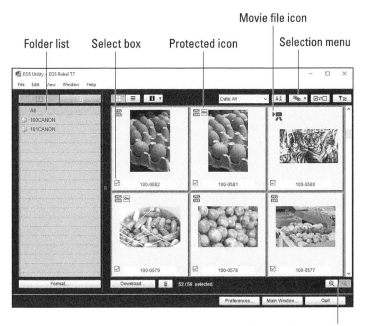

Folder list Select box Protected icon Movie file icon Selection menu

FIGURE 10-14:
Select the
thumbnails
of the images
you want to
transfer.

Change thumbnail size

9. **Select the images you want to copy to the computer.**

Each thumbnail contains a check box in its lower-left corner. I labeled one of the boxes "Select box" in the figure. To select an image for downloading, click the box to put a check mark in it.

A couple of tips about this window:

- If you used the Protect Images feature, explained earlier in this chapter, you see a key icon with each protected image. I labeled one of the icons in the figure.

- Movie files are indicated by a movie-camera symbol, also labeled in the figure.

- Stars under a thumbnail indicate the rating that you assigned using the Rating feature, also covered earlier in this chapter. If you didn't rate the photo, that area of the thumbnail shows no stars, as in the figure.

- Click the button labeled "Selection menu" in the figure to display a list of batch selection options. You can tell the program to select all protected files, for example, all files that have a certain star rating, all new files, or all files.

- Click the magnifying glass buttons in the lower-right corner of the window to change the size of the thumbnails. I highlighted the buttons in Figure 10-14.

10. Click the Download button to display the dialog box shown in Figure 10-15.

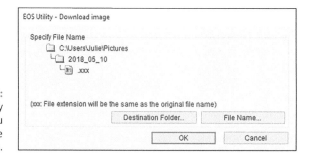

FIGURE 10-15: You can specify where you want to store the photos.

11. **Verify or change the storage location and file-naming settings for your pictures.**

TIP

The top half of the dialog box indicates where the program wants to store your downloaded pictures. By default, pictures are stored in the Pictures or My Pictures folder in Windows (depending on the version of Windows you use) and in the Pictures folder on a Mac. A new folder is created for each batch of files you download, and the download date is used as the folder name. To change these details, click the Destination Folder button.

Normally, the program retains the original filenames when downloading. But if you want to assign files different names, click the File Name button. (For example, if all the pictures are from Ted's birthday party, you might tell the program to name the files Ted_001, Ted_002, and so on.)

12. **Click OK to begin the download.**

A progress window appears, showing you the status of the download. You also may see a preview window showing you a quick look at each picture as it's downloaded.

When the download is complete and the memory-card access light on the back of the camera turns off, *turn off the camera.* You can then disconnect the camera from the computer. The EOS Utility window should close automatically after the program notices the disappearance of the camera.

Now for the promised details about the automatic downloading setting and a couple of other fine points about direct camera-to-computer file transfer:

>> **Using the automatic download option:** If you don't want to take the time to preview photos before downloading them, follow Steps 1–7 as just outlined. Then choose Start Automatic Download on the screen shown in Figure 10-13. (It's the top option, appearing in yellow type in the figure.) By default, the program downloads only images you haven't already transferred to the computer. But if you click the Settings button to the right of the Start Automatic Download option, you can specify that you instead want to download all images, all protected images that haven't already been downloaded, or images to which you assigned a print order setting via the Print Order option on Playback Menu 1. (I cover the Print Order feature in Chapter 12.)

The program uses the default file destination and file-naming settings I described in the steps. To access those settings so that you can change them, click the Preferences button at the bottom of the EOS Utility 3 dialog box (refer to Figure 10-13) and then click the Destination Folder tab.

>> **Auto-launching Digital Photo Professional 4:** By default, Digital Photo Professional 4 opens after the download is finished so that you can view, edit, and organize your files. To stop that program from launching automatically, connect the camera to the computer and click the Preferences button at the bottom of the first EOS Utility 3 window that appears (refer to Figure 10-12). Click the Linked Software tab and select None from the drop-down list labeled Software to Link. Or click the Register button to choose another photo program that you want to open automatically after picture download completes.

>> **Setting other download preferences:** You can adjust many other aspects of the download, including whether images are displayed one by one during the download, via the Preferences dialog box. Again, you must connect your camera to the computer to adjust these settings. (Turn off the Quick Preview option on the Basic Settings tab if you don't want to see the image-by-image previews during downloading.)

Downloading from a card reader

Canon's EOS Utility 3 doesn't offer an automated tool that works for downloads from card readers. But you can use Digital Photo Professional 4 to view and transfer your photos the "old-fashioned" way, which is to select the files you want to download and then drag and drop them to an existing folder on your computer.

When you launch the program, you should see the card reader as just another drive in the list of drives that appears on the left side of the program window. (If you don't see the folder list, labeled in Figure 10-16, open the View menu, choose Open/Close Pane, and select left.) The card reader may display the name EOS_DIGITAL, as in the figure.

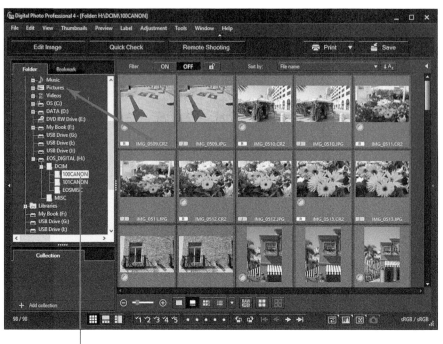

Memory card image folder

After locating the card drive, you need to crack open its main folder, named DCIM. Inside that folder, you see subfolders containing your images; the subfolder names may be 100Canon, 101Canon, and so on. (Ignore the folder named EOS-MISC.) Double-click the folder that contains the images you want to download.

You then see thumbnails to the right of the folder list, as shown in the figure. Select the images that you want to download as follows:

>> **Select a single file:** Click its thumbnail to select it.

>> **Select multiple files:** Click one thumbnail and then hold down the Ctrl key (Windows) or Command key (Mac) as you click additional files. You also can click the first file in a group and then Shift-click on the last file to select the first and last images and all the ones in between.

>> **Select all files:** Click in the thumbnail pane and then press the Control key and the A key if you use a Windows-based computer. Press the Command key and the A key on a Mac. (You may see such *keyboard shortcuts* presented like so: Ctrl+A or Command+A.)

Next, just drag the selected files to the folder where you want to store them, as illustrated in the figure.

Although it's not visible in the figure, you should see a little plus sign next to your cursor when you drag. The plus sign indicates that you're placing a *copy* of the picture files on the computer; your originals remain on the card.

Of course, if you already have a program you like to use for picture downloads, you're free to stick with it. You can even use the Windows and Mac file-management programs — Windows Explorer and Mac Finder — to drag and drop files if you prefer. You can still use Digital Photo Professional 4 to edit your files after you download them.

Processing Raw (CR2) Files

Chapter 2 introduces you to the Raw file format, which enables you to capture images as raw data. Before you can take Raw pictures to a retail lab for printing, share images online, or do much of anything else with them, you need to convert the Raw files to a standard file format. You can do Raw conversions in Digital Photo Professional 4; again, this program is available free for download from the Canon website.

REMEMBER

If you have a previous version of this program, you cannot open Raw files from your T7/2000D. You must update to Version 4 to work with your Raw images. Be sure to also download the software instruction manual. As you can see in Figure 10-17, which shows the main program window, Digital Photo Professional 4 is loaded with features — too many for me to detail here.

That said, here's a quick overview of the process of using the program to convert your Raw files:

1. **After opening the program, track down the Raw file you want to convert.**

 Use the folder tree on the left side of the window to navigate to the folder where the file is stored. You can hide and display the folder pane by clicking the triangle labeled in the figure. Or open the View menu, click Open/Close Pane, and then click Left.

2. **Click the thumbnail of the image you want to process, and then click the Edit Image button, labeled in Figure 10-17.**

 Your photo appears inside an editing window, as shown in Figure 10-18. The appearance of the window depends on your program settings. If you don't see the Tool palette on the right side of the window, open the View menu and click Tool Palette. Other View menu options enable you to further customize the window display.

Hide/display Folder pane

Click to open edit window

Selected image

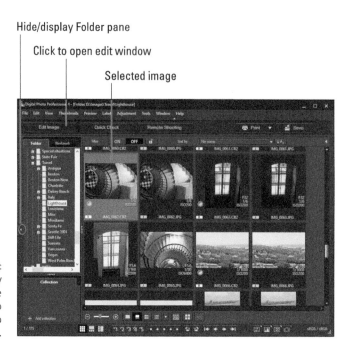

FIGURE 10-17:
Start by
selecting the
Raw photo
you want to
process.

Zoom display

Drag to scroll palette

Exit editing window

Click tabs to display more controls

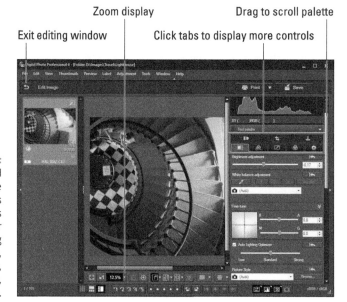

FIGURE 10-18:
The Tool
palette
contains
multiple tabs
of options for
manipulating
exposure,
color,
sharpness,
and more.

3. **Open the Adjustment menu and choose the Work Color Space option. Then select your preferred color space.**

The *color space* determines the spectrum of colors that can be used to generate the image. By default, the program uses the color space selected when you shot the picture (sRGB or Adobe RGB, Shooting Menu 2). But you can select from a couple of other options if you prefer. The color space determines the spectrum of colors your image can contain; sRGB is the best option if you're not yet schooled in this subject, which I explain in Chapter 11.

4. **Adjust the image using controls in the Tool palette.**

The Tool palette offers multiple tabs, each offering its own assortment of adjustment tools. The tab shown in the figure is the Basic tab, which appears by default when you first open the window. To explore another tab, click its icon. The icons are near the top of the palette, in the area surrounded by the red box in the figure. You may need to drag the scroll bar, also labeled in the figure, to access all the options on a particular tab.

As you change the various settings, the large image preview updates to show you the results. You can magnify the display by using the controls underneath the preview, as shown in Figure 10-18. Place your cursor inside the preview and drag to scroll the display so that you can see another part of the image when the view is magnified.

REMEMBER

At any time, you can revert the image to the original settings by opening the Adjustment menu and selecting Revert to Shot Settings.

5. **Open the File menu and choose Convert and Save.**

You see the standard file-saving dialog box with a few additional controls. Here's the rundown of critical options:

- *Save as type:* Choose Exif-TIFF (8bit). This option saves your image in the TIFF file format, which preserves all image data. Don't choose the JPEG format; doing so is destructive to the photo because of the lossy compression that's applied. (Chapter 2 explains JPEG compression.)

TECHNICAL STUFF

A *bit* is a unit of computer data; the more bits you have, the more colors your image can contain. Some photo-editing programs can't open 16-bit files, or else they limit you to a few editing tools, so stick with the standard, 8-bit image option unless you know that your software can handle the higher bit depth. If you prefer 16-bit files, you can select TIFF 16bit as the file type.

- *Output Resolution:* This option *does not* adjust the pixel count of an image, as you might imagine. It only sets the default output resolution to be used if you send the photo to a printer. The final resolution will depend on the print size you choose, however. See the next section for more information about printing and resolution.

- *Embed ICC Profile:* Select this check box to include the color-space data in the file. If you then open the photo in a program that supports color profiles, the colors are rendered more accurately. *ICC* refers to the International Color Consortium, the group that created color-space standards.

- *Resize*: Clear this check box so that your processed file contains all its original pixels.

6. **Enter a filename, select the folder where you want to store the image, and then click Save.**

 A progress box appears, letting you know that the conversion and file saving is going forward. Close the progress box when the program announces that the process is complete.

7. **Close the editing window by clicking the exit button (labeled in Figure 10-18).**

 You're returned to the main Digital Photo Professional 4 window.

8. **Close Digital Photo Professional 4.**

 You see a dialog box that tells you that your Raw file was edited and asks whether you want to save the changes.

9. **Click Yes to store your raw-processing "recipe" with the Raw file.**

 The Raw settings you used are then kept with the original image so that you can create additional copies of the Raw file easily without having to make all your adjustments again.

Again, these steps give you only a basic overview of the process. If you regularly shoot in the Raw format, take the time to explore the Digital Photo Professional 4 instruction manual so that you fully understand all the program's Raw conversion features.

Preparing Pictures for Online Sharing

Have you ever received an email message containing a photo so large that you can't view the whole thing on your monitor without scrolling the email window? This annoyance occurs because monitors can display only a limited number of pixels. The exact number depends on the screen resolution setting, but suffice it to say that most of today's digital cameras produce photos with pixel counts in excess of what the monitor can handle.

Thankfully, the newest email programs incorporate features that automatically shrink the photo display to a viewable size. But that doesn't change the fact that a large photo file means longer downloading times and, if recipients hold onto the picture, a big storage hit on their hard drives.

Sending a high-resolution photo *is* the thing to do if you want the recipient to be able to generate a good print. But for simple onscreen viewing, I suggest limiting your photos to about 1,000 pixels on the longest side. That ensures that people who use an email program that doesn't offer the latest photo-viewing tools can see the entire picture without scrolling the viewer window.

REMEMBER

At the lowest Image Quality setting on your camera, S3, pictures contain 720 x 480 pixels. But recording your originals at that tiny size isn't a good idea because if you want to print the photo, you won't have enough pixels to produce a good result. Instead, shoot your originals at a resolution appropriate for print and then create a low-res copy of the picture for email sharing or for other online uses, such as posting to Facebook. (Posting only low-res photos to Facebook and online photo-sharing sites also helps dissuade would-be photo-thieves looking for free images for use in their company's brochures and other print materials.)

In addition to resizing high-resolution images, also check their file types; if the photos are in the Raw or TIFF format, you need to create a JPEG copy for online use. Web browsers and email programs can't display Raw or TIFF files.

You have a couple ways to tackle both bits of photo prep:

>> Use Canon Digital Photo Professional 4 to convert Raw and TIFF files to the JPEG format. After selecting the image thumbnail, open the File menu and choose Convert and Save. In the Convert and Save dialog box, choose JPEG as the file type. Next, set the file size: Select the Resize box and then enter your desired photo width and height. (Keep the Lock Aspect Ratio box checked to avoid distorting the image.)

WARNING

To resize a JPEG original, you only need to worry about the Resize part of the process. But be sure to save the resized file under a new name so that the original remains intact at its full size. (When you start with a Raw or TIFF file, you don't have that issue because your reduced-size file is saved in a different format than the original.)

>> For photos captured in the JPEG format, you also have the option to create a small-size copy right in the camera. The only exceptions are pictures captured using the S3 Quality setting. At 740 x 480 pixels, they're already the smallest images the camera can create.

Use either of these approaches to use the in-camera shrink ray:

>> **Quick Control screen:** After putting the camera in Playback mode, display the photo you want to resize, press the Q button, and then highlight the Resize icon, as shown in Figure 10-19. Size options appear at the bottom of the screen. Which sizes appear depends on the size of the original photo; you're offered only sizes that produce a smaller picture. The text label above the options indicates the file size (in megapixels, not megabytes) and pixel count of the selected setting.

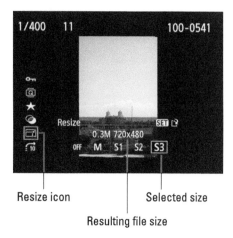

Resize icon Selected size

Resulting file size

FIGURE 10-19:
You can resize photos from the Quick Control screen during playback.

Use the left/right cross keys to highlight a size and press the Set button. A confirmation screen appears, asking permission to save the resized copy as a new file. Highlight OK and press Set. The camera creates your low-res copy and displays a text message along with a seven-digit number. The first three numbers indicate the folder number where the copy is stored, and the last four numbers are the last four numbers of the image filename. Be sure to note the filename of the small copy so that you can tell it apart from its higher-resolution sibling later. Press Set one more time to wrap up.

>> **Playback Menu 1:** Choose Resize, as shown on the left in Figure 10-20. You see a photo along with a Resize icon and Set symbol in the upper-left corner, as shown on the right in the figure.

FIGURE 10-20:
Choose the Resize command to make a low-resolution copy of an existing image.

Scroll to the picture you want to resize and then press the Set button. You then see display size options available for the photo. Choose the one you want to use and press Set again. On the confirmation screen, highlight OK and press Set.

Transferring Files to a Smartphone or Tablet

Your camera's Wi-Fi feature enables you to transfer files to a smartphone or tablet so that you can easily share them online when you're away from your computer. After sending the files to your smart device, you use its Wi-Fi or cell connection to post them on your favorite social media site, attach them to an email or text message, or otherwise launch them into cyberspace.

REMEMBER

To take advantage of this option, your device needs to be compatible with the Canon Camera Connect app. The app is available for Android and iOS (Apple) devices; visit Google Play Store for the Android version and the Apple App store for the iOS version. Be sure to check the app specs to make sure that it's compatible with the version of the operating system on your device.

The next section explains the steps for setting up your camera for Wi-Fi transfer. You need to take these steps only the first time you connect the camera to your smart device. Following the setup information, I provide information about connecting to your smart device and viewing and transferring photos.

A few critical points before you start:

>> You can't transfer movie files over the Wi-Fi connection. Nor can you enable the camera's Wi-Fi functions when the Mode dial is set to Movie mode.

>> Wi-Fi features are inoperable while the camera is connected via cable to your computer or a TV set. This restriction puts a crimp in my ability to show you all the camera screens that you see during the connection process. I can record the screens only while the camera is connected to my computer's video-capture card, and as soon as I make that connection, the Wi-Fi is disabled.

I provide as many text cues as I can, but if you hit a snag, check the camera's instruction manual. Toward the back of the manual, Canon provides a quick guide to the Wi-Fi features. For more complete instructions, visit the Canon support site and download the complete camera instruction manual as well as the Wi-Fi manual. Both contain additional information about the wireless functions of your camera.

>> The Canon Camera Connect app offers a built-in guide that walks you through the steps of setting up the camera and connecting it to your smart device. To use that guide, just tap Easy Connection Guide on the first screen that appears when you open the app. However, because the guide isn't specific to your camera, understanding which choices to make as you work your way through the setup steps can be confusing. I suggest at least scanning the instructions in the following section so that you'll better understand what to do if you opt to use the Easy Connection Guide feature.

Setting up the camera for Wi-Fi functions

Before you can use any of the wireless features, you need to take a few steps:

1. **Open Setup Menu 3 and choose Wi-Fi/NFC, as shown in Figure 10-21.**

2. **Press Set.**

3. **On the screen that appears, highlight Enable.**

 After you do so, the camera displays a check box related to NFC Connectivity.

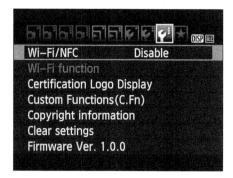

 NFC stands for *Near Field Communication.* If your smartphone or other smart device is NFC capable, you *may* be able to establish a

FIGURE 10-21:
Wi-Fi functions are controlled via the two top options on Setup Menu 3.

 connection between it and the camera simply by placing the two devices next to each other. I say *may* because some devices offer NFC only for limited functions, such as using Apple Pay on an iPhone. Anyway, if your device doesn't offer NFC, press the DISP button to remove the check mark from the NFC box. Press again to enable the option.

4. **Press the Set button.**

 You see a screen asking you to enter a nickname for the camera.

5. **Press the Set button again.**

 Now you see a keyboard input screen like the one shown in Figure 10-22. The screen is divided into two sections: the text box, which shows the current nickname, and the keyboard, which you use to enter new characters. In the text box, the yellow line indicates the text cursor.

6. **Enter a camera nickname.**

This name will identify your camera on your smart device. By default, the camera name is EOST7, as shown in Figure 10-22. If that's okay with you, you don't have to change the name; just skip to Step 7.

If you do want to create a custom name, the keyboard works like so:

- *Press the Q button to toggle between the text entry box and the keyboard.* The blue outline indicates which part of the screen is active. In the figure, the keyboard is active.

- *To delete the default nickname:* First, press the Q button to activate the text box. Press the right cross key to move the cursor to the end of the text, as shown in the figure. Then press the Erase button; each press deletes one character.

- *To enter new text:* Again, press Q to toggle to the keyboard if needed. Then use the cross keys or Main dial to highlight a character. To enter the character, press Set. If you make a mistake, press Q to switch back to the text box, move the cursor as needed, and press the Erase button to remove the offending character. To enter an empty space, choose the very first character on the keyboard, highlighted in the figure. (The orange box surrounds the selected character — which, in this case, is an empty space.)

Your camera nickname can be up to 10 characters long.

7. **Press the Menu button.**

You see a confirmation screen.

8. **Select OK and press the Set button.**

Setup Menu 3 appears. The camera is now ready for Wi-Fi connections.

Cursor Text box

Space character Keyboard

FIGURE 10-22:
The name you enter will be used to identify the camera's wireless network.

Transferring images to your smart device

After you complete the steps in the preceding sections, follow these instructions to connect your camera to your device and transfer photos for the first time. After

you make an initial connection, things work a little differently; more on that topic and on NFC connectivity after the steps.

1. **On the camera, open Setup Menu 3 and choose Wi-Fi Function, located just below the Wi-Fi/NFC option (refer to Figure 10-21).**

 The next screen offers four icons.

2. **Highlight the phone icon (second icon, top row) and press Set.**

 Now you see the Connection Method screen, which offers two options: Easy Connection and Select a Network.

3. **Choose Easy Connection, press Set to highlight OK, and press Set again.**

 On the resulting screen, the camera displays the nickname that you assigned in the steps found in the preceding section. You also see an encryption key, a string of nine characters that serve as the password to your camera's Wi-Fi network.

4. **On your smartphone or tablet, enable Wi-Fi and then open the device's wireless settings screen.**

 Your camera's nickname should appear on the list of available Wi-Fi networks. If you didn't assign a nickname, the camera name should start with *EOST7* followed by some additional characters.

5. **Select the camera name from the list of networks and, when prompted for a password, enter the encryption key shown on the camera monitor.**

 After entering the password, tell the smart device to join the network.

6. **On your phone or tablet, exit the settings screen and open the Canon Camera Connect app.**

 If all the planets are in alignment, a screen should appear on your device that indicates that a new camera has been found and asks you to select the camera to finalize the connection.

7. **Tap Canon EOS Rebel T7.**

8. **On the camera, press the DISP button to specify which images you want to access.**

 You can select All Images, images from just the past few days, images assigned a particular rating, or a specific file-number range. If you choose anything but All Images, you can then set parameters for the file selection.

9. **After selecting the type of images you want to access, press the Set button as needed to exit the camera screens.**

The monitor goes dark, and the app shows that the camera is connected. The left screen in Figure 10-23 gives you a look at the home screen for the iOS version of the app; you get the same options on an Android device, although the window dressing is a little different.

Tap to access additional settings

Tap to view thumbnails Tap to select images for download

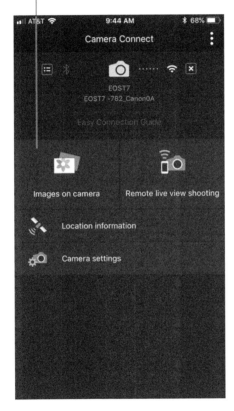
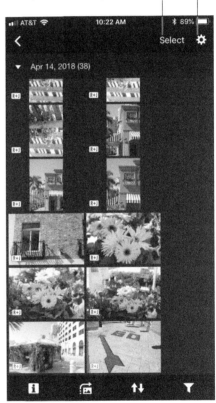

FIGURE 10-23: In the Canon Camera Connect app, tap Images on Camera (left) to view pictures stored on the camera memory card (right).

10. **On your device, choose Images on Camera.**

Thumbnails of your images appear, as shown on the right in Figure 10-23.

To toggle between the display you see in the figure and one that includes some shooting data for each image, tap the **i** symbol in the lower-left corner of the screen.

TIP

11. **To transfer multiple images, tap Select.**

You see circles next to each thumbnail, as shown on the left in Figure 10-24. To select an image for transfer, tap its thumbnail to place a checkmark in the circle. Then tap the Download icon, labeled in the figure. You're asked to specify whether you want to send the image at its original size or a reduced size, as shown on the right in the figure. Tap your choice and then tap OK to transfer a copy of the images to your device.

Selected for transfer

Not selected Select All

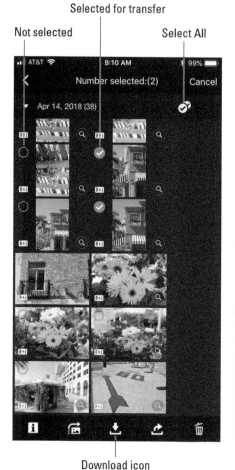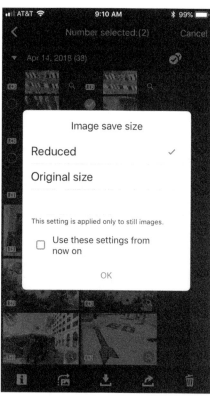

FIGURE 10-24:
After selecting images for transfer, tap the Download icon (left) and then specify the size of the file that will be saved on your device (right).

Download icon

12. **To transfer a single image, return to the main thumbnails screen, tap the photo's thumbnail, and then tap the Download icon.**

Again, choose the download size and then tap OK.

That's the basic concept; here are a few more pieces of the puzzle that may help:

>> After you get to the thumbnails screen, you can adjust a few aspects of the file transfer by tapping the Settings icon, labeled in Figure 10-24.

>> Where the image files end up depends on how you have picture storage set up on your device. Look for the Canon Camera Connect app in your device's main settings panel to sort this out. You may need to give the app permission to access the photo-storage folder on the device.

>> For NFC transfer, look for the camera's NFC thing-a-ma-jiggy on the left side of the camera, just forward of the door that covers the connection ports. I labeled the spot where the NFC connection lives in Figure 10-25. Bring the device's NFC antenna into contact with that mark until a message on the camera monitor says that the connection is established. Then move the two devices apart. At that point, the Camera Connect icon should launch automatically on the device.

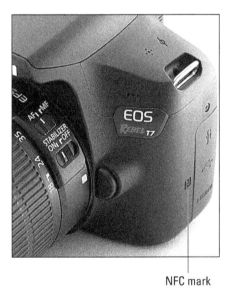 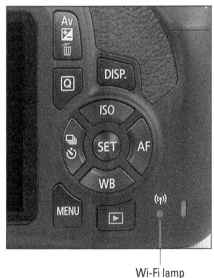

FIGURE 10-25:
Here's where
to find the NFC
connection
point (left) and
the Wi-Fi con-
nection lamp
(right).

NFC mark Wi-Fi lamp

>> While a Wi-Fi connection is active, the lamp labeled on the right side of Figure 10-25 lights. You can't access any camera functions by using the camera's own controls while the devices are connected. (See Chapter 12 to find out how to use the device as a remote-control for the camera.)

Reconnecting your devices

After you connect the camera to your smart device for the first time, you no longer have to go through all the steps spelled out in the earlier section, "Setting up the camera for Wi-Fi functions." Take these steps instead:

1. **On your camera, open Setup Menu 3 and set the Wi-Fi/NFC option to Enable.**

2. **On the same menu, choose Wi-Fi Function and then choose the phone icon.**

 This time, you see a different screen than during initial screen setup. All your previous settings, such as the type of images you want to access, are stored in a "set" — Set 1, by default.

3. **To use the same settings as your previous connection, highlight Connect and press Set.**

4. **On the next screen, select OK and press Set.**

5. **On your smart device, open the device settings screen and select your camera from the list of available wireless networks.**

6. **On your smart device, open Canon Camera Connect.**

 The two devices should connect automatically, at which point the camera monitor turns off and you then control things through the app.

If you want to change settings that affect image transfers to your smart device, do so on the camera, from the menu that appears after you choose the phone icon in Step 2. You can opt to review and change settings or delete all settings and start over.

To clear all Wi-Fi settings or change the camera's assigned nickname, stop after choosing Wi-Fi Function in Step 2. When you see the icon screen, press the DISP button to bring up a screen where you can change the camera nickname or restore all Wi-Fi settings to the original, default settings.

One final note: You can set up connections to multiple devices. For example, you can set up one connection for your smartphone and another for a tablet. The two devices don't even have to run on the same platform — one can be an iOS device and the other, an Android device. The downloadable Wi-Fi instruction manual contains details about creating multiple connections as well as other aspects of fine-tuning your Wi-Fi setup.

4

The Part of Tens

button

» **Turning off the beep and AF-assist beam**

» **Creating your own folders and camera menu**

» **Customizing a few other camera behaviors**

Chapter **11**

Ten More Ways to Customize Your Camera

Have you ever tried to cook dinner in someone else's house or work from another colleague's desk? Why is *nothing* stored in the right place? The coffee cups, for example, should be stowed in the cabinet above the coffee maker, and yet there they are, way across the kitchen, in the cupboard near the fridge. And everyone knows that the highlighter pens belong in the middle top drawer, not the second one on the left. Yeesh.

In the same way, you may find a particular aspect of your camera's design illogical or a tad inconvenient. If so, check out this chapter, which introduces you to ten customization options not detailed in earlier chapters. You can give the Set button a new job, for example, silence the camera's beeper, and even create your own camera menu.

REMEMBER

Many of the adjustments covered here involve the Custom Functions menu, which I explain how to navigate in Chapter 1. You can access this menu only when the camera's Mode dial is set to P, Tv, Av, or M.

Changing the Function of the Set Button

Normally, the main role of the Set button during shooting is to select items from the camera menus and Quick Settings screens. In the P, Tv, Av, or M exposure modes, though, you can set the button to perform a different function during shooting. (The button still performs its regular operations when a menu or Quick Settings screen is displayed.) To modify the Set button assignment, select Custom Functions from Setup Menu 3 and then press the left/right cross keys until you see Custom Function 9, shown in Figure 11-1. Choose from these alternative Set button functions:

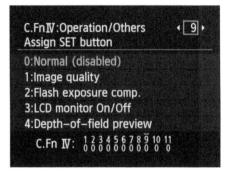

FIGURE 11-1:
You can configure the Set button to perform an extra function.

>> **Image Quality:** Displays the screen where you can change the Image Quality setting.

>> **Flash Exposure Compensation:** Displays the setting that enables you to adjust flash power.

>> **LCD Monitor On/Off:** Toggles the Shooting Settings screen on and off. (This function doesn't work in Live View mode.)

>> **Depth-of-Field Preview:** If you press and hold the Set button down, the lens aperture stops down to the chosen f-stop, giving you a preview of how the aperture setting affects depth of field. You can see the change happen in the viewfinder or, when Live View is engaged, on the camera monitor. Both displays may become pretty dark at high f-stop settings, which limits the amount of light entering through the lens.

To go back to the default setting, choose Normal (disabled).

Customizing the AE Lock and Shutter Buttons

By default, you initiate autofocusing by pressing the shutter button halfway and lock autoexposure by pressing the AE (autoexposure) Lock button. (The AE Lock button looks like the margin icon shown here.) I recommend that you stick with

this setup while learning about your camera; otherwise, my instructions won't work, and neither will the ones in the camera manual. But after you feel more comfortable, you may want to customize the locking behaviors of the two buttons.

To configure the buttons, set the Mode dial to P, Tv, Av, or M. Then head for Custom Function 8. As shown in Figure 11-2, you can choose from the following configuration options. The part of the option name before the slash indicates the result of pressing the shutter button halfway; the name after the slash indicates the result of pressing the AE Lock button.

➤➤ **AF/AE Lock:** This is the default setting. Pressing the shutter button halfway initiates autofocus; pressing the AE Lock button locks autoexposure.

➤➤ **AE Lock/AF:** With this option, pressing the shutter button halfway locks autoexposure. To initiate autofocusing, press the AE Lock button. In other words, this mode is the exact opposite of the default setup.

➤➤ **AF/AF Lock, No AE Lock:** Pressing the shutter button halfway initiates autofocusing and exposure metering, and pressing the AE Lock button locks focus. Autoexposure lock isn't possible.

FIGURE 11-2:
Adjust autoexposure and autofocus lock behavior via Custom Function 8.

TIP

This option is designed to prevent focusing mishaps when you use AI Servo autofocusing, a viewfinder-shooting option explained in Chapter 5. In AI Servo mode, the autofocus motor continually adjusts focus from the time you press the shutter button halfway until the time you take the image. This feature helps keep moving objects focused. But if something moves in front of your subject, the camera may mistakenly focus on that object instead. To cope with that possibility, this locking option enables you to initiate autofocusing as usual, by pressing the shutter button halfway. But at any time before you take the picture, you can hold down the AE Lock button to stop the autofocusing motor from adjusting focus. Releasing the button restarts autofocusing. Exposure is set at the time you take the picture.

➤➤ **AE/AF, No AE Lock:** In this mode, press the shutter button halfway to initiate autoexposure and press the AE Lock button to autofocus. In AI Servo mode, continuous autofocusing occurs only while you hold down the AE Lock button, which is helpful if your subject repeatedly moves and then stops. Exposure is set at the moment you take the picture.

Disabling the AF-Assist Beam

In dim lighting, your camera may emit an AF (autofocus)-assist beam from the built-in flash when you press the shutter button halfway — assuming that the flash unit is open, of course. This pulse of light helps the camera "see" its target better, improving the performance of the autofocusing system. In situations where the AF-assist beam may be distracting, you can disable it in the P, Tv, Av, or M exposure modes. Make the change via Custom Function 7, which offers these choices:

>> **Enable:** This setting is the default and turns the AF-Assist Beam function on.

>> **Disable:** I know you can figure this one out.

>> **Enable External Flash Only:** Choose this setting to permit an external flash unit to emit the beam but prevent the built-in flash from doing so. (The idea is to save you the time and hassle of revisiting the Custom Functions setting to enable or disable the beam every time you switch from the built-in flash to an external flash — two settings in one, if you will.) The external flash must be a compatible EX-series Speedlite unit, such as the Speedlite 430EX II.

>> **IR AF Assist Beam Only:** This setting allows an external Canon EOS Speedlite with infrared (IR) AF-assist to use only the IR beam to aid in focusing instead of pulsing a series of small flashes like the built-in flash does when it tries to play autofocus guide dog. This setting gives you the best of both worlds: an AF assist beam that is invisible to the naked eye.

REMEMBER

An external Canon Speedlite has its own provision to disable the AF-assist beam. If you turn off the beam on the flash unit, it won't light no matter which Custom Functions setting you choose.

Silencing the Camera

By default, your camera beeps after certain operations, such as after it sets focus when you use autofocusing and during the timer-countdown when you use the Self-Timer Drive mode. If you need the camera to hush up, set the Beep option on Shooting Menu 1 to Disable. This option is available in all shooting modes.

Preventing Shutter Release without a Memory Card

WARNING

By default, you can take a picture without any memory card in the camera. But the image you shoot is only temporary, appearing for just a few seconds on the monitor and then dissolving into digital nothingness. During the instant image-review period, your camera warns you that there's no card in the camera. You also see a warning message on the monitor if no card is installed when you turn on the camera.

If you're wondering about the point of this option, it's designed for use in camera stores, enabling salespeople to demonstrate cameras without having to keep a memory card in every model. Unless that describes the way you're using the camera, turn this feature off by opening Shooting Menu 1 and changing the Release Shutter without Card option to disable. The camera then prevents the shutter button from releasing and tricking you into thinking you just took a picture.

Reducing the Number of Exposure Stops

TECHNICAL STUFF

In photography, the term *stop* refers to an increment of exposure. To increase exposure by one stop means to adjust the aperture or shutter speed to allow twice as much light into the camera as the current settings permit. To reduce exposure a stop, you use settings that allow half as much light. Doubling or halving the ISO value also adjusts exposure by one stop.

By default, major exposure-related settings on your camera are based on one-third stop adjustments. If you prefer, you can tell the camera to present exposure adjustments in half-stop increments so that you don't have to cycle through as many settings each time you want to make a change. Make your preferences known via Custom Function 1.

Note that when you use the 1/2-stop setting, the exposure meter appears slightly different in the Shooting Settings display and Live View display than you see it in this book: Only one intermediate notch appears between each number on the meter instead of the usual two. The viewfinder meter doesn't change, but the exposure indicator bar appears as a double line if you set the Exposure Compensation value to a half-step value (+0.5, +1.5, and so on).

Creating Your Own Camera Menu

Through the My Menu feature, you can create a custom menu containing up to six items from the camera's other menus. Grouping menu items this way makes it easier to access the options you use most frequently because they're all on one menu. Take these steps to create a custom menu:

1. **Set the camera Mode dial to P, Tv, Av, or M.**

 You can create and order from the custom menu only in these exposure modes.

2. **Press Menu and rotate the Main dial to bring up the My Menu screen.**

 The menu is represented by a green star and initially shows only a single item: My Menu Settings, as shown on the left in Figure 11-3.

FIGURE 11-3:
The My Menu feature lets you put six favorite menu options on a single menu.

3. **Choose My Menu Settings.**

 The screen shown on the right in Figure 11-3 appears.

4. **Choose Register to My Menu.**

 You see a scrolling list that contains every item found on the camera's menus, as shown on the left in Figure 11-4. Scroll the menu screen by using the up/down cross keys.

5. **Highlight the first item to include on your custom menu.**

TIP

To add a specific Custom Function to your menu, scroll *past* the item named Custom Functions to find and highlight the individual function. (The item named Custom Functions simply puts the Custom Functions menu item on your menu, and you still have to wade through multiple levels of steps to reach the function you want to change.)

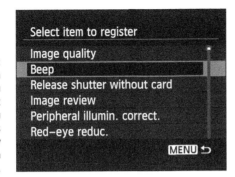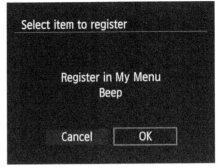

FIGURE 11-4:
Highlight an
option you
want to put
on your menu
(left) and press
Set to display
a confirmation
screen (right).

6. **Press Set to display the confirmation screen shown on the right in Figure 11-4.**

7. **Highlight OK and press Set.**

 The list of menu items reappears, with the option you just added to your menu dimmed in the list.

8. **Repeat Steps 5 through 7 to add up to five additional items to your menu.**

9. **Press the Menu button to return to the My Menu Settings screen.**

10. **Press the Menu button again to return to the My Menu screen.**

 The items you added appear on the menu. You now can access those menu options either through your custom menu or their regular menu.

After creating your menu, you can manage it as follows:

TIP

» **Give your menu priority.** You can tell the camera that you want it to automatically display your custom menu anytime you press the Menu button. To do so, choose My Menu Settings on the main My Menu screen to display the screen shown on the right side of Figure 11-3. Then set the Display from My Menu option to Enable.

» **Change the order of the list of menu items.** Once again, navigate to the right screen in Figure 11-3. This time, choose the Sort option. Highlight a menu item, press Set, and then press the up/down cross keys to move the menu item up or down in the list. Press Set again to glue the menu item in its new position.

» **Delete menu items.** Display your menu, choose My Menu Settings, and then choose Delete Item/Items (refer to the right screen in Figure 11-3). Highlight the menu item that you want to delete and press Set. On the resulting confirmation screen, choose OK and then press the Set button.

 To remove all items from your custom menu, choose Delete All Items (again, refer to the right side of Figure 11-3) and press Set. On the confirmation screen, highlight OK and press Set.

Creating Custom Folders

Normally, your camera automatically creates folders to store your images. The first folder has the name 100Canon; the second, 101Canon; the third, 102Canon; and so on. Each folder can hold 9,999 photos. If you want to create a new folder before the existing one is full, choose Select Folder from Setup Menu 1 and then choose Create Folder, as illustrated in Figure 11-5. You might take this organizational step so that you can separate work photos from personal photos, for example.

FIGURE 11-5: You can create a new image-storage folder at any time.

The camera asks for permission to create the folder; choose OK and press Set. The folder is automatically assigned the next available folder number and is selected as the active folder — the one that will hold any new photos you shoot. Press the Set button to return to Setup Menu 1.

To make a different folder the active folder, choose Select Folder again, choose the folder you want to use, and press Set.

TIP

If you select a folder that contains images, two thumbnails appear to the right of the folder name. The top thumbnail shows the first image in the folder, along with the last four numbers of its filename. The bottom thumbnail shows the last image in the folder.

Turning Off the Shooting Settings Screen

When you turn on your camera, the monitor automatically displays the Shooting Settings screen. At least, it does if you stick with the default setting selected for Custom Function 11, which bears the lengthy name LCD Display When Power On and appears in Figure 11-6.

You can prevent the monitor from displaying the screen every time you power up the camera by changing this setting from Display On to Previous Display Status. The monitor is one of the biggest drains on the camera battery, so limiting it to displaying information only when you need it can extend the time between battery charges.

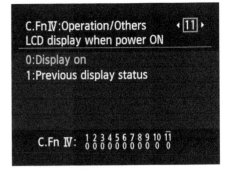

C.Fn IV:Operation/Others ◄ 11 ►
LCD display when power ON

0:Display on
1:Previous display status

C.Fn IV: 1 2 3 4 5 6 7 8 9 10 11
0 0 0 0 0 0 0 0 0 0 0

WARNING

Note the setting name, though: Previous Display Status. At this setting, the camera operates just as the name implies. The camera preserves the monitor status when you turn the camera off and then back on again. If the Shooting Set-

FIGURE 11-6:
This option affects whether the Shooting Settings screen appears when you turn on the camera.

tings screen was displayed when you turned off the camera, it *will* appear the next time you power up. If the screen was off when you turned off the camera, it remains dark when you turn the camera back on. You then have to press the DISP button to view the screen.

I find all this way too much to remember, so I leave this option at the default and just use the DISP button to turn off the monitor when needed.

REMEMBER

If you do want to take advantage of this feature, note that as with other Custom Functions, it works only when the camera is set to P, Tv, Av, or M exposure mode. In other modes, the screen still appears automatically.

Changing the Color Space from sRGB to Adobe RGB

By default, your camera captures photographs and movies using the *sRGB color mode,* which simply refers to an industry-standard spectrum of colors. (The *s* is for *standard,* and the *RGB* is for *red, green, blue,* which are the primary colors in the digital color world.) The sRGB color mode was created to help ensure color consistency as an image moves from camera (or scanner) to monitor and printer; the idea was to create a spectrum of colors that all these devices can reproduce.

However, the sRGB color spectrum leaves out some colors that *can* be reproduced in print and onscreen, at least by some devices. So, as an alternative, your camera also offers the Adobe RGB color mode — which includes a larger spectrum of

colors. It's important to know that some colors in the Adobe RGB spectrum *can't* be reproduced in print; the printer just substitutes the closest printable color, if necessary.

So which option is right for you? Well, the point is moot for movie recording; you can't record a movie in the Adobe RGB color space. For photographs, most people are better off sticking with sRGB because most printers and web browsers are designed around that color space. Second, to retain all your original Adobe RGB colors when you work with your photos, your editing software must support that color space, and not all programs do. You also must be willing to study the whole topic of digital color a little bit because you need to use some specific settings to avoid really mucking up the color works.

REMEMBER

To use Adobe RGB, you must shoot in the advanced exposure modes: P, Tv, Av, and M. After setting the Mode dial to one of those settings, make your decision known via the Color Space option on Shooting Menu 2, shown in Figure 11-7. In other modes, the camera automatically selects sRGB. Additionally, your color space selection is applied to only your JPEG images; with Raw captures, you select the color space as you process the Raw image and convert it to a JPEG or TIFF, not when you capture it. (See Chapter 10 for details about Raw-image processing.)

FIGURE 11-7:
Choose sRGB unless you're savvy about image color management.

TIP

After you transfer pictures to your computer, you can tell whether you captured an image in the Adobe RGB color space by looking at its filename: Adobe RGB images start with an underscore, as in _MG_0627.jpg. Pictures captured in the sRGB color space start with the letter *I*, as in IMG_0627.jpg.

Chapter **12**

Ten More Cool Features to Explore

C onsider this chapter the literary equivalent of the end of one of those late-night infomercial offers — the part where the host exclaims, "But wait! There's more!" Options covered here aren't the sort of features that drive people to choose one camera over another, and they may come in handy only for certain users, on certain occasions. Still, they're included at no extra charge with your camera, so check 'em out when you have a spare moment. Who knows? You may discover just the solution you need for one of your photography problems.

Adding Cleaning Instructions to Images

If small spots appear consistently on your images and you know that dirt on your lens isn't the cause, your sensor may need cleaning. I don't recommend that you clean the sensor yourself because you can easily ruin your camera if you

don't know what you're doing. Instead, take the camera to a good repair shop for cleaning.

Until you can have the camera cleaned, however, you can use a software-based dust-removal filter found in Digital Photo Professional 4, one of the programs available for free download from the Canon website. You start by recording a data file that maps the location of the dust spots on the sensor. Then when you open the file in Digital Photo Professional 4, the software uses the map as a guide and runs a spot-removal filter that may diminish or eliminate the dust.

To create your reference shot, grab a white piece of paper and then take these steps:

1. **Set the lens focal length at 50mm or longer.**

 If you have the 18–55mm kit lens sold with the T7/2000D, zoom the lens to its maximum position (55mm).

2. **Switch the lens to manual focusing and set focus at infinity.**

 Set the switch on the lens to MF. Then hold the camera normally and turn the lens focusing ring counter-clockwise until it stops.

3. **Set the camera to the P, Tv, Av, or M exposure mode.**

 You can create the dust data file only in these modes.

4. **Display Shooting Menu 3 and choose Dust Delete Data.**

5. **On the next screen, highlight OK and press Set.**

6. **Position the white paper 8 to 12 inches from the camera and make sure that the paper fills the viewfinder.**

7. **Press the shutter button all the way to record the data.**

 No picture is taken; the camera just records the Dust Delete Data in its internal memory. If the process was successful, you see the message "Data obtained."

TIP

 If the camera can't record the data, the lighting is likely to blame. Make sure that the lighting is even across the entire surface of your paper and that the paper is sufficiently illuminated, and then try again.

8. **When the Data Obtained screen appears, press Set to exit to Shooting Menu 3.**

 The next time you choose Dust Delete Data, the screen that appears in Step 5 indicates the date on which you last completed the process.

After you create your Dust Delete Data file, the camera attaches the data to every image you shoot. To clean a photo, open Digital Photo Professional 4. Click the

image thumbnail and then click the Edit Image button near the top of the screen (or open the View menu and choose Edit Image Window). When the picture appears inside the editing window, open the Adjustment menu and choose Apply Dust Delete Data.

Tagging Files with Your Copyright Claim

By using the Copyright Information feature on Setup Menu 3, you can add copyright information to the image *metadata* (extra data) recorded with the image file. You can view metadata in Digital Photo Professional 4; Chapter 10 shows you how.

TIP

Including a copyright notice is a reasonable first step to prevent people from using your pictures without permission. Anyone who views your picture in a program that can display metadata can see your copyright notice. Obviously, that won't be enough to completely prevent unauthorized use of your images. But it at least informs people that they should seek permission before printing or sharing your work.

To turn on the copyright function, take these steps:

1. **Set the camera Mode dial to P, Tv, Av, or M.**

 You can create or modify copyright information only in these modes. However, your copyright information (after it's created) will be added to images you shoot in any exposure mode.

2. **Display Setup Menu 3 and choose Copyright Information, as shown on the left in Figure 12-1. Press Set.**

 Now you see the screen shown on the right in Figure 12-1.

FIGURE 12-1: Tagging files with your copyright notice lets people know who owns the rights to the picture.

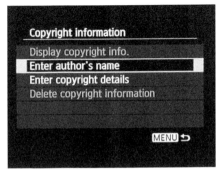

3. **Choose Enter Author's Name and press Set to open a data entry screen, shown in Figure 12-2.**

4. **Enter your name.**

 Use these tricks to enter up to 63 characters:

 - To alternate between the text box and the keyboard below, press the Q button. (Note the Q symbol to the right of the text box; it's there to remind you to use the button for this function.) The blue outline indicates the active area of the screen; in the figure, the keyboard is active.

 - To enter a character, activate the keyboard and use the cross keys or Main dial to highlight the character. Then press Set.

 The first character on the keyboard adds a space character. I highlighted that character in the figure.

 - To delete a character, press Q to toggle the action back to the text box. Use the cross keys or Main dial to position the cursor — the yellow line highlighted in the figure — to the right of the character you want to erase. Then press the Erase button.

5. **Press Menu to return to the screen shown on the right in Figure 12-1.**

6. **Choose Enter Copyright Details and press Set to display a second text-entry screen, where you can add more copyright data.**

 You might want to add the year and possibly a web address, for example, or your company name. (You don't need to enter the word *Copyright* — it's added automatically.)

7. **Press Menu to exit the text entry screen.**

8. **To wrap things up, press Menu one more time.**

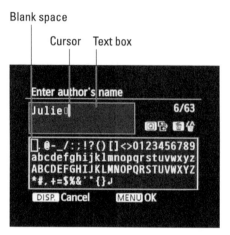

FIGURE 12-2: Enter your name and other copyright information that you want tagged to your images.

On the Copyright Information screen (the right side of Figure 12-1), choose Display Copyright Info to see the finalized copyright text. To later disable copyright tagging, choose the Delete Copyright Information option on that same screen. (These two options are unavailable, as in the figure, until you add copyright data.)

Exploring Two Special Printing Options

Through the Print Order option on Playback Menu 1, you can access two features that enable you to print directly from a memory card or the camera:

>> **DPOF (Digital Print Order Format) printing.** After choosing Print Order from the menu, you select pictures from your memory card and then specify how many prints you want of each image. Then, if your photo printer has a card reader compatible with your memory card and supports DPOF, you just pop the card into the reader. The printer checks your print order and outputs just the requested prints. You also can print by connecting the camera to the printer using a USB cable (which must be purchased separately).

>> **PictBridge printing.** With a PictBridge–enabled photo printer, you can send pictures to the printer by connecting the two devices via a USB cable.

If you're interested in exploring either feature, look for details in the PDF version of the camera manual, available for download from the Canon website. You can pick up one compatible cable, Canon Interface Cable IFC-400PCU, for under $10.

Adding Special Effects to Your Photos

With the Creative Filters, you can add special effects to your pictures. For example, I used the filters to create three variations of a city scene in Figure 12-3.

When you use this feature, the camera creates a copy of your image and applies the filter to the copy; your original remains intact. If the original was captured using the Raw Quality setting, the altered image is stored in the JPEG format.

You can choose from these effects:

>> **Grainy B/W:** Creates a black-and-white photo with a speckled appearance.

>> **Soft Focus:** Blurs the photo to make it look soft and fuzzy.

>> **Fish-Eye:** Distorts your photo so that it appears to have been shot using a fish-eye lens, as illustrated in the top-right image in Figure 12-3.

>> **Toy Camera:** Creates an image with dark corners — called a *vignette* effect. Vignetting is caused by poor-quality lenses not letting enough light in to expose the entire frame of film (like in toy cameras). When you choose this effect, you can also add a warm (yellowish) or cool (blue) tint. I applied the effect with a warm tint to create the lower-left variation in Figure 12-3.

Original

Fish-Eye

Toy Camera

Miniature Effect

FIGURE 12-3:
I used the Creative Filters feature to create these variations on a city scene.

» **Miniature:** Creates a trick of the eye by playing with depth of field. It blurs all but a very small area of the photo to produce a result that looks something like one of those miniature dioramas you see in museums. I applied the filter to the original city scene to produce the lower-right variation in Figure 12-3. This effect works best on pictures taken from a high angle.

To try out the filters, take either of these approaches:

>> **Quick Control screen:** After setting the camera to Playback mode, display the photo, press the Q button and then use the up/down cross keys to highlight the Creative Filters icon, as shown on the left in Figure 12-4. Symbols representing the available filters appear at the bottom of the screen. Use the left/right cross keys to highlight a filter icon and then press Set.

Creative Filters icon

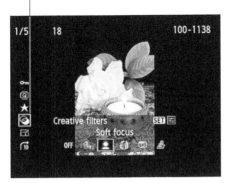 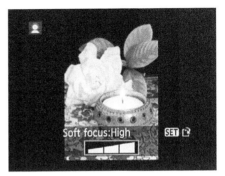

FIGURE 12-4:
During playback, press Q to access Creative Filters.

You see a preview of your photo with the currently selected filter active, as shown on the right in the figure. You then can make minor adjustments to the effect. The screen on the right side of Figure 12-4 shows the adjustment available for the Soft Focus filter, for example. Press the right or left cross keys to increase or decrease the blurring effect. Similarly, you can adjust the amount of contrast change applied by the Grainy B/W filter, the strength of the Fish-Eye effect, and the color of the Toy Camera effect.

For the Miniature effect, use the up or down cross keys to change the position of the focus frame, which determines which part of the image is kept in sharp focus. Press the DISP button to change the orientation of the focus box.

To save the filtered image as a new file, press Set, select OK, and press Set again.

>> **Playback Menu 1:** Highlight Creative Filters and press Set. The camera shifts to Playback mode. Use the cross keys or Main dial to select a photo, press Set, use the cross keys to select a filter, and then press Set again to access any available filter options. From there, things work as described in the previous bullet point.

Tagging Pictures for a Photo Book

Many online and retail photo-printing sites make it easy to print books featuring your favorite images. The Photobook Set-Up option on Playback Menu 1 is a nod to this popular trend. Using this feature, you can tag photos that you want to include in a photo book. Then, if you use the Canon EOS Utility software to transfer pictures to your computer, tagged photos are dumped into a separate folder so they're easy to find. This feature works only when you download pictures by connecting the camera to the computer. In addition, it doesn't work with Raw (CR2) files.

Unfortunately, I don't have room in this book to provide steps for the process of creating your photo books this way, but if you're interested, check out the instruction manuals for the camera and the EOS Utility program. You can download both from the Canon website.

Presenting a Slide Show

Ready to see a retrospective of your art? Check out the Slide Show option, which automatically displays pictures and movies one by one. You can view the show on the camera monitor or, for a better view, connect your camera to a TV for playback, as outlined later in this chapter.

One nice aspect of the Slide Show function is that you can specify which files you want to include. You can tell the camera to show just still photos, for example, or to display only photos that you rated highly using the Rating feature that I cover in Chapter 10.

To set up and run the slide show, follow these steps:

1. **Display Playback Menu 2 and choose Slide Show, as shown on the left in Figure 12-5.**

 You see the screen shown on the right in Figure 12-5. The thumbnail shows the first image that will appear in the slide show if you stick with the current show settings.

2. **Use the cross keys to navigate to the file-selection box, highlighted in Figure 12-5.**

3. **Press the Set button.**

 The file-selection box becomes active, with up and down arrows appearing on the right.

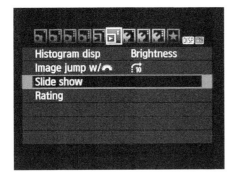

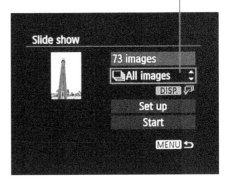

Choose files to include

FIGURE 12-5: Choose Slide Show and then either start it or customize different aspects.

4. **Press the up or down cross keys to specify which files to include in your show.**

Choose from these settings:

- *All Images:* Includes all files, regardless of whether they're still photos or movies.

- *Date:* Plays pictures or movies taken on a single date. As soon as you select the option, the DISP label underneath the option box turns white, clueing you in to the fact that you can press the DISP button to display a screen listing all shooting dates on the memory card. Again, press the up or down cross keys to select a date and then press Set to exit the date list.

- *Folder:* Includes still photos and movies in the selected folder. Again, press DISP to display a list of folders and highlight the one you want to use, and then press Set to exit the folder list. Chapter 11 shows you how to create custom folders.

- *Movies:* Includes only movies.

- *Stills:* Includes only still photos.

- *Rating:* Selects photos and movies based on their rating. (Chapter 10 shows you how to rate photos.) Press DISP to display a screen where you can specify the rating that qualifies a file for inclusion and to see how many files have that rating. After selecting the rating, press Set to exit the rating screen.

5. **Press Set.**

The file-selection box is deactivated.

6. **Highlight Set Up and then press Set.**

You cruise to the screen shown in Figure 12-6, which offers the following additional show options:

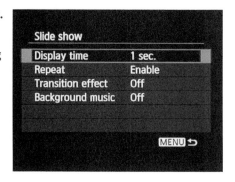

FIGURE 12-6:
Use these four options to specify your play-back preferences.

- *Display Time:* Determines how long each still photo appears on the screen. You can choose timing settings ranging from 1 to 20 seconds. Movies, however, are always played in their entirety.

- *Repeat:* Set this option to Enable if you want the show to play over and over until you decide you've had enough. Choose Disable to play the show only once.

- *Transition Effect:* You can enable one of five transition effects. (Experiment to see which one you prefer.) Choose Off if you don't want any effects between slides.

- *Background Music:* The camera can play background music with your show, but you have to load the audio files onto the camera's memory card first. For this task, you must use Canon EOS Utility, one of the free programs that I introduce in Chapter 10. See the program's instruction manual, also available for download, for help with this step.

 If you add music files to the memory card, use the Background Music option to enable or disable the music accompaniment. Leave the option set to Off, as it is by default, if you don't want to mess with this issue.

7. **After selecting your playback options, press Menu to return to the main Slide Show screen.**

Refer to the screen on the right in Figure 12-5.

8. **Highlight Start and press Set to start the show.**

Your slide show begins playing.

9. **Use the camera buttons to control playback.**

Here's the list of playback functions:

- *Pause/restart playback:* Press the Set button. While the show is paused, you can press the right or left cross key to view the next or previous photo. Press Set again to continue playback from the current slide.

- *Change the playback display style:* Press the DISP button to cycle through the available styles, each of which presents different shooting data. You can get details on playback display styles in Chapter 9.

- *Adjust audio volume:* Rotate the Main dial.

- *Exit the slide show:* Press the Menu button once to return to the Slide Show setup screen; press again to return to Playback Menu 2. You also can exit a slide show and return to normal playback mode by pressing the Playback button. To return to shooting mode, press the shutter button halfway and release it.

Creating Video Snapshots

The Video Snapshot feature, found on Movie Menu 2, enables you to capture short video clips that you stitch into a single recording, called a *video album*. A few pertinent facts about this feature:

>> Each clip can be no more than 8 seconds long. You also can record 2- and 4-second clips.

>> All clips in an album must be the same length.

>> You cannot shoot normal movies when the Video Snapshot feature is enabled.

To create your first album, set the camera to Movie mode, pull up Movie Menu 2, and highlight Video Snapshot, as shown on the left in Figure 12-7. Press OK, select the Video Snapshot shooting time (as shown in the right image), and press OK again. Exit to shooting mode by pressing the shutter button halfway and releasing it, or by pressing the Menu button. Now you're ready to start recording snapshots.

FIGURE 12-7: Video Snapshots are short movie clips combined into a single recording.

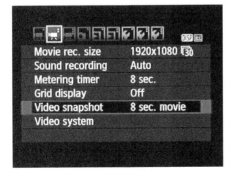
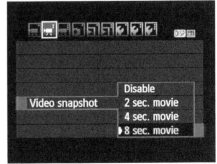

 Press the Movie-record button (also known as the Live View button) to record your first snapshot. While you're shooting, a blue progress bar shows you how much time you have left for the clip. When you reach the maximum clip length, recording stops automatically, with the last frame of the clip displayed. At the bottom of the screen, you see three white icons representing the following options, from left to right: Save as Album, Playback Video Snapshot, or Do Not Save to Album. Select Save as Album to store the clip in your first album.

After you record your second clip, you see four white icons, indicating that you can choose from four options: Add to Album, Save as a New Album, Playback Video Snapshot, and Delete Without Saving to Album. Make your decision and then lather, rinse, and repeat until you tire of the snapshot-recording process. To return to normal movie recording, display Movie Menu 2 and set the Video Snapshot option to Disable.

TIP

While the camera is in Movie mode, you also can use the Quick Control screen to enable and disable Video Snapshot recording. After pressing the Q button to enter Quick Control mode, highlight the Video Snapshot icon, labeled on the left in Figure 12-8. Press the Set button to display the screen where you can choose the recording length. Highlight your choice, press Set, and then press Q to exit the Quick Control screen.

A few final notes about recording video snapshots:

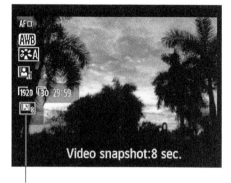

Video Snapshot icon

FIGURE 12-8:
You also can enable and disable the Video Snapshot feature via the Quick Control screen.

>> **Sound recording:** By default, audio is recorded; you can control audio recording through the Sound Recording option on Movie Menu 2. You can also play background music. Changing the audio settings causes the camera to create a new album for your next snapshot.

>> **Movie Recording Size:** All clips in an album must use the same Movie Recording Size option (which you choose from Movie Menu 2). Changing this setting also results in a new album.

>> **Autofocusing:** Your options are the same as for normal movie recording; Chapter 5 has the details.

>> **Normal playback:** To play a video snapshot after you exit the creation process, use the normal movie-playback steps, detailed at the end of Chapter 8.

Trimming Movies

Your camera's movie-edit feature makes it possible to remove unwanted material from the beginning or end of a movie. To access the editing tools, first charge the camera battery; movie editing isn't possible when the battery is low. Next, set the camera to Playback mode, select a movie for playback, and press the Set button to display the controls shown on the left in Figure 12-9. Use the cross keys to highlight the Edit symbol (the scissors icon, labeled in the figure) and press Set to enter the editing screen.

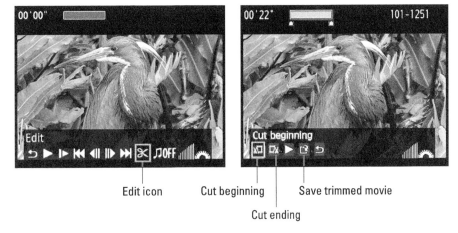

Edit icon Cut beginning Save trimmed movie

Cut ending

To trim content from the start of a movie, highlight the Cut Beginning icon, labeled on the right in Figure 12-9, and press Set. Press the left/right cross keys to advance to the first frame you want to keep and then press Set. Then choose the Save option, labeled in the figure, press Set, and select New File. This step saves your trimmed movie as a new file instead of overwriting your original. (Choose Overwrite if you wish to do so, but this is a riskier option.)

To trim the end of a movie, follow the same process, but choose the Cut Ending icon (labeled in Figure 12-9) instead of the Cut Beginning icon.

TIP

The in-camera movie-editing function doesn't provide very precise trimming because it can slice and dice only in 1-second increments. That means that the resulting trimmed movie may not start or end exactly on the frame you selected. If you want frame-by-frame control, download your movies to a computer and edit them using video-editing software.

Viewing Your Photos and Movies on an HDTV

Your camera is equipped with a feature that allows you to play your pictures and movies on an HDTV screen. However, you need to purchase an HDMI cable to connect the camera and television; the Canon part number you need is HDMI cable HTC-100.

REMEMBER

This function isn't available when the camera's Wi-Fi feature is enabled. So head to Setup Menu 3 and set the Wi-Fi/NFC option to Disable. (Likewise, you can't use the Wi-Fi features when the camera is connected to a TV or your computer.)

Next, turn the camera off and connect the smaller end of the HDMI cable to the HDMI port found under the cover on the left side of the camera. I labeled the port in Figure 12-10.

At this point, I need to point you to your TV manual to locate the HDMI terminal on the TV or monitor where you should connect your camera. You also need to consult your manual to find out which channel or input source to select for playback of signals from auxiliary devices. It's best to turn off your TV before plugging in the camera.

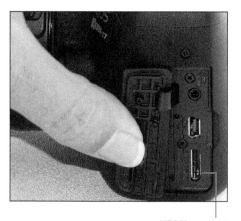

HDMI terminal

FIGURE 12-10:
Plug the small end of the cable into this camera port.

After you sort out those issues, turn on the TV and your camera to send the camera signal to the TV set. For the most part, you can control playback using the same camera controls as you normally do to view pictures on your camera monitor. But if you're playing movies or a slide show with background music, you must adjust the volume via your TV's audio controls.

Exploring More Wi-Fi Functions

At the end of Chapter 10, I explain how to set up your camera to transfer photos via a wireless connection to a smartphone or tablet, using the Canon Camera Connect app. Of all the Wi-Fi functions, I think that one is the feature that you're likely to find most useful. But you can also enjoy the following wireless operations:

» **Use your smart device to trigger the camera's shutter release.** This feature gets my vote for the second-most useful Wi-Fi function, although if you have a regular remote control, using it is significantly easier because you don't have to go through the steps of getting the camera and your phone to talk to each other.

To try this feature, follow the setup steps in Chapter 10 to connect your camera to your smart device via the Camera Connect app. I show the iOS version of the app in Figure 12-11, but the Android version looks similar. On the home screen of the app, shown on the left in the figure, choose Remote Live View Shooting. The camera automatically shifts into Live View mode, and the camera monitor turns off. You then see the live preview on your device screen, as shown on the right in the figure.

If the camera lens is set to autofocus mode, set focus by tapping your subject on the smart device's screen. The box in the preview indicates the current focus point. If the camera lens is set to manual focus, the box disappears, and you must turn the focus ring on the camera to set focus. Either way, take the picture by tapping the app's shutter button, labeled in the figure. And don't forget — as I always do — that if you want to reframe the shot, you have to move the camera, not the phone. (Doh!)

You can adjust some camera settings via the app, but most must be set before you hand over control to your smart device. Unfortunately, I don't have room in this book to provide details on all the remote-control shooting options. If you need help, first check the paper instruction manual that shipped in your camera box. If that booklet doesn't provide the answers you need, head for the Canon website and download the entire instruction manual along with the separate Wi-Fi instruction manual. The paper manuals provided in the camera box don't offer the full story on all camera features.

» **Upload photos to Canon's web service through a wireless Internet connection:** Canon offers a free online photo sharing site called Canon iMage Gateway. After creating your account, you have access to 10GB of photo storage space and can create and share albums with others. You also can post a link to your albums on your social media pages.

Free storage space is always a good thing. But as for the photo-sharing part of the service, it's much easier to go the direct route provided by the Canon Camera Connect app, assuming that you have a compatible smart phone or device. If you do want to take advantage of Canon iMage Gateway, you need to configure your camera to connect to your computer's wireless network. That process is different from the one you use to connect to a smartphone, and it involves a lot of variables depending on what kind of network security you have in place. So I must point you toward the image Gateway website to get specifics on connecting to and using the service. Use your web browser's search engine to find the link to the Canon image Gateway home page for your country or region.

FIGURE 12-11: The Canon Camera Connect app enables you to use your smartphone or tablet as a wireless remote control.

Shutter button

>> **Send files to a Canon Connect Station.** The Connect Station, which retails for about $300, is a combination of an external data-storage drive and media hub. You can store up to 1TB (terabyte) of data on the station. For playback, you can connect the station via an HDMI cable to a TV or monitor. The Connect Station also can be linked to a Canon iMage Gateway album. In order to reserve space for topics I think will be of interest to the most readers, I opted not to cover this feature. But again, you can get full details on product features and installation at the Canon website.

Appendix

Glossary of Digital Photography Terms

Can't remember the difference between a pixel and a bit? USB and UHS? Turn here for a refresher on that term that's stuck somewhere in the dark recesses of your brain and refuses to come out and play.

24-bit image: An image containing approximately 16.7 million colors.

Adobe RGB: One of two Color Space settings available on your camera; contains the largest spectrum of colors that your camera can capture.

AEB: *Auto Exposure Bracketing,* a feature that automatically records three photos using different exposure settings.

AE lock: A way to prevent the camera's autoexposure system from changing the current exposure settings before the image is recorded.

AF Operation: An autofocus setting that determines whether the camera locks focus when you press the shutter button halfway, continuously adjusts focus up to the time you take the shot, or chooses which of the two strategies to employ. Applies to viewfinder photography only.

AF Point Selection mode: An autofocus setting that tells the camera whether to choose a focus point automatically or base focus on a specific point that you select. Available only for viewfinder photography.

AI Focus: One of three AF Operation settings. Focus locks when you press the shutter button halfway unless the camera senses motion, in which case it adjusts focus as needed to track the subject up to the time you take the shot.

AI Servo: An AF Operation setting designed for focusing on moving subjects. The camera adjusts focus as needed until you press the shutter button all the way to take the shot.

aperture: An opening in an adjustable diaphragm in the camera lens. The size of the opening is measured in f-stops (f/2.8, f/8, and so on), with a smaller number resulting in a larger aperture opening.

aspect ratio: The proportions of an image or movie frame.

Auto Lighting Optimizer: A feature designed to improve underexposed or low-contrast shots automatically.

Av mode (aperture-priority autoexposure): A semiautomatic exposure mode: You select the aperture, and the camera selects the appropriate shutter speed to produce a good exposure. *Av* stands for *aperture value.*

backlight: Bright light coming from behind your subject, which can cause your subject to be underexposed in autoexposure shooting modes.

Basic Zone modes: Canon's way of referring to all exposure modes except P, Tv, Av, and M. Exposure modes in this category provide automated exposure control and limit access to advanced camera features.

bit depth: Refers to the number of bits of data available to store color information. More bits means more data.

Bulb mode: A shutter speed setting that keeps the shutter open as long as you hold down the shutter button. Available only in the M (manual) exposure mode.

burst mode: Another name for the Continuous Drive mode setting, which records images in rapid succession as long as you hold down the shutter button.

Close-up mode: An automated exposure mode designed for shooting subjects at close range; chooses settings that produce a blurry background, thereby emphasizing your subject.

color temperature: Refers to the color cast emitted by a light source; measured on the Kelvin scale.

CR2: The Canon Raw format. *See also* Raw.

Creative Auto exposure mode: An automatic-exposure mode that gives you a little more flexibility than the other fully automatic modes.

Creative Zone mode: Canon's term for the advanced exposure modes: P (programmed autoexposure), Tv (shutter-priority autoexposure), Av (aperture-priority autoexposure), and M (manual exposure).

Custom Functions: A group of advanced camera options accessed via Setup Menu 3 and available only in the P, Tv, Av, and M exposure modes.

depth of field: The distance over which focus appears acceptably sharp. With a shallow depth of field, the subject is sharp but objects in front of and behind the subject are blurry. With a large depth of field, both the subject and distant objects are in focus. Manipulated by adjusting the aperture, lens focal length, or camera-to-subject distance.

Drive mode: The camera setting that determines when and how the shutter is released when you press the shutter button. Options include Single, which produces one picture for each button press; Continuous, which records a continuous burst of images as long as you hold down the button; and three self-timer modes.

dSLR: Stands for *digital single-lens reflex,* the type of technology used by your Canon Rebel.

dynamic range: The overall range of brightness values in a photo, from black to white.

exposure: The overall brightness and contrast of a photograph, determined mainly by three settings: aperture, shutter speed, and ISO.

Exposure Compensation: A way to adjust the exposure settings chosen by the camera's autoexposure mechanism. EV stands for *exposure value;* EV settings appear as EV 1.0, EV 0.0, EV –1.0, and so on.

(Face Detection) Live Mode: A Live View and movie-recording autofocusing option that searches for faces in the scene and, if it finds them, automatically focuses on them. If no faces are found, the camera operates as it does in the FlexiZone-Single autofocusing mode.

FE Lock: Stands for *flash exposure lock.* A feature that forces the camera to base flash exposure only on the subject at the center of the frame.

file format: A way of storing image data in a digital file; your camera offers two formats, JPEG and Raw (CR2).

firmware: The internal software that runs the camera's "brain." Canon occasionally releases firmware updates that you should download and install in your camera (follow the instructions at the download site).

flash exposure compensation: A feature that adjusts flash output.

Flash Off mode: The same as Scene Intelligent Auto exposure mode (fully automated shooting), but with flash disabled.

FlexiZone-Single AF: A Live View and movie-only autofocus option; you specify a single focus point for the camera to use when setting focus.

f-number, f-stop: Refers to the size of the camera aperture opening. A higher number indicates a smaller aperture opening. Written as f/2, f/8, and so on. Affects both exposure and depth of field.

formatting: An in-camera process that wipes all data off the memory card and prepares the card for storing pictures.

frame rate: In a movie, the number of frames recorded per second (fps). A higher frame rate translates to crisper video quality.

gigabyte: Approximately 1,000 megabytes, or 1 billion bytes. In other words, a really big collection of bytes. Abbreviated as GB.

HDR: Stands for *high dynamic range* and refers to a picture that's created by merging multiple exposures of the subject into one image using special computer software. The resulting picture contains a greater range of brightness values — a greater dynamic range — than can be captured in a single shot.

Highlight Tone Priority: A feature designed for shooting high-contrast scenes; brightens shadows without making highlights too bright.

histogram: A graph that maps out brightness values in an image. Can be displayed during playback and, during Live View shooting, on the monitor.

hot shoe: The connection on top of the camera where you attach an auxiliary flash.

Image Stabilization: A feature designed to compensate for small amounts of camera shake, which can blur a photo. Indicated on Canon lenses by the initials IS; enabled via the Stabilizer switch on the lens.

Image Zone modes: Canon nomenclature for the automated, scene-specific exposure modes: Portrait, Landscape, Close-up, Food, Sports, and Night Portrait.

Index mode: A playback feature that displays four or nine image thumbnails at a time.

ISO: A setting that determines the camera's light sensitivity. The higher the number, the greater the light sensitivity. Raising the ISO allows faster shutter speed, smaller aperture, or both, but also can result in a noisy (grainy) image.

JPEG: Pronounced *jay-peg.* The primary file format used by digital cameras; also the leading format for online and web pictures. Uses *lossy compression,* which eliminates some data in order to reduce file size. A small amount of compression does little discernible damage, but a high amount destroys picture quality.

JPEG artifact: A defect created by too much JPEG compression.

Jump mode: A playback feature that enables you to jump through images 10 at a time, 100 at a time, or by date, by type of file, by folder, or by rating.

Kelvin: A scale for measuring the color temperature of light. Sometimes abbreviated as *K,* as in 5000K. (Note that in computer-speak, the initial *K* more often refers to kilobytes, as described next.)

kilobyte: One thousand bytes. Abbreviated as *K,* as in 64K.

Landscape mode: An automated exposure mode designed to render landscapes with high contrast and bold, crisp colors.

LCD: Stands for *liquid crystal display.* Often used to refer to the display screen included on digital cameras.

Live View: The feature that enables you to use the camera monitor instead of the viewfinder to compose your shots.

lossy compression: A compression scheme that eliminates important image data in the name of achieving smaller file sizes, used by file formats such as JPEG. High amounts of lossy compression reduce image quality.

M (manual) exposure mode: An exposure mode that enables you to control both aperture and shutter speed.

manual focus: A setting that turns off autofocus and instead enables you to set focus by rotating the focusing ring on the lens.

megabyte: One million bytes. Abbreviated as MB. *See also* bit.

megapixel: One million pixels; used to describe the resolution offered by a digital camera. Abbreviated as MP.

metadata: Extra data that gets stored along with the primary image data in an image file. Metadata often includes information such as aperture, shutter speed, and EV compensation setting used to capture the picture, and can be viewed during playback, and after downloading in some photo programs.

metering mode: Refers to the area of the frame the camera considers when calculating exposure settings.

Night Portrait mode: Designed for photographing people in dim lighting; combines a slow shutter speed with flash for brighter backgrounds and softer lighting. For good results, use a tripod and ask your subject to remain still.

noise: Graininess in an image, caused by a very long exposure, a too-high ISO setting, or both.

One-Shot AF: An AF Operation (autofocusing) option, available for viewfinder photography. Focus is locked when you press the shutter button halfway and remains locked as long as you hold the button down halfway.

P mode: *Programmed autoexposure* shooting mode. The camera selects both f-stop and shutter speed, but you can select from different combinations of the two and access all other camera features.

Peripheral Illumination Correction: A feature designed to correct *vignetting,* a lens defect that causes the corners of the image to appear darker than the rest of the scene.

Picture Styles: Settings designed to render images using different color, sharpness, and contrast characteristics.

pixel: Short for *picture element.* The basic building block of every image.

Portrait mode: An automated mode designed to render portraits in the traditional style, with softer skin texture, warmer skin tones, and a blurry background.

ppi: Stands for *pixels per inch.* Used to state image output (print) resolution. A higher ppi usually translates to better-looking printed images.

Quick Control mode: Press the Q button to shift the monitor to this mode, which enables you to adjust certain camera settings quickly.

Quick Mode AF: A Live View and movie-recording autofocusing option, you tell the camera to automatically select from one of nine autofocus points or to base focus on a point that you select.

Raw: A file format that records the photo without applying any of the in-camera processing or file compression that is done when saving photos in the JPEG format. Indicated by the file extension .CR2.

Raw converter: A software tool that translates Raw files into a standard image format such as JPEG or TIFF.

red-eye: Light from a flash being reflected from a subject's retina, causing the pupil to appear red in photographs. It can sometimes be prevented by using the Red-Eye Reduction flash setting.

resolution: A term used to describe the number of pixels in a digital image or a video frame. Also a specification describing the rendering capabilities of scanners, printers, and monitors; means different things depending on the device.

RGB: The standard color model for digital images; all colors are created by mixing red, green, and blue light.

Scene Intelligent Auto: The most automatic of automatic exposure modes, represented by the A+ symbol on the Mode dial. The camera analyzes the subject and selects the settings it deems appropriate for capturing the photo.

SD card: The type of memory card used by your camera; stands for *Secure Digital.*

SDHC card: Stands for *Secure Digital High Capacity* and refers to cards with capacities ranging from 4MB to 32MB.

SDXC card: *Secure Digital eXxtended Capacity;* used to indicate an SD memory card with a capacity greater than 32MB.

shutter: A light-barrier inside the camera that opens when you press the shutter button, allowing light to strike the image sensor and expose the image.

shutter speed: The length of time the shutter remains open, measured in fractions of a second, as in 1/60 second.

slow-sync flash: A flash setting that allows (or forces) a slower shutter speed than is typical for the normal flash setting. It results in a brighter background than normal flash.

Sports mode: An automated exposure mode designed for capturing action; selects a fast shutter speed to "freeze" the subject in mid-motion.

sRGB: Stands for *standard RGB,* the default Color Space setting on your camera. Developed to create a standard color spectrum that (theoretically) all devices could capture or reproduce.

stop: An increment of exposure adjustment. Increasing the exposure by one stop means to select exposure settings that double the light; decreasing by one stop means to cut the light in half.

TIFF: Pronounced *tiff,* as in a little quarrel. Stands for *tagged image file format.* A popular image format supported by most Macintosh and Windows programs. It is *lossless,* meaning that it retains image data in a way that maintains maximum image quality. It's often used to save Raw files after processing.

Tv mode: Shutter-priority autoexposure; you set the shutter speed and the camera selects the f-stop to properly expose the image. Tv stands for *time value* (length of exposure).

UHS-1, -2, or -3: A classification assigned to some SD memory cards; stands for *Ultra High Speed.* The higher the number, the faster the card's read/write speed.

USB: Stands for *Universal Serial Bus.* A type of port for connecting your camera to your computer.

Video Snapshot: A special movie mode that records a 2-, 4-, or 8-second movie clip. Multiple clips can be combined into a snapshot *album.*

White Balance: The feature that automatically compensates for the color temperature of the light source, ensuring accurate rendition of.

Index

Numerics

A

About the Author

Julie Adair King has been teaching and writing about digital photography for more than two decades. She is the author of the best-selling book *Digital Photography For Dummies* as well as a series of *For Dummies* guides to Canon, Nikon, and Olympus cameras. Other works include *Digital Photography Before & After Makeovers, Shoot Like a Pro!: Digital Photography Techniques,* and *Digital Photo Projects For Dummies.*

Author's Acknowledgments

I am deeply grateful for the support of the team that made this book possible. It is every writer's dream to work with an editor who is as skilled as Kim Darosett and a technical editor who has as much knowledge as Theano Nikitas. I am also indebted to Steve Hayes, Mary Corder, and the other publishing professionals at John Wiley and Sons. Thank you all for being part of this journey.

Publisher's Acknowledgments

Executive Editor: Steven Hayes
Project Editor: Kim Darosett
Technical Editor: Theano Nikitas
Editorial Assistant: Matthew Lowe
Sr. Editorial Assistant: Cherie Case

Production Editor: Mohammed Zafar Ali
Front Cover Image: Courtesy of Julie Adair King